THE CANADIAN ART CLUB

1907–1915

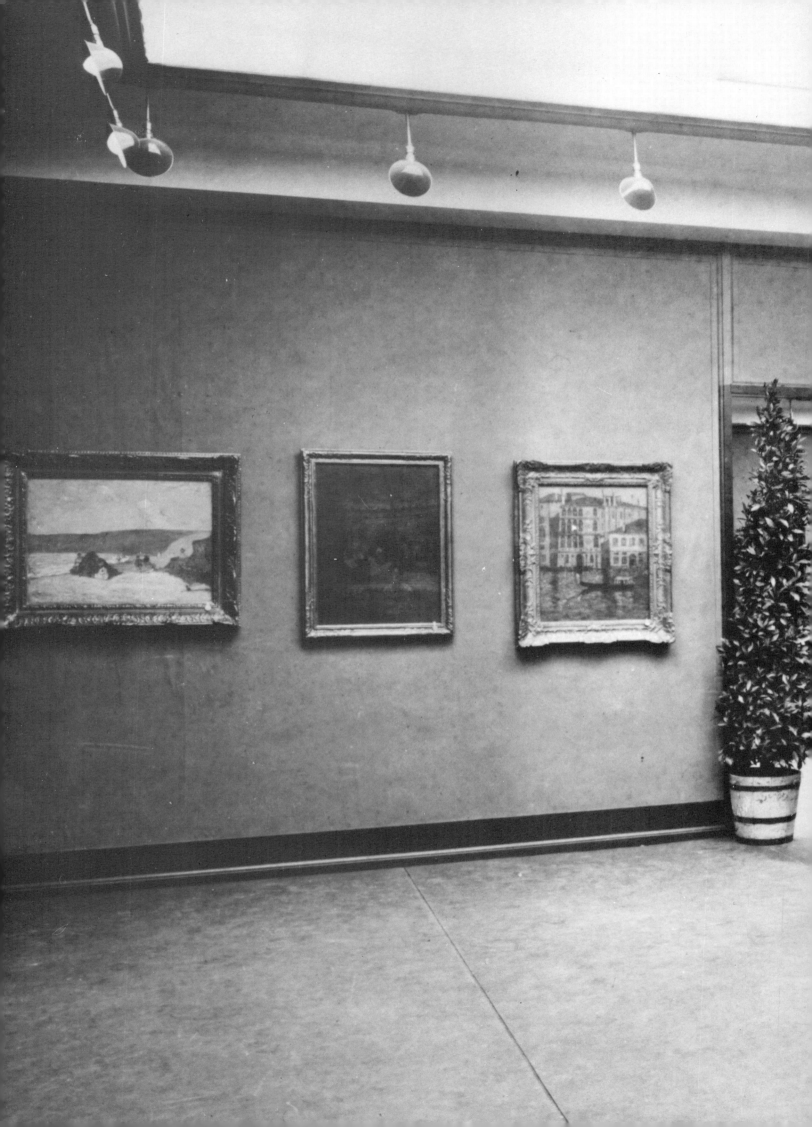

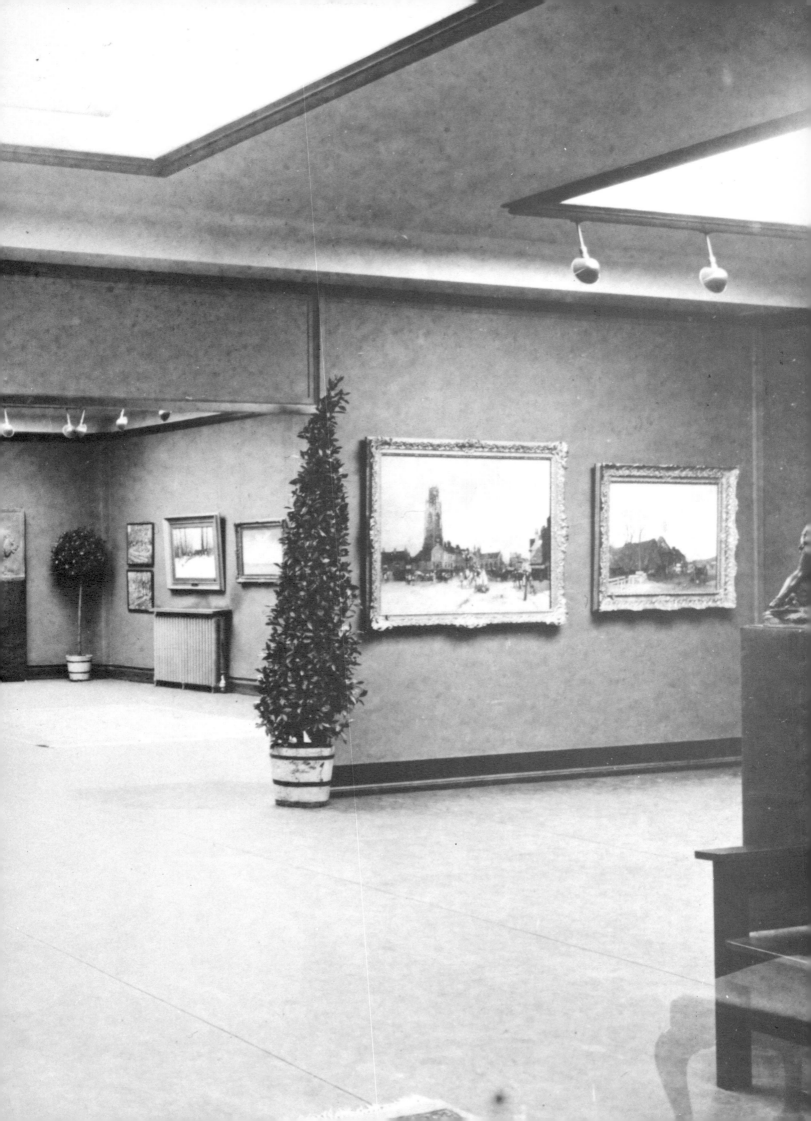

Publication Credits
Ont collaboré à la publication

Supervisor of Publications
Responsable des Publications: *Gerald J. Gongos*

Editor/Éditeur: *Stacey Bertles*
Editorial Secretary
Secrétaire à la rédaction: *Branka Racic*

Designer: *Jorge Frascara*
Design Assistant
Assistante-designer: *Susan Colberg*

Typesetter/Composition: *Contempratype*
Printer/Impression: *Co-op Press Limited*

The Edmonton Art Gallery is a registered, non-profit organization, supported by memberships and donations and by grants from the City of Edmonton, the Alberta Art Foundation, the Canada Council and Communications Canada, Museum Assistance Program.

L'Edmonton Art Gallery est un organisme enregistré à but non lucratif qui subsiste grâce aux cotisations de ses membres, aux dons divers, et aux subventions que lui accordent la ville d'Edmonton, l'Alberta Art Foundation, le Conseil des Arts et Communications Canada, programmes d'aide aux musées.

The Canadian Art Club 1907-1915
Robert J. Lamb

ISBN 0-88950-049-5
Printed in Canada/Imprimé au Canada

Frontispiece

Installation, Canadian Art Club, 6th Annual Exhibition/6e exposition annuelle, 1913, Art Museum of Toronto. Photo: E.P. Taylor Reference Library, Art Gallery of Ontario

Cover/Couverture

Curtis Williamson. *Misty Morning, Newfoundland*. c. 1906. Oil on canvas/Huile sur toile, 97.8 x 128.3 cm. Art Gallery of Ontario. Photo: Harry Korol

THE CANADIAN ART CLUB

1907–1915

Organized by/Exposition organisée par

DR. ROBERT J. LAMB

for/pour

THE EDMONTON ART GALLERY

Made possible by/Grâce au soutien de Communications Canada
and/et
University-Community Special Projects Funds of the University of Alberta
au fonds de l'Université d'Alberta consacré aux projets communautaires spéciaux

ACKNOWLEDGEMENTS

During the more than three years I have been thinking of this exhibition, I have incurred many debts with many kind people. The Edmonton Art Gallery agreed to sponsor it and various members of its staff: Terry Fenton, Roger Boulet, Kate Davis, Maggie Callahan and Stacey Bertles especially, worked enthusiastically to bring it off. The National Museums Corporation supported the research and much of the production costs. A grant from the University of Alberta covered some of the catalogue expenses and Professor Jorge Frascara of the University donated his time to design the catalogue.

The staff of the E.P. Taylor Reference Library at the Art Gallery of Ontario and the Library of the National Gallery of Canada not only put up with me during several long periods of research on their premises, but did so in a friendly and helpful manner. Curators, dealers and assorted experts across Canada and the United States all helped me tremendously in locating works and information. Special thanks here go to Charles C. Hill, Dennis Reid, Patricia Ainslie, Ken McCarthy, Eric Klinkhoff, Sylvia Antoniou, Victoria Baker, Christine Boyanoski, Nicole Cloutier, Yves Lacasse, Michael Parke-Taylor, Geoffrey Simmins, John Snell, David Somers, George Loranger, Pierre l'Allier, David Karel, Norbert Ferré, Barry Fair and the late Janet Braide. My two research assistants, Diana Chown and Ann Hemingway-Kubo, typed and toiled for me in the bowels of the University of Alberta Library. Thanks are also due, of course, to all the lenders of the exhibition, especially those who have to put up with an empty space on their walls. My final thanks go to my late friend, T. Ladd Hilland, who often discussed the exhibition with me, encouraged my research and was so looking forward to seeing it come to fruition. I dedicate this catalogue to his memory.

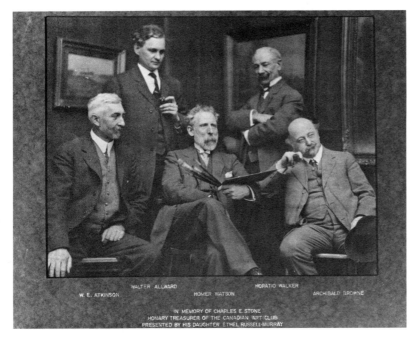

Members of the/Membres du/Canadian Art Club l. to r./de gauche à droite: W.E. Atkinson, Walter Allward, Homer Watson, Horatio Walker, Archibald Browne. Photo: Arts and Letters Club of Toronto

REMERCIEMENTS

Le projet de cette exposition aura mûri pendant plus de trois années au cours desquelles j'ai accumulé une dette de reconnaissance envers de nombreuses personnes et institutions. L'Edmonton Art Gallery qui a accepté de la présenter et parmi les membres de son personnel plus particulièrement: Terry Fenton, Roger Boulet, Kate Davis, Maggie Callahan et Stacey Bertles qui ont travaillé avec enthousiasme à sa mise au point. La Corporation des musées nationaux a subventionné la recherche et la plupart des frais de réalisation. Un subside de l'Université de l'Alberta a couvert une partie des coûts de cette publication, au design de laquelle le Professeur Jorge Frascara (U of A) a généreusement donné de son temps.

C'est avec beaucoup de gentillesse et de dévouement que le personnel de la bibliothèque E. P. Taylor de l'Art Gallery of Ontario et de la bibliothèque du Musée des beaux-arts du Canada m'a accueilli durant les longues périodes nécessaires à ma recherche. Dans tout le Canada et les États-Unis, conservateurs de musées, marchands de tableaux et spécialistes divers m'ont été d'un immense secours et m'ont permis de retrouver les oeuvres et la documentation que je cherchais. Un merci tout spécial aux personnes suivantes: Charles C. Hill, Dennis Reid, Patricia Ainslie, Ken McCarthy, Eric Klinkhoff, Sylvia Antoniou, Victoria Baker, Christine Boyanoski, Nicole Cloutier, Yves Lacasse, Michael Parke-Taylor, Geoffrey Simmins, John Snell, David Somers, George Loranger, Pierre L'Allier, David Karel, Norbert Ferré, Barry Fair, et la regrettée Janet Braide. Merci à mes deux assistantes de recherche, Diana Chown et Ann Hemingway-Kubo qui ont tapé le manuscrit et qui ont laborieusement travaillé pour moi dans les dédales de la bibliothèque de l'Université (U of A). Merci bien sûr, à tous les collectionneurs qui ont accepté de se départir de leurs tableaux durant plus d'une année pour notre projet. Merci enfin à mon regretté ami T. Ladd Hilland, qui discutait souvent de cette exposition avec moi, qui m'a encouragé dans ma recherche et souhaitait si vivement en voir les fruits. C'est à sa mémoire que je dédie cette publication.

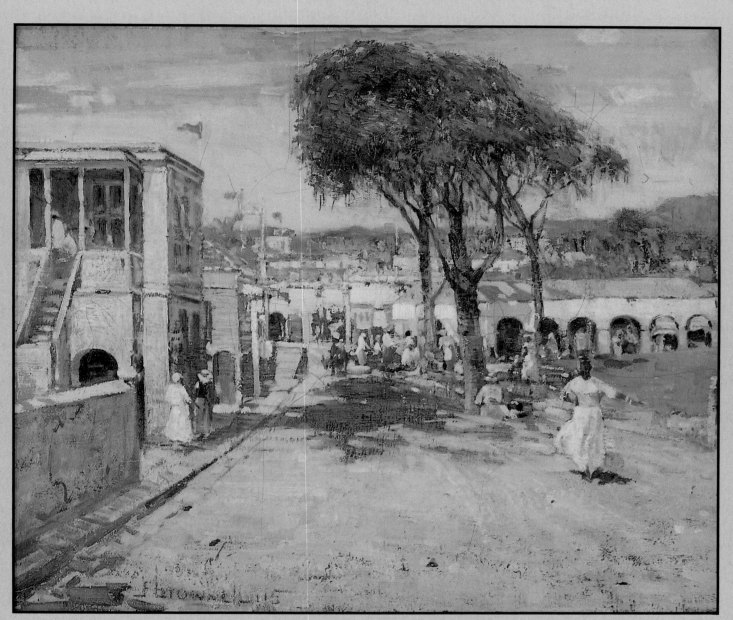

Franklin Brownell. *Street Scene, West Indies*. 1915. Oil on canvas/Huile sur toile, 37 x 44 cm. Private Collection. Photo: Harry Korol

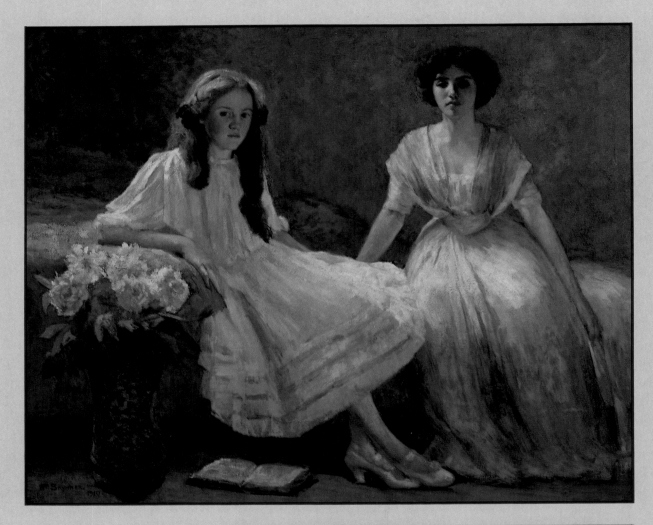

William Brymner. *The Vaughan Sisters*. 1910.
Oil on canvas/Huile sur toile, 102 x 128 cm.
Art Gallery of Hamilton

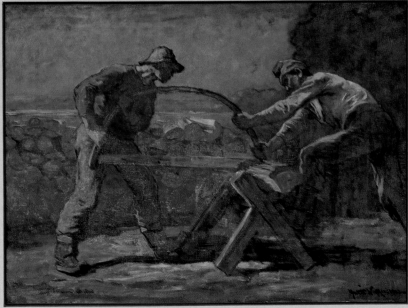

Horatio Walker. *Les Scieurs de Bois*. 1900. Oil
on canvas/Huile sur toile, 71.3 x 96.8 cm.
Musée du Québec. Photo: Harry Korol

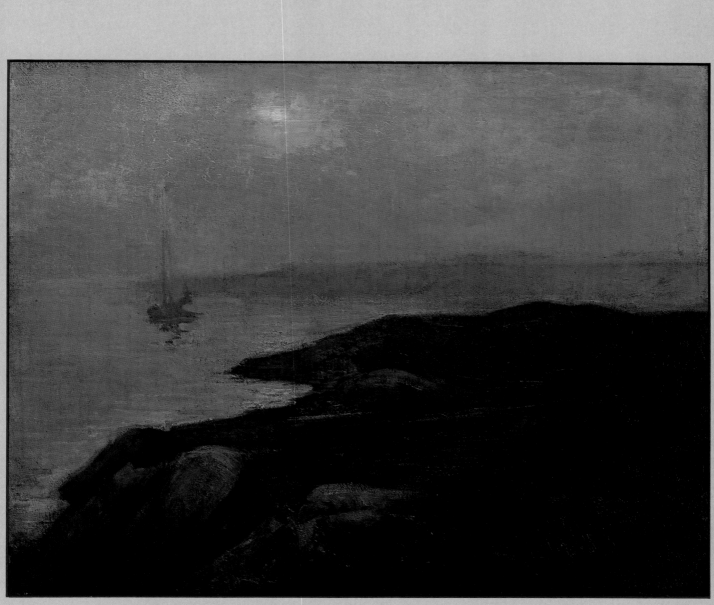

Curtis Williamson. *Misty Morning, Newfoundland.* c. 1906. Oil on canvas/Huile sur toile, 97.8 x 128.3 cm. Art Gallery of Ontario. Photo: Harry Korol

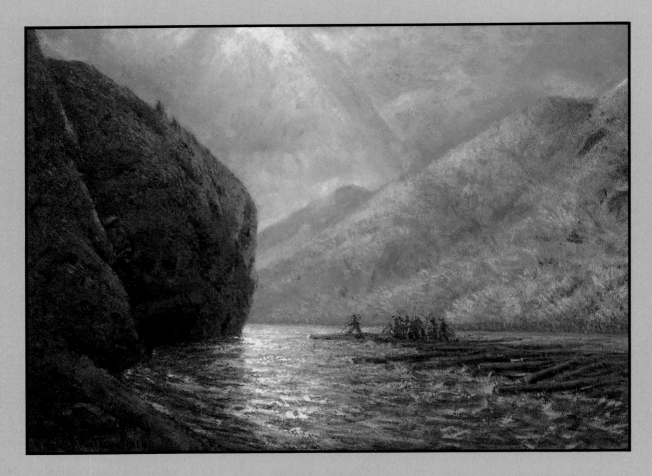

Homer Watson. *The River Drivers*. 1914 &
1925. Oil on canvas / Huile sur toile, 87 x
121.9 cm. The Mackenzie Gallery. Photo:
Don Hall

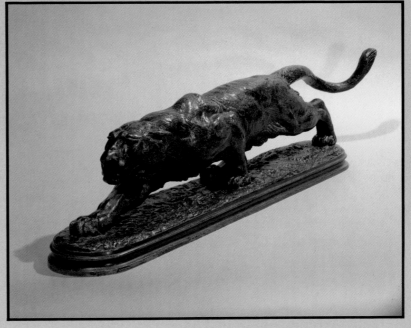

A. Phimister Proctor. *Prowling Panther*. 1891-92.
Bronze / Bronze, 24 x 85 cm. The Agnes
Etherington Art Centre. Photo: Harry Korol

INTRODUCTION

From the 1890s to 1914, the western world experienced a great economic boom and with it a period of great artistic fecundity. Canada, a young country, dramatically felt the effects of this boom with massive immigration, the industrialization and urbanization of Ontario and Quebec, the settling of the west, the development of diverse institutions and, with them, a growing national consciousness that sat uneasily with loyalty to Empire.[1]

Sir Wilfrid Laurier's proclaimed belief that the twentieth century belonged to Canada permeated Canadian thought, both profound and ignorantly boosterish. It also generated a broad historical stock-taking seen in the publication of the first massive, multi-volume histories of the country, the first dictionaries of Canadian biography, the first Canadian literary bibliographies and the first essays surveying Canadian art history.[2]

Today, the art of the Laurier period seems strangely ambiguous, complex and unresolved, sometimes with national aspirations but with few distinctly national qualities. A safe, "juste milieu" tone prevails and, when we Canadians think of our national artistic development, we think quantitatively of gross amounts of activity or institutional growth or, more subjectively, of increasing professionalism. In music and theatre, we think of the success of individual performers rather than original Canadian composers or playwrights, more of the institutions of performance than of the few Canadian works performed. In literature we think of Charles G.D. Roberts who first created the role of the "Man of Letters" in Canada and who demonstrated "that the high style, as the Victorians understood it, could be achieved by a Canadian."[3] We think of Canadian writers by the score but with Roberts, Lampman, Carman and Scott, we realize their overwhelming debt to the English romantic and Victorian poets.

"Breaks with the past" and "new beginnings" are generally dated to the years around World War I or sometimes the 1920s. A new nationalism and a new realism, a "Canadian art" — not "art in Canada" — is associated with the works of Frederick Philip Grove and Morley Callaghan, of Emily Carr and the Group of Seven. In fact, the Group believed that they were the first Canadian artists to transcend European artistic conventions and tell the truth about Canada. Several generations shared their belief and wrote whiggish Canadian art histories reflecting a search for nationality that culminated in the Group. These histories worked to the special detriment of the Group's immediate predecessors from the Laurier period. Within the past 20 years, however, the myth of the Group's national purity has been dispelled. Their debts to the impressionists and post-impressionists, to the symbolists and art nouveau designers now stand revealed.[4] This important reinterpretation opens to question the importance of the Laurier period in the development of Canadian art. Perhaps it is not just an ending. Perhaps it is a beginning, with the Group of Seven as its culmination.[5] Perhaps it is even more complex.

Abbreviations

PAC NMP — Public Archives of Canada, Newton MacTavish Papers
AGO CACS — Art Gallery of Ontario, Canadian Art Club Scrapbooks
AGO EMLB — Art Gallery of Ontario, Edmund Morris Letter Books
AGO EMP — Art Gallery of Ontario, Edmund Morris Papers
NY NMP — North York Public Library, Newton MacTavish Papers
OA OSA — Ontario Archives, Ontario Society of Artists Papers
UT EWP — University of Toronto, Sir Edmund Walker Papers

1
For a discussion of this relationship see Carl Berger, *The Sense of Power*. Toronto: University of Toronto Press, 1970.

2
Some of the more notable histories are J. Castell Hopkins, ed., *Canada: An Encyclopedia of the Country*. 5 Vols. Toronto: The Linscott Publishing Co., 1898; Duncan Campbell Scott and Pelham Edgar, eds., *The Makers of Canada*. 21 vols. Toronto: Morang and Co. Ltd., 1903-11; Adam Shortt and Arthur G. Doughty, eds. *Canada and Its Provinces*. 23 vols. Toronto: The Publishers Assoc. of Canada Ltd., 1913. The most notable biographical dictionary was Henry James Morgan, ed., *The Canadian Men and Women of the Time*. Toronto: William Briggs, 1912. The first literary bibliography was Lewis Emerson Horning and Lawrence Burpee, *A Bibliography of Canadian Fiction (English)*. Toronto: William Briggs, 1904. The first essays were the five essays in Hopkins, *Canada...*, vol. 4, section 4; Edmund Morris, *Art in Canada: The Early Painters*. Toronto: n.p., 1911; E.F.B. Johnston, "Painting and Sculpture in Canada." vol. 12 of Shortt and Doughty, *Canada...*, pp. 593-640.

3
Roy Daniells, "Lampman and Roberts." in Carl F. Klinck, ed., *Literary History of Canada*. Toronto: University of Toronto Press, 1965, p. 403.

4
The main recent interpretations of the Group are Dennis Reid, *The Group of Seven*. Ottawa: The National Gallery of Canada, 1970; Peter Mellen, *The Group of Seven*. Toronto: McClelland and Stewart, 1970; Roald Nasgaard, *The Mystic North*. Toronto: University of Toronto Press, 1984.

5
This interpretation is seen in William Colgate, *Canadian Art: Its Origin and Development*. Toronto: The Ryerson Press, 1943, p. 76.

INTRODUCTION

Abréviations

PAC NMP — Public Archives of
 Canada, Newton MacTavish Papers
AGO CACS — Art Gallery of Ontario,
 Canadian Art Club Scrapbooks
AGO EMLB — Art Gallery of Ontario,
 Edmund Morris Letter Books
AGO EMP — Art Gallery of Ontario,
 Edmund Morris Papers
NY NMP — North York Public Library,
 Newton MacTavish Papers
OA OSA — Ontario Archives, Ontario
 Society of Artists Papers
UT EWP — University of Toronto,
 Sir Edmund Walker Papers

1
Pour une discussion de ce rapport, voir
Carl Berger, *The Sense of Power*. Toronto:
University of Toronto Press, 1970.

2
Parmi les histoires les plus remarquables
figurent: J. Castell Hopkins, *Canada: An
Encyclopedia of the Country*. 5 Vols.
Toronto: The Linscott Publishing Co.,
1898; Duncan Campbell Scott and Pelham
Edgar, eds., *The Makers of Canada*. 21 vols.
Toronto: Morang and Co. Ltd., 1903-11;
Adam Shortt and Arthur G. Doughty, eds.
Canada and Its Provinces. 23 vols.
Toronto: The Publishers Assoc. of Canada
Ltd., 1913. Le dictionnaire biographique
le plus notoire est: Henry James Morgan,
ed., *The Canadian Men and Women of the
Time*. Toronto: William Briggs, 1912. La
première bibliographie littéraire fut écrite
par Lewis Emerson Horning et Lawrence
Burpee, *A Bibliography of Canadian Fiction
(English)*. Toronto: William Briggs, 1904.
Les cinq premiers essais parurent dans
Hopkins, *Canada...*, vol. 4, section 4;
Edmund Morris, *Art in Canada: The
Early Painters*. Toronto: n.p., 1911; E.F.B.
Johnston, "Painting and Sculpture in
Canada." vol. 12 de Shortt and Doughty,
Canada..., pp. 593-640.

3
Roy Daniells, "Lampman and Roberts."
in Carl F. Klinck, ed., *Literary History of
Canada*. Toronto: University of Toronto
Press, 1965, p. 403.

Des années 1890 à 1914, le monde occidental vécut une forte prospérité économique accompagnée d'une grande fécondité artistique. Pour ce pays jeune qu'était le Canada, le phénomène devait se manifester de façon spectaculaire par une immigration massive, l'industrialisation et l'urbanisation de l'Ontario et du Québec, le peuplement de l'Ouest et le développement d'institutions diverses—le tout assorti d'une conscience nationale grandissante qui s'accommodait mal de l'allégeance à l'Empire.[1]

La proclamation de foi de Sir Wilfrid Laurier selon laquelle le vingtième siècle appartenait au Canada était au coeur même de la pensée canadienne—à la fois profonde et d'une arrogante naïveté. Elle devait entraîner un large inventaire historique qui se traduit par la publication des premières histoires volumineuses du pays, par les premiers dictionnaires biographiques canadiens, les premières bibliographies littéraires canadiennes, et les premières études consacrées à l'histoire de l'art canadien.[2]

Aujourd'hui, les arts de l'époque de Laurier paraissent étrangement ambigus, complexes et indécis. Parfois animés d'aspirations nationales, ils présentent toutefois peu de qualités qui leur soient propres et se caractérisent surtout par une prudente retenue. Quand nous, Canadiens, pensons à notre développement artistique national, c'est en termes quantitatifs, en mesurant le nombre de nos activités ou la croissance de nos institutions; ou alors plus subjectivement, par le développement de notre professionnalisme. Dans le domaine de la musique et du théâtre, c'est le succès personnel des interprètes qui nous vient à l'esprit plutôt que les compositeurs et les dramaturges, et plus que les quelques oeuvres canadiennes qui ont été jouées, nous retenons le nom des institutions qui les ont présentées. En littérature, nous pensons à Charles G.D. Roberts qui créa le rôle de "l'homme de lettres" au Canada et démontra que le style élevé, au sens victorien, pouvait être maîtrisé par un des nôtres.[3] Nous pouvons bien évoquer toute une pléiade d'auteurs canadiens mais Roberts, Lampman, Carman et Scott nous rappellent leur dette envers les poètes victoriens et les romantiques anglais.

En général, les "ruptures avec le passé" et les "nouveaux départs" remontent à l'époque de la première guerre mondiale ou parfois aux années vingt. Un nouveau nationalisme, un nouveau réalisme, la notion d'un art proprement canadien, plutôt que produit au Canada, émerge avec les oeuvres de Frederick Philip Grove et de Morley Callaghan, d'Emily Carr et du Groupe des Sept. En fait, les membres du Groupe se considéraient comme les premiers artistes canadiens à transcender les conventions européennes et à exprimer le vrai Canada. Plusieurs générations allaient partager leur conviction et publier des histoires d'art canadien partisanes où s'exprimait la quête d'un esprit national dont le Groupe des Sept représentait le sommet. Les ouvrages en question devaient se faire au détriment des artistes de la période de Laurier qui venaient de les précéder. Cependant, au cours des vingt dernières années, le mythe de pureté nationale du Groupe s'est érodé et l'on reconnaît tout ce qu'ils doivent aux impressionnistes et aux post-

At the centre of artistic activity in the Laurier period lies the Canadian Art Club, a Toronto-based exhibiting society active from 1907 to 1915. It displayed the work of most of the leading Canadian artists of the day and aimed for a national achievement that met international standards. In the 73 years since its demise, its reputation has waxed and waned in proportion to that of the Group of Seven. In 1925, in *The Fine Arts in Canada*, Newton MacTavish featured the members of the Club and wrote that:

> *...during its brief period, it was an important organization. Its ideals, notwithstanding apparent inconsistencies, were lofty, its purpose sincere, its membership distinguished.... It caused a perceptible quickening of public interest in art and even among artists its effect was stimulating and healthful.*[6]

One year later, however, in his polemic in favour of the Group of Seven, Fred Housser bemoaned the lack in Club exhibitions, of:

> *...a single Canadian Landscape. There were Dutch windmills, German forests, English duchesses, feudal castles, Venetian canals and still-lifes of fruit and old brass kettles; nowhere a snake fence, a Quebec steeple, a northern Beaver dam, a touch of Canadian autumn, nor a whiff of the north. Canadian opulence bought pictures as it bought stocks, bonds, rugs or antiques.*[7]

In the late 1930s, Graham McInnes wrote that the Club:

> *had little effect on the development of our art, yet by its very existence, produced controversy, and by its failure pointed a moral for the future.... Artistically it had misfired. It had sought to remedy apathy and artistic resentment with palliatives only. It is an interesting example of the way in which the strength of a 'rebel' movement can be dissipated, through misunderstanding of the root causes against which it struggles.*[8]

A little later, William Colgate's assessment was more positive. The Club "was a healthful influence," he wrote,

> *...and while it lived, beneficial to artist and layman alike. It bred self-confidence in Canadian art...that had hitherto been lacking. Canada aesthetically was beginning to find her feet.*[9]

The Club practically vanished from books on Canadian art during the 1950s and 1960s. Donald Buchanan and Robert Hubbard did not see fit to mention it at all and Russell Harper mentioned it only in passing.[10] A new recognition of its importance did not come until 1973, with Dennis Reid's history of Canadian painting.[11] Unlike most of his predecessors, Reid devoted a whole chapter to the Club, making it the focus of turn-of-the-century art activity. It is on Reid's foundation that this exhibition builds.

What was the state of art in Canada at the beginning of the Laurier period? With what did the Canadian Art Club have to contend? Art in Canada during the 1890s was not radically different in kind from art in most other western nations. It differed merely in its sophistication and its scale of operation. Most nations had been bitten by the bug of

6
Newton MacTavish, *The Fine Arts in Canada*, Toronto: The Macmillan Co. of Canada Ltd., 1925, p.74.

7
F.B. Housser, *A Canadian Art Movement: The Story of the Group of Seven*. Toronto: The Macmillan Co. of Canada Ltd., 1926, pp.44-45.

8
Graham McInnes, *A Short History of Canadian Art*. Toronto: The Macmillan Co. of Canada Ltd., 1939, pp.63,71.

9
Colgate, *Canadian Art*, p.75

10
Donald W. Buchanan, *The Growth of Canadian Painting*. Toronto: William Collins Sons and Co. Ltd., 1950; Robert H. Hubbard, *An Anthology of Canadian Art*. Toronto: Oxford University Press, 1960; J. Russell Harper, *Painting in Canada: A History*. Toronto: University of Toronto Press, 1966, p.215.

11
Dennis Reid, *A Concise History of Canadian Painting*. Toronto: Oxford University Press, 1973, chapter 9.

4
Les interprétations majeures récentes du Groupe sont: Dennis Reid, *The Group of Seven*. Ottawa: The National Gallery of Canada, 1970; Peter Mellen, *The Group of Seven*. Toronto: McClelland and Stewart, 1970; Roald Nasgaard, *The Mystic North*. Toronto: University of Toronto Press, 1984.

5
Cette interprétation se trouve dans William Colgate, *Canadian Art: Its Origin and Development*. Toronto: The Ryerson Press, 1943, p. 76.

6
Newton MacTavish, *The Fine Arts in Canada*, Toronto: The Macmillan Co. of Canada Ltd., 1925, p.74.

7
F.B. Housser, *A Canadian Art Movement: The Story of the Group of Seven*. Toronto: The Macmillan Co. of Canada Ltd., 1926, pp.44-45.

8
Graham McInnes, *A Short History of Canadian Art*. Toronto: The Macmillan Co. of Canada Ltd., 1939, pp.63,71.

9
Colgate, *Canadian Art*, p.75

impressionnistes, aux symbolistes et aux designers de l'art nouveau.[4] Cette importante réinterprétation entraîne un nouvel examen de l'influence qu'a exercée l'époque de Laurier sur le développement de l'art canadien. Peut-être ne marque-t-elle pas simplement une fin. Peut-être signale-t-elle un commencement dont le Groupe des Sept serait l'apogée.[5] Ou est-ce plus complexe encore?

Le Canadian Art Club est situé au centre des activités de l'époque de Laurier. Établie à Toronto, cette société qui organise des expositions sera active de 1907 à 1915. Elle a exposé les oeuvres de la plupart des artistes canadiens importants du jour et aspirait à un niveau national d'excellence de calibre international. Au cours des 73 années qui auront suivi sa fin, sa réputation aura subi des fluctuations, selon la bonne fortune du Groupe des Sept. En 1925, dans *The Fine Arts in Canada*, Newton MacTavish se penchait sur les membres du Club et écrivait que

> *...durant sa courte vie, [le Club] avait été un organisme important. Toute apparente inconséquence mise à part, ses idéaux étaient élevés, ses objectifs sincères et ses membres distingués. Il avait su aiguiser l'intérêt du public envers l'art et même parmi les artistes, il avait produit un effet stimulant et bénéfique.*[6]

Un an plus tard cependant, dans la polémique où il s'engageait en faveur du Groupe des Sept, Fred Housser regrettait qu'on ne trouvât pas dans les expositions du Club:

> *...un seul paysage canadien. Il y avait bien des moulins hollandais, des forêts allemandes, des duchesses anglaises, des châteaux féodaux, des canaux vénitiens et des natures mortes aux fruits et aux pots de cuivre; nulle part cependant une clôture qui serpente, un clocher québécois, un barrage de castors nordique, une touche d'automne canadien, ou une bouffée venue du Nord. Au Canada, la classe opulente achetait les tableaux comme elle achetait les actions, les tapis ou les antiquités.*[7]

À la fin des années trente, Graham McInnes écrivait que si le Club:

> *...avait exercé une influence négligeable sur le développement de notre art, son existence même avait soulevé la controverse et l'on pouvait tirer de son échec une morale pour l'avenir... Artistiquement, il avait engagé le mauvais pari en pensant qu'il suffisait de palliatifs pour corriger l'apathie et remédier aux ressentiments artistiques. Il illustrait de façon intéressante comment la force d'un mouvement rebelle peut se dissiper dans la méconnaissance des causes premières contre lesquelles il se bat.*[8]

Un peu plus tard, l'analyse de William Colgate s'avérait plus positive. Selon lui, le Club avait exercé une saine influence,

> *....également bénéfique à l'artiste et à l'amateur d'art durant son existence. Il avait inspiré à l'art canadien une certaine confiance en soi qui lui avait fait défaut jusque là. Sur le plan esthétique, le Canada commençait à voler de ses propres ailes.*[9]

Dans les années cinquante et soixante, le Club est pratiquement absent des livres traitant d'art canadien. Ni Donald Buchanan ni Robert Hubbard n'ont jugé bon de le mentionner et Russell Harper ne lui

romantic nationalism. In painting, this could be seen in the historical works of the Wanderers in Russia, the northern landscapes of the Scandinavians, the marine views of the British and the Rocky Mountain panoramas of the Americans. Canadian artistic nationalism focussed on the late romantic landscapes of artists like John Fraser and Lucius O'Brien, who had dominated the scene since Confederation. The style of these landscapes was international, based on ideas of "truth to nature."[12] Their subjects, it was felt, were what made them effectively Canadian. One writer, seeing O'Brien's western landscapes, declared:

> ...surely the pictures of all that glorious land, a veritable promised land, that is ours, must send the blood tingling through our veins with wild enthusiasm and wilder hopes.[13]

National feeling was also expressed in scenes of rural labour and heroic exploration by younger realist artists like Homer Watson and George Reid.

Most nations' art also showed tendencies toward internationalism and cosmopolitanism. This can be seen in such turn-of-the-century groups as the World of Art, gathered around Diaghilev in Russia, the New English Art Club in Britain and The Ten, a group of impressionist painters in the United States. Canadian internationalism had been on the rise since 1880s, with more artists studying abroad, staying abroad as expatriates and justifying their work by international standards. Homer Watson, for instance, aspired to the grandeur of the European landscape tradition, while James Wilson Morrice restlessly pursued transient sensuous pleasures in Paris.

The balance of focus between national and international tendencies varied from country to country but all made use of the conventions (realist, impressionist, symbolist, etc.) that were the common currency of the time. Although neat distinctions are difficult to make, it is probably safe to say that by 1900 realism of a sort, derived from ideas of the Barbizon and Hague schools, plein-air painting and outright impressionism, was more common in Canada than symbolism, at least of the exotic or decadent variety. A mild, proto-symbolist aestheticism coming from Whistler and emphasizing the artist's creative freedom from mundane reality was also common, and often mingled with various realist approaches. Realist subjects like landscape and rural life preoccupied more North American artists than European ones. Other realist subjects like industry and the urban scene were relatively rare.[14] If anything was common to Canadian art, it was probably an earnest and wholesome air. If anything divided it in a serious, public way, it was probably the questions of finish and truth to nature. In 1900, the romantic landscape generation still dominated art institutions. Younger artists would lead reactions against them, reforms from within, or secessions to promote new ideals. The secessionist idea was then internationally common. Secessions had taken place in Berlin, Munich, Vienna and New York and soon would come to Toronto. As in those other cities, however, they did not long disturb the working of art world institutions.

12
On this international phenomenon see Robert Roseblum and H. W. Janson, *19th Century Art.* New York: Harry N. Abrams Inc., 1984, pp.381-384. On its Canadian expression see Dennis Reid, *Our Own Country Canada.* Ottawa: The National Gallery of Canada, 1979.

13
"Montreal Letter." *The Week*, 8 March 1888, p.233.

14
A recent exhibition on the neglected area of industrial subjects is Rosemary Donegan, *Industrial Images.* Hamilton: Art Gallery of Hamilton, 1987.

10
Donald W. Buchanan, *The Growth of Canadian Painting*. Toronto: William Collins Sons and Co. Ltd., 1950; Robert H. Hubbard, *An Anthology of Canadian Art*. Toronto: Oxford University Press, 1960; J. Russell Harper, *Painting in Canada: A History*. Toronto: University of Toronto Press, 1966, p.215.

11
Dennis Reid, *A Concise History of Canadian Painting*. Toronto: Oxford University Press, 1973, chapitre 9.

12
Au sujet de ce phénomène international, voir Robert Roseblum et H. W. Janson, *19th Century Art*. New York: Harry N. Abrams Inc., 1984, pp. 381-384. Son expression canadienne est traitée dans Dennis Reid, *Our Own Country Canada*. Ottawa: The National Gallery of Canada, 1979.

13
"Montreal Letter." *The Week*, 8 March 1888, p.233.

consent qu'une brève référence.[10] Il faut attendre 1973 pour que Dennis Reid reconnaisse son importance dans son histoire de la peinture canadienne.[11] Contrairement à la plupart de ses prédécesseurs, Reid consacre un chapitre entier au Club et le place au centre des activités du tournant du siècle. Ce sont sur les bases établies par Reid que repose cette exposition.

Quelle était la situation de l'art au Canada au début de l'époque de Laurier? Avec quoi le Canadian Art Club devait-il composer? Durant les années 1890, l'art du Canada ne se distinguait pas radicalement de l'art des autres pays occidentaux, si ce n'est par le degré de son raffinement et l'étendue de sa pratique. La plupart des pays avait eu la piqûre du nationalisme romantique. En peinture, le phénomène se manifestait dans les oeuvres historiques—les voyageurs errants de la Russie, les paysages nordiques des Scandinaves, les marines des Britanniques et les panoramas des Montagnes Rocheuses des Américains. Le nationalisme artistique canadien se retrouvait surtout dans les paysages romantiques d'artistes tels que John Fraser et Lucius O'Brien, qui régnaient en maîtres depuis la Confédération. Fondé sur les idées d'imitation exacte de la nature,[12] le style de ces paysages était international; c'est au choix de leurs sujets que l'on attribuait un caractère proprement canadien. Après avoir vu les paysages de l'Ouest de O'Brien, un écrivain relevait:

> ...il est évident que les images de ce magnifique pays, de cette véritable terre promise qui est la nôtre, doivent faire courir le sang dans nos veines, nous emplir d'un enthousiasme délirant et d'espoirs plus fous encore.[13]

Le sentiment national s'exprimait aussi dans les scènes rurales et les hauts faits des explorateurs tels que les rendaient les jeunes artistes réalistes comme Homer Watson et George Reid.

Comme on peut le relever parmi les groupes du tournant du siècle dans la plupart des pays, l'art manifestait aussi certaines tendances cosmopolites — tel est le cas pour le World of Art qui gravitait autour de Diaghilev en Russie, le New English Art Club en Angleterre et The Ten, un groupe de peintres impressionnistes des États-Unis. Au Canada, ce mouvement grandissait depuis les années 1880. Un nombre croissant d'artistes partaient étudier à l'étranger, s'expatriaient et soumettaient leurs oeuvres à des critères internationaux. Homer Watson, par exemple, aspirait à la grandeur des paysages de tradition européenne tandis que James Wilson Morrice se perdait dans la quête plus éphémère des plaisirs de la vie parisienne.

Ce rapport de forces entre tendances nationales et internationales variait d'un pays à l'autre mais tous les artistes faisaient usage des conventions qui étaient alors monnaie courante (réalisme, impressionnisme, symbolisme, etc.). Bien qu'il soit difficile d'établir des distinctions claires et nettes, on peut probablement affirmer qu'à partir de 1900, une sorte de réalisme issu des écoles de Barbizon et de La Haye, de la peinture en plein air et de l'impressionnisme pur, était plus courant au Canada que le symbolisme (de style exotique ou décadent tout du moins). Un certain esthétisme proto-symboliste et modéré, inspiré de Whistler et célébrant

The institutional structure of the Canadian art world was similar to, but smaller than, that in other nations. Patronage was rather more private than public but still came from the prosperous middle and upper classes. The creation and distribution of art were organized into a complex system of schools, professional societies, exhibitions, museums, critics and collectors. Most professional art activities were based in Quebec and Ontario. The west was still too close to a frontier state to cultivate the arts on anything more than an amateur basis. The Manitoba Society of Artists was not formed until 1903 and, in British Columbia, the B.C. Society of Artists until 1909. The first western art school and museum, in Winnipeg, were not founded until 1912-1913.[15] The Maritimes had a stagnating economy and a population base that was too small and scattered to support more than two small art schools, in Halifax and in Sackville.

Even in central Canada, the scale of art activity was extremely small. Fewer than 80 real professionals were at work and most of those depended on teaching or some other job for their support.[16] Montreal was the largest, richest and most sophisticated art centre, but Toronto, two-thirds its size and growing quickly, was narrowing the gap. Although Montreal had several small art schools and Toronto the Central Ontario School of Art and Design, money was in short supply, facilities were limited, and only the most basic professional instruction could be provided.

Most professional activity and exhibiting were initiated under the auspices of three societies, the Royal Canadian Academy of Arts (R.C.A.) the Ontario Society of Artists (O.S.A.) and the Art Association of Montreal (A.A.M.), all formed between 1860 and 1880.[17] Each held an annual exhibition of 150 to 200 works, providing most of the members' public sales. Commercial dealers were few and one-person shows on dealers' premises were uncommon. By 1900, most of the original founders of these three societies were dead or retired. Their successors continued in the direction they had set, but it was not until the next decade that new inspiration and initiatives would follow.

As for art museums, there had been one in Montreal, run by the A.A.M., since 1879 and expanded in 1893.[18] In Ottawa, the National Gallery had no home of its own but came to occupy rooms in the Fisheries Building.[19] Its collection consisted mainly of R.C.A. diploma pieces. Its budget was minimal and its activities few. In Toronto, the only public collection of any sort was that of the Educational Museum, formed by Egerton Ryerson and consisting mainly of old master copies and plaster busts of famous Canadians.[20] In 1900, a committee was struck to plan for a serious art museum. It would not see real results for nearly a decade.

Criticism was probably the least developed of all the areas of art-related activity. Art history, even internationally, was barely established as a field of study and full-time professional writers about art simply didn't exist as they do today. Artists, as always, talked and wrote about what

15
On this subject see Marilyn Baker, *The Winnipeg School of Art: The Early Years.* Winnipeg: University of Manitoba Press, 1984.

16
In 1900 the Royal Canadian Academy had about 60 members and the Ontario Society of Artists about 40 members.

17
George Reid and the Guild of Civic Art had been trying to develop support in public bodies for heroic Canadian mural painting. They had not been very successful and thus, as a group, had a very low public profile.

18
On the Montreal situation see Rosalind M. Pepall, *Building a Beaux-Arts Museum: Montreal 1912.* Montreal: The Montreal Museum of Fine Arts, 1986.

19
For a history of the Gallery see Jean Sutherland Boggs, *The National Gallery of Canada.* London: Thames and Hudson, 1971.

20
Fern Bayer, *The Ontario Collection.* Toronto: Fitzhenry and Whiteside, 1984.

14
Une exposition récente consacrée à ce sujet négligé a été présentée par Rosemary Donegan, *Industrial Images*. Hamilton: Art Gallery of Hamilton, 1987.

15
À ce sujet, voir Marilyn Baker, *The Winnipeg School of Art: The Early Years*. Winnipeg: University of Manitoba Press, 1984.

16
En 1900, la Royal Canadian Academy comptait environ 60 membres et l'Ontario Society of Artists à peu près 40.

17.
George Reid et la Guild of Civic Art avaient tenté de gagner le soutien des organismes publics pour la peinture murale héroïque. Ils avaient eu peu de succès et la popularité du groupe était très faible.

la liberté créatrice de l'artiste envers les réalités prosaïques existait aussi, quoique mêlé à diverses approches réalistes. Les sujets réalistes tels les paysages et les scènes tirées de la vie rurale intéressaient plus les artistes nord-américains que les Européens. (Les sujets inspirés du monde industriel et urbain étaient relativement rares.)[14] S'il existait un élément commun à l'art canadien, c'était sans doute une certaine atmosphère honnête et saine. S'il y avait par ailleurs un élément qui le divisait publiquement et sérieusement, c'était probablement la question du fini et l'imitation de la nature. En 1900, la génération des paysagistes romantiques dominait encore les institutions. De jeunes artistes se liguèrent alors contre elles, exigèrent des réformes de l'intérieur ou firent sécession afin de promouvoir de nouveaux idéaux. Ce mouvement sécessionniste était alors chose commune sur la scène internationale — il avait gagné Berlin, Munich, Vienne et New York et allait bientôt atteindre Toronto. Mais ici comme ailleurs, il n'allait pas perturber très longtemps la vie des institutions artistiques.

Au Canada, la structure de ces institutions ressemblait à celle des autres nations, bien qu'à plus petite échelle. Le mécénat était plus privé que public mais il remontait encore à la haute société et aux classes moyennes prospères. Les créations artistiques et leur distribution étaient organisées en un système complexe d'écoles, de sociétés professionnelles, d'expositions, de musées, de critiques et de collectionneurs. La plupart des activités professionnelles avaient pour base le Québec et l'Ontario. L'Ouest relevait encore trop d'un état-frontière pour cultiver les arts autrement qu'en amateur. Les sociétés d'artistes ne devaient pas voir le jour avant 1903 au Manitoba, et 1909 en Colombie-Britannique. Dans l'Ouest, la première école des beaux-arts et le premier musée ne furent fondés qu'en 1912-13, à Winnipeg. L'économie des Maritimes était trop stagnante et sa population trop maigre et dispersée pour soutenir plus de deux petites écoles de peinture (l'une à Halifax, l'autre à Sackville).[15]

Même au Canada central, l'art se pratiquait à très petite échelle. Moins de 80 artistes de métier travaillaient dans le domaine et la plupart d'entre eux dépendaient de l'enseignement et autre profession pour leur subsistance. Montréal représentait le centre artistique le plus grand, le plus riche et le plus avancé, mais Toronto qui était plus petite d'un tiers la talonnait de près. Bien que Montréal s'enorgueillît de plusieurs petites écoles des beaux-arts, et Toronto de la Central Ontario School of Art and Design, l'argent se faisait rare, les conditions étaient difficiles et seule l'instruction la plus rudimentaire pouvait être dispensée.[16]

La plupart des activités professionnelles et des expositions se faisaient sous l'égide de trois sociétés: la Royal Canadian Academy of Arts (R.C.A.), l'Ontario Society of Artists (O.S.A.) et l'Art Association of Montréal (A.A.M.), toutes trois formées entre 1860 et 1880.[17] Chacune réalisait une exposition annuelle de 150 à 200 oeuvres et organisait des ventes publiques pour la plupart des membres. Les commerçants de métier étaient rares, et les expositions monographiques tenues chez le marchand même étaient peu communes. En 1900, la plupart des membres fondateurs de ces trois sociétés étaient soit décédés soit inactifs. Ils

they saw but aside from this, criticism was the realm of the amateur: the journalist, collector and moonlighting academic — and didn't exist on any but a mundane intellectual level. Specialized Canadian art magazines did not evolve till the 1940s. Criticism, such as it was, was found in unsigned newspaper reviews of exhibitions and the occasional article in journals such as *Saturday Night* or *The Canadian Magazine*. To posterity, it merely reveals public taste and documents exhibited works. Only during the Laurier period would individual writers of any distinction emerge. Newton MacTavish, Hector Charlesworth, James Mavor and E.F.B. Johnston were some of the best-informed critics. All would write about the Canadian Art Club and some would become closely involved in its activities.[21]

Collectors were more common than critics, but there were few of any great seriousness, ambition or international stature. Most big-time collectors in Canada were based in Montreal, and a few lived in Toronto.[22] None were rich enough to offer serious competition to the great American collectors of the day. Sir William Van Horne of the C.P.R., the most sophisticated of them, bought works by Rembrandt and Rubens, El Greco, Velasquez, Goya and Turner, yet still was dismissed by that formidable connoisseur, Bernard Berenson, as owning too many "indifferent pictures." "Provincial America," Berenson wrote, "is one and the the same whether millionaire or modest. They have no taste."[23] Only a few besides Van Horne could afford to buy old masters. In Toronto, Sir Edmund Walker formed a fine collection of old master prints,[24] but most collections were made of less expensive European masters from the latter half of the nineteenth century, especially from the Hague and Barbizon schools with their debts to the Dutch and Spanish old masters.[25] Some also bought works from living Canadians, though this formed a small part of what they spent on art in general and brought them no particular prestige. None were very adventurous or pioneering especially in the realm of modern art and, though Van Horne bought works by Renoir, Toulouse-Lautrec and Cézanne, he was not as single-mindedly modern as such American contemporaries as the Havemeyers.[26]

The Canadian art world, overall, had developed tremendously since Confederation. Its artistic and intellectual standards were still not terribly high but a start had been made. Artists were becoming established as solid professionals and institutions to support them were founded. The old puritan attitudes towards art, lamented by Samuel Butler in 1875,[27] were still strong, especially in the west, but were gradually losing their intensity. Toronto might have been "the most Philistine city in the Dominion," but it was developing tremendous wealth, civic pride and ambition and, with them, the desire to buy "culture."[28] James Mavor, one of the city's more thoughtful art writers, commented that:

> *Culture seems a kind of craze in Canada. What they mean by it is perhaps hazy even to themselves, but they undoubtedly have a yearning for something which is not specie.*[29]

21
Typical of the innocence of Canadian critics of the time is Newton MacTavish, who noted in his diary "I intend to write Williamson up in the magazine if he will give me a picture for my trouble." Diary entry for 4 February 1908, PAC NMP, MG30 D278, vol.1.

22
Some of the most prominent Montreal collectors were Sir William Van Horne, Lord Mount Stephen, Lord Strathcona, James Ross, R.B. Angus, E.B. Hosmer, Sir George Drummond, Joseph Learmont and E.B. Greenshields. Some of their Toronto counterparts were Sir Edmund Walker, Sir E.B. Osler and Chester Massey.

23
Ernest Samuels, *Bernard Berenson: The Making of a Legend*. Cambridge: The Belknap Press of Harvard University Press, 1987, p.170.

24
Katharine A. Jordan, *Sir Edmund Walker: Print Collector*. Toronto: Art Gallery of Ontario, 1974.

25
On this collecting phenomenon see Peter Bermingham, *American Art in the Barbizon Mood*. Washington, D.C.: National Collection of Fine Arts, 1975; Marta H. Hurdalek, *The Hague School: Collecting in Canada at the Turn of the Century*. Toronto: Art Gallery of Ontario, 1983.

26
On the Havemeyers see Frances Weitzenhoffer, *The Havemeyers: Impressionism Comes to America*. New York: Harry N. Abrams, Inc., 1986.

27
Samuel Butler's "A Psalm of Montreal," with its famous refrain, "O God! O Montreal!" was written in 1875 and first appeared in *The Spectator* (London), 18 May 1878.

28
Remarks made by Prof. Coleman at the founding meeting of the Art Museum of Toronto. Cited by Jordan, *Sir Edmund Walker*, p.21.

29
James Mavor, Diary entry, 1 September 1892. Cited by Rachel Grover, *James Mavor and His World*. Toronto: Thomas Fisher Rare Book Library, University of Toronto, 1975, p.4.

eurent des successeurs mais il fallut attendre la décennie suivante pour trouver une inspiration nouvelle et des initiatives originales.

Il y avait un musée à Montréal, géré par l'A.A.M. depuis 1879 et agrandit en 1913. À Ottawa, la Galerie nationale—qui n'avait pas même ses propres locaux—s'installa dans quelques salles du bâtiment des Pêches.[19] Sa collection rassemblait principalement les tableaux d'admission des académiciens de la R.C.A., son budget était minime et ses activités limitées. L'unique collection publique de Toronto appartenait à l'Educational Museum fondé par Egerton Ryerson. Elle comprenait en majeure partie des copies de maîtres anciens et les bustes en plâtre de Canadiens célèbres.[20] En 1900, un comité fut créé en vue d'établir un musée sérieux. Il faudra attendre presque toute une décennie avant qu'il n'aboutisse.

La critique était probablement le domaine le moins développé de toutes les activités concernant l'art. Dans le monde, l'histoire de l'art était une discipline à peine établie et les critiques de profession n'existaient simplement pas. Comme depuis toujours, les artistes discutaient et faisaient état de leurs expériences, mais ceci mis à part, la critique appartenait aux amateurs: journalistes, collectionneurs, universitaires d'esprit aventureux — et elle n'existait qu'à un niveau intellectuel assez superficiel. Les périodiques canadiens spécialisés ne se développèrent pas avant les années quarante. La critique se limitait donc aux revues non signées consacrées aux expositions, et aux articles occasionnels parus dans le *Saturday Night* ou *The Canadian Magazine*. Ils ne laissent à la postérité qu'un aperçu du goût d'alors et quelques renseignements sur les oeuvres exposées. Ce n'est qu'à l'époque de Laurier que devaient émerger les critiques éminents. Newton MacTavish, Hector Charlesworth, James Mavor et E.F.B Johnston comptaient parmi les mieux informés. Tous parleraient du Canadian Art Club et certains allaient s'engager personnellement dans ses activités.[21]

Les collectionneurs étaient plus nombreux que les critiques, mais peu parmi eux étaient ambitieux, sérieusement engagés ou de stature internationale. La plupart des acheteurs importants résidaient à Montréal, quelqu'uns à Toronto.[22] Aucun d'eux n'était suffisamment riche pour rivaliser avec les grands collectionneurs américains du jour. Sir William Van Horne du C.P.R., le plus raffiné de tous, avait acheté des Rembrandt et des Rubens, El Greco, Velasquez, Goya et Turner. Mais l'impitoyable connaisseur Bernard Berenson lui reprochait encore de posséder trop de tableaux insignifiants. Selon lui, "l'Américain provincial restera toujours provincial—millionnaire ou modeste. Il n'a aucun goût."[23] À part Van Horne peu de gens pouvaient se permettre d'acheter les oeuvres des grands maîtres. À Toronto, Sir Edmund Walker se constituait une belle collection de gravures anciennes,[24] mais pour la plupart, les collections comprenaient les maîtres européens plus abordables de la fin du dix-neuvième siècle — ceux de l'école de la Haye et de Barbizon surtout, inspirés des maîtres hollandais et espagnols.[25] Certains achetèrent aussi des oeuvres d'artistes canadiens contemporains, mais ces tableaux ne représentaient qu'une petite partie de leur investissement

18
Pour un aperçu de la situation à Montréal, voir Rosalind M. Pepall, *Building a Beaux-Arts Museum: Montreal 1912*. Montreal: The Montreal Museum of Fine Arts, 1986.

19
Pour retracer l'histoire du musée, voir Jean Sutherland Boggs, *The National Gallery of Canada*. London: Thames and Hudson, 1971.

20
Fern Bayer, *The Ontario Collection*. Toronto: Fitzhenry and Whiteside, 1984.

21
La simplicité des critiques canadiens de l'époque est illustrée par cette remarque de Newton MacTavish, consignée dans son journal: "J'ai l'intention de parler de Williamson dans la revue, s'il accepte de me donner un tableau pour ma peine." Entrée du 4 février 1908, PAC NMP, MG30 D278, vol. 1.

22
Parmi les collectionneurs montréalais les plus importants, on remarque Sir William Van Horne, Lord Mount Stephen, Lord Strathcona, James Ross, R.B. Angus, E.B. Hosmer, Sir George Drummond, Joseph Learmont et E.B. Greenshields. Et à Toronto: Sir Edmund Walker, Sir E.B. Osler et Chester Massey.

23
Ernest Samuels, *Bernard Berenson: The Making of a Legend*. Cambridge: The Belknap Press of Harvard University Press, 1987, p.170.

24
Katharine A. Jordan, *Sir Edmund Walker: Print Collector*. Toronto: Art Gallery of Ontario, 1974.

25
Sur la question, consulter Peter Bermingham, *American Art in the Barbizon Mood*. Washington, D.C.: National Collection of Fine Arts, 1975; Marta H. Hurdalek, *The Hague School: Collecting in Canada at the Turn of the Century*. Toronto: Art Gallery of Ontario, 1983.

This yearning would lie behind much of the art activity of the Laurier period. This yearning also explains much of the popular success of the Canadian Art Club.

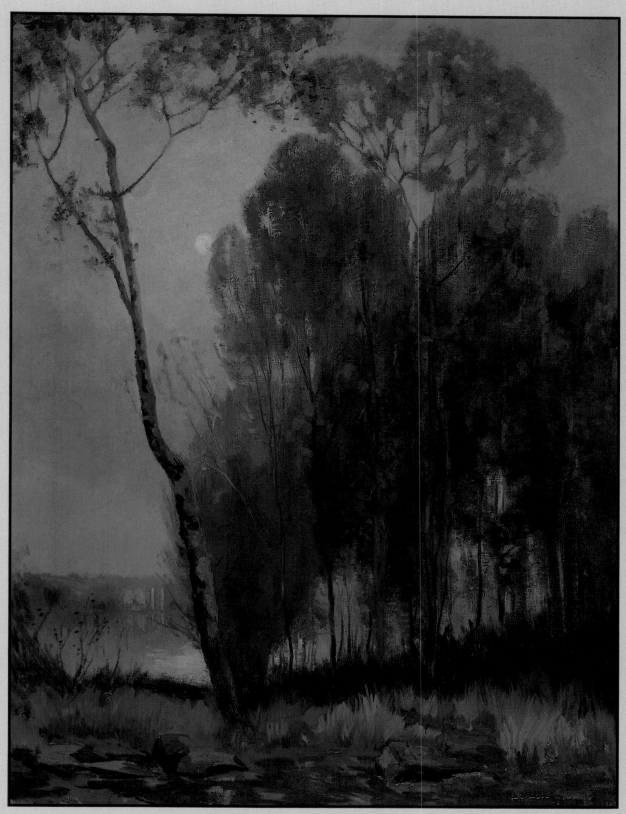

Archibald Browne. *Bewitchment*. c. 1910. Oil on canvas/Huile sur toile, 91 x 63 cm. Collection of D.R. Wilkie. Photo: Harry Korol

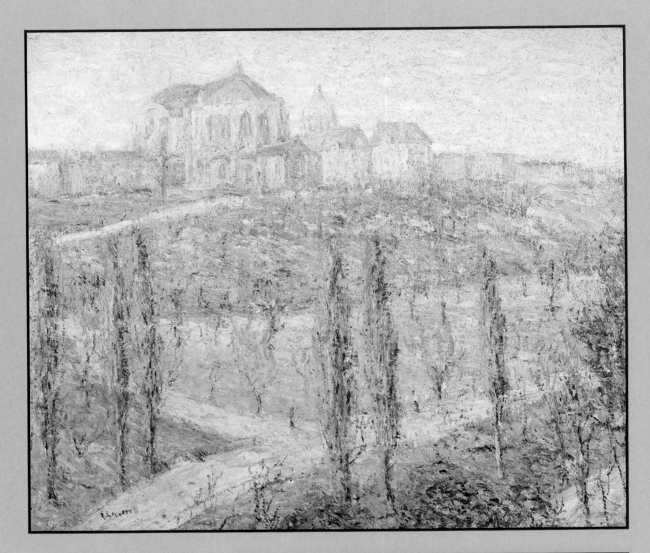

Ernest Lawson. *Cathedral Heights.* c. 1912.
Oil on canvas / Huile sur toile, 63.8 x 76.5 cm.
Columbus Museum of Art

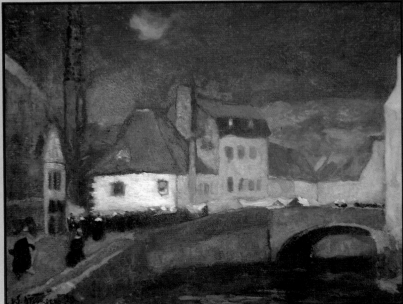

William E. Atkinson. *The Old Town, Brittany,
Night Effect.* 1913. Oil on canvas / Huile sur
toile, 46 x 58 cm. The Government of Ontario
Art Collection

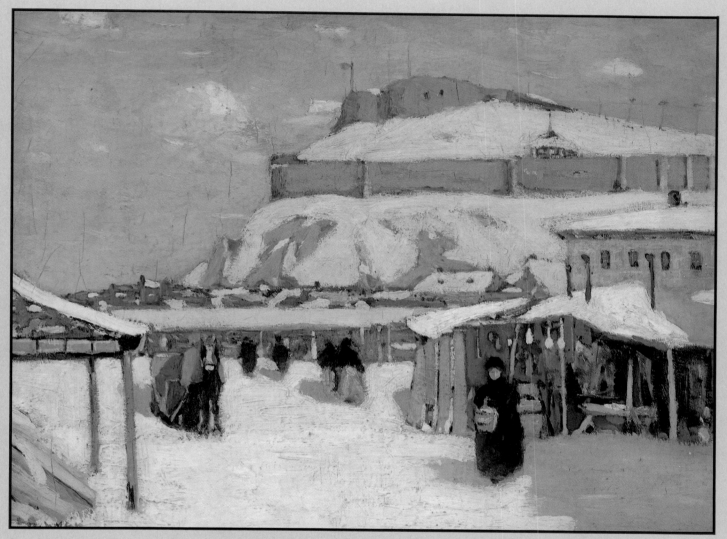

James Wilson Morrice. *The Citadel, Quebec.* c. 1900. Oil on canvas/Huile sur toile, 49 x 65.3 cm. Musée du Québec. Photo: Harry Korol

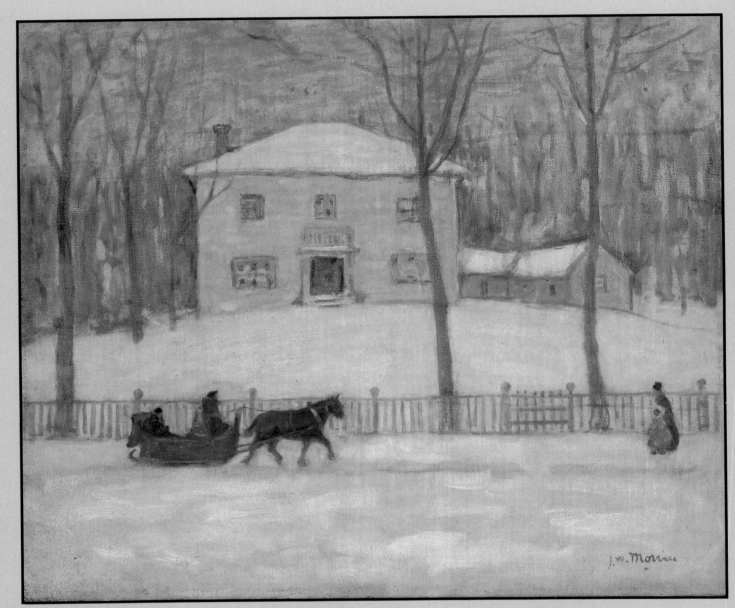

James Wilson Morrice. *The Old Holton House, Montreal.* c. 1908-10. Oil on canvas / Huile sur toile, 61 x 73.6 cm. The Montreal Museum of Fine Arts

26
Au sujet des Havemeyers, voir Frances Weitzenhoffer, *The Havemeyers: Impressionism Comes to America*. New York: Harry N. Abrams, Inc., 1986.

27
"A Psalm of Montreal," et son famous refrain, "O God! O Montreal!" fut écrit par Samuel Butler en 1875 et parut tout d'abord dans *The Spectator* (Londres), 18 May 1878.

28
Remarques exprimées par le Professeur Coleman au cours de l'assemblée qui vit la fondation de l'Art Museum of Toronto. Citation de Jordan, *Sir Edmund Walker*, p.21.

29
James Mavor, entrée de journal, 1 September 1892. Citée par Rachel Grover, *James Mavor and His World*. Toronto: Thomas Fisher Rare Book Library, University of Toronto, 1975, p.4.

global et ne leur apportaient aucun prestige particulier. Bien que Van Horne ait acquis des tableaux de Renoir, de Toulouse-Lautrec et de Cézanne, il n'était pas résolument moderne ainsi que l'étaient certains Américains de la trempe des Havemeyers.[26] En résumé, aucun collectionneur n'était particulièrement audacieux, dans le domaine de l'art moderne surtout.

Dans son ensemble, l'art canadien s'était considérablement développé depuis la Confédération. Ses normes intellectuelles et artistiques n'étaient pas encore très élevées, mais il y avait eu un essor certain. Les artistes commençaient à s'établir solidement dans la profession et les institutions destinées à les soutenir furent fondées. Les vieilles attitudes puritaines que Samuel Butler avaient exprimées en 1875[27] prévalaient encore dans l'Ouest, mais elles étaient toutefois en perte de vitesse. Toronto pouvait bien être la plus philistine des villes au sein du Dominion, sa prospérité grossissait à vue d'oeil et avec elle sa fierté civique, son ambition, son désir d'acheter "de la culture".[28] James Mavor, l'un des critiques d'art les plus fins de l'endroit, relevait que:

La culture semble en vogue au Canada. Ce qu'ils entendent par là est peut-être assez flou à ceux-là mêmes qui utilisent le terme, mais il est indiscutable qu'ils ont soif de quelque chose qui ne soit pas monnayable.[29]

Ce besoin, qui allait animer bon nombre d'activités de la période de Laurier, explique aussi en grande partie le succès populaire du Canadian Art Club.

PART I

The Canadian Art Club was formed in 1907 by seceding members of the Ontario Society of Artists. For several years, its younger members had been unhappy with what they saw as its parochial point of view, the low standards of its exhibitions, the ineptness of its administration and much of its petty politics. Their anger focussed on the aging president of the Society, Frederic Marlett Bell-Smith, the secretary, Robert F. Gagen, as well as such prominent older members as Thomas Mower Martin and Marmaduke Matthews. Insults and complaints had flown back and forth.[30] The incident that sparked the secession was the purchase by the Ontario government, as part of its annual O.S.A. grant, of works by Archibald Browne and Franklin Brownell. Bell-Smith protested these purchases in a letter of March 21 to the Minister of Education, on the technical grounds that Browne and Brownell, recently elected members of the Society, did not have works in its current exhibition.[31] Only such works were eligible for purchase. For Browne and Brownell this must have seemed the worst sort of petty politics, a taking of bread from their mouths. Within days, they and friends such as W. E. Atkinson, Edmund Morris, Curtis Williamson and Homer Watson (who would become the first president) agreed to secede from the O.S.A and were discussing the creation of a new society. By May and June, they had submitted their formal letters of resignation.[32]

Reaction to their secession was slow. Attempts to keep them within the fold came only in July at the hand of George Reid, president of the R.C.A, former president of the O.S.A. and current O.S.A. executive member. Reid reproved Bell-Smith for letting the situation get out of hand and asked Curtis Williamson if the group would reconsider its actions.[33] Williamson aired their grievances and, over the course of

30
Letter, George Reid to Frederic Bell-Smith, 6 July 1907, OA OSA, Series 1, Box 1, MU2250.

31
Letter, Frederic Bell-Smith to Hon. Dr. Pyne, 21 March 1907, OA OSA, Series 1, Box 1, MU2250.

32
Morris resigned on 22 May, Williamson on 23 May, Brownell on 5 June, Watson on 10 June and Browne on 14 June. Atkinson did not resign until 31 April 1909. These letters are all OA OSA.

33
Letter, George Reid to Frederic Bell-Smith, 7 July 1907. OA OSA.

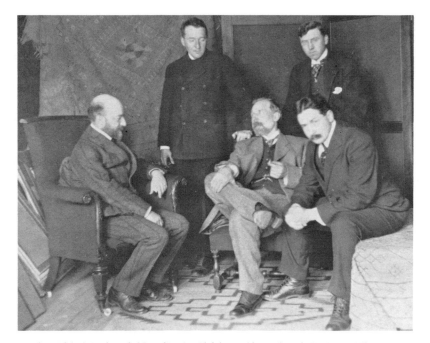

Members of the/Membres du/Canadian Art Club l. to r./de gauche à droite: James Wilson Morrice, Edmund Morris, Homer Watson, Newton MacTavish, Curtis Williamson. Photo: E.P. Taylor Reference Library, Art Gallery of Ontario

PREMIÈRE PARTIE

30
Lettre de George Reid à Frederic Bell-Smith, 6 July 1907, OA OSA, Series 1, Box 1, MU2250.

31
Lettre de Frederic Bell-Smith à l'Hon. Dr Pyne, 21 March 1907, OA OSA, Series 1, Box 1, MU2250.

32
Morris démissionna le 22 mai, Williamson le 23 mai, Brownell le 5 juin, Watson le 10 juin et Browne le 14 juin. Atkinson attendit jusqu'au 31 avril 1909. Ces lettres sont toutes déposées aux OA OSA.

En 1907, le Canadian Art Club fut fondé par certains sécessionnistes de l'Ontario Society of Artists. Depuis de nombreuses années, les plus jeunes des membres avaient été déçus par ce qu'ils considéraient comme l'esprit de clocher de la société, la piètre qualité de ses expositions, l'ineptie de ses dirigeants et ses manigances politiques. Ils concentrèrent leur ressentiment contre son président vieillissant, Frederic Marlett Bell-Smith, le secrétaire, Robert F. Gagen, et contre certains membres âgés importants tels Thomas Mower Martin et Marmaduke Matthews. Ils avaient échangé insultes et récriminations auparavant,[30] mais l'incident qui mit le feu aux poudres, ce fut l'acquisition que fit le gouvernement ontarien—comme partie de sa subvention annuelle à l'O.S.A. — d'oeuvres d'Archibald Browne et de Franklin Brownell. Bell-Smith s'éleva contre cette décision pour vice de procédure, dans une lettre datée du 21 mars et adressée au Ministre de l'éducation; il alléguait que Browne et Brownell, récemment élus membres, n'avaient pas encore de pièces dans la collection de la société.[31] Cette manoeuvre dut sembler du plus bas étage à Browne et à Brownell, à qui elle enlevait le pain de la bouche. En quelques jours, appuyés d'amis tels W. E. Atkinson, Edmund Morris, Curtis Williamson et Homer Watson (qui allait devenir le premier président), ils décidèrent de faire sécession et d'envisager la création d'une nouvelle société. En mai et en juin, ils avaient remis leur démission officielle.[32]

La réaction se fit d'abord attendre. C'est en juillet seulement que George Reid, Président de la R.C.A., ancien Président de l'O.S.A. et membre

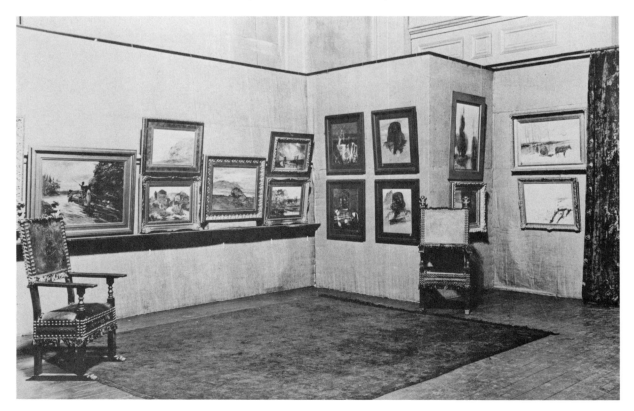

Installation, Canadian Art Club, 1st Annual Exhibition/1e exposition annuelle, 1908, 57 Adelaide St. East. Photo: Edmund Morris Papers, Manitoba Archives

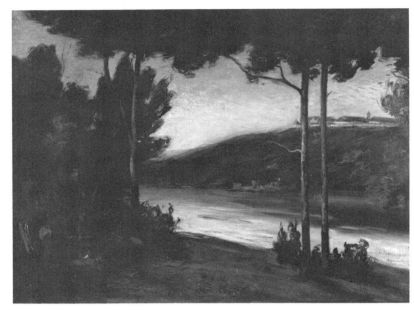

Edmund Morris. *Landscape, Old Fort Edmonton.* c. 1910. Oil on canvas/Huile sur toile, 85.1 x 112.3 cm. The Glenbow Museum

several letters, Reid admitted the truth of much they said. He appealed to them not to "divide Canadian artists against themselves" and thus diminish what little official support they received.[34] He urged them to stay with the O.S.A. and help reform it from within. He also enclosed copies of two motions of reconciliation he would introduce at an upcoming O.S.A. meeting. Reid's appeals fell on deaf ears. Williamson icily replied that the group:

> *...had carefully considered the matter [of their resignations] in all its bearings and have no intention of altering that decision.*[35]

After this, nothing could be done. Tensions with the group gradually eased and, within a few months, O.S.A. members could admit to Newton MacTavish that they were very hopeful for its success but, of course, they were not in sympathy with it.[36]

In the meantime, there was much work to be done, most of it by Morris and Watson. New members had to be recruited, organizational principles had to be defined, and a location for the first exhibition had to be found. A name for the group was not obvious. "The Canadian Art Club" was only arrived at after much discussion. "The New Art Club" seems to have been the next most popular name and "The Society of Canadian Artists" was also suggested.[37] The Club was to be a private exhibiting society, without formal government support. Membership was to be by election and be limited to established professional artists. Franklin Brownell advised that members should be "...such men as show stimulus to be honest in their work and towards the work of others."[38]

James Wilson Morrice warned, "Keep the number of members limited and no amateur work."[39] Horatio Walker took it for granted "that no pot

34
Letter, George Reid to Curtis Williamson, 7 July 1907, OA 0SA.

35
Letter, Curtis Williamson to George Reid, 3 December 1907, OA OSA, Series 3, Box 7, MU2254.

36
Diary entry, Newton MacTavish on conversation with R.F. Gagen and C.M. Manly, 4 February 1908, PAC, NMP, MG30 D278, vol.1.

37
Letter, Franklin Brownell to Edmund Morris, 5 June 1907, AGO EMLB.

38
Letter, Franklin Brownell to Edmund Morris, undated (c. March 1907), AGO EMLB.

39
Letter, James Wilson Morrice to Edmund Morris, 1 July 1907, AGO EMLB.

33
Lettre de George Reid à Frederic Bell-Smith, 7 July 1907. OA OSA.

34
Lettre de George Reid à Curtis Williamson, 7 July 1907, OA 0SA.

35
Lettre de Curtis Williamson à George Reid, 3 December 1907, OA OSA, Series 3, Box 7, MU2254.

36
Entrée de journal, Newton MacTavish au sujet de sa conversation avec R.F. Gagen et C.M. Manly, 4 February 1908, PAC, NMP, MG30 D278, vol.1.

37
Lettre de Franklin Brownell à Edmund Morris, 5 June 1907, AGO EMLB.

38
Lettre de Franklin Brownell à Edmund Morris, s. d. (mars 1907, environ), AGO EMLB.

39
Lettre de James Wilson Morrice à Edmund Morris, 1 July 1907, AGO EMLB.

40
Lettre de Horatio Walker à Edmund Morris, 4 July 1907, AGO EMLB.

41
Exposé dactylographié des principes du Club, s. d. (1908, env.) AGO CACS.

42
Lettre de Franklin Brownell à Edmund Morris, 30 April 1907, AGO EMLB.

43
Lettre de Horatio Walker à Edmund Morris, 20 December 1909, AGO EMLB. À l'exposition de 1909, Muntz montrait deux aquarelles, *Portrait of a Young Girl* (29) et *Portrait of a Child* (30).

de l'exécutif de l'O.S.A. tenta de leur faire réintégrer les rangs. Reid reprocha à Bell-Smith de ne pas avoir su maîtriser la situation et pria Curtis Williamson et le groupe de bien vouloir revenir sur leur décision.[33] Williamson exposa ses griefs et Reid finit par admettre leur bien-fondé au cours d'échanges de lettres. Il les exhorta à ne pas créer, parmi les artistes canadiens, une division qui diminuerait le peu de soutien officiel qu'ils recevaient.[34] Il les supplia enfin de rester dans l'O.S.A. et d'aider à apporter des réformes de l'intérieur. Il joignit également la copie de deux propositions de réconciliation qu'il proposait de soumettre à l'assemblée suivante de l'O.S.A. Mais en vain. Williamson répondit froidement que le groupe

> *...avait soigneusement pesé la question [de leurs démissions] dans toutes ses conséquences et qu'ils n'avaient aucunement l'intention de revenir sur leur décision.*[35]

Il ne restait plus rien à faire. Les tensions se relâchèrent graduellement avec le groupe et en quelques mois, les membres de l'O.S.A. pouvaient confier à Newton MacTavish qu'ils avaient confiance en son succès, même si bien sûr, ils n'étaient pas de son côté.[36]

En attendant, il restait beaucoup de travail à abattre, et Morris et Watson surtout allaient s'en charger. Il fallait recruter de nouveaux membres, définir les principes d'organisation et dénicher un local pour la première exposition. Il fallait aussi se trouver un nom. Après avoir balancé entre "The New Art Club" et "The Society of Canadian Artists" et au terme de longues discussions, on opta pour "The Canadian Art Club."[37] Il fut décidé que le Club serait une société privée, qui se passerait de soutien gouvernemental formel. Les membres seraient élus et leur nombre se limiterait aux artistes professionnels établis. Franklin Brownell souhaitait que ce soient " des hommes déterminés à être honnêtes dans leur travail et envers le travail des autres."[38]

James Wilson Morrice donna son avis: "Limitez le nombre des membres et refusez le travail d'amateur,"[39] et pour Horatio Walker, il était entendu "que les opportunistes seraient exclus."[40] Un peu plus tard, une déclaration officielle réclamait que tous soient des artistes canadiens:

> *...dont l'oeuvre soit reconnue ici et ailleurs comme possédant un trait de qualité tel qu'il devient nécessaire de lui accorder une attention toute spéciale.*[41]

Brownell souleva la question de l'admission éventuelle des femmes mais le résultat du vote n'est pas connu.[42] Walker, entre autres, recommanda à Morris d' "éviter la compagnie des...femmes artistes comme celle du diable lui-même." Finalement, Laura Muntz fut la seule invitée dont le Club exposa les oeuvres et on ne lui proposa jamais de devenir membre titulaire.[43]

Le Club voulait également attirer les artistes canadiens qui s'étaient expatriés en Europe et aux États-Unis:

> *...qui n'avaient jamais été enclins à séjourner dans les conditions ingrates*

boilerists need apply."[40] A little later, a formal policy statement declared that members were to be Canadian artists:

...whose work is recognized at home and abroad as possessing a distinction which makes it necessary to pay it special attention.[41]

Brownell raised the question of whether women should be members but what the Club consensus was is not known.[42] Horatio Walker, for one, warned Morris to "keep clear of...women artists, as of the devil." The end result was that only one woman, Laura Muntz, would ever exhibit with the Club, as a guest who was never invited to full membership.[43]

Other artists to whom the Club wanted to appeal were the Canadian expatriates in Europe and the United States,

...who have had no desire to sojourn amid the somewhat harsh and indifferent conditions hitherto imposed on them here, and who consequently...have received renown in other climes.[44]

It also created a program of lay memberships appealing to a broader public. This idea was probably suggested by Watson and taken from the International Society of Sculptors, Painters and Gravers, a progressive British exhibiting society with which he was acquainted. Lay memberships would provide another source of revenue to help defray the cost of exhibitions. They were especially meant to appeal to journalists, who could give the Club free publicity, and rich collectors, who could afford to buy its members' works. Within the first year, over 25 lay members joined. They were headed by an Honorary President and Treasurer, men with excellent business skills and broad community contacts. The first Hon. President was D.R. Wilkie, head of the Imperial Bank of Canada. Artists filled the other executive positions.

It was quickly decided that Club exhibitions would be held once a year. The Club, however, had national ambitions and hoped, at first, to rotate their shows among the major cities of the Dominion. This hope was slowly abandoned because costs were too high and few suitable facilities existed outside of Toronto and Montreal. A special Club exhibition would be held at the Art Association of Montreal in February 1910, but that was the extent of the Club's exposure outside of Toronto.

As for a place to exhibit, inquiries were made in a number of quarters. The Club discussed renting a room in the new King Edward Hotel[45] but, by the end of 1907, decided to rent several rooms on an upper floor of the former York County Court House at 57 Adelaide St. East, in the heart of Toronto's artistic bohemia.[46] These rooms had recently served as the studio of the muralist Frederick Challener. When the Club vacated them, several years later, they were taken over by the Arts and Letters Club.[47]

The first Canadian Art Club exhibition opened on February 4, 1908. Over two hundred guests attended the reception. Judging from the

40
Letter, Horatio Walker to Edmund Morris, 4 July 1907, AGO EMLB.

41
Typed statement of Club Policy, undated (c.1908), AGO CACS.

42
Letter, Franklin Brownell to Edmund Morris, 30 April 1907, AGO EMLB.

43
Letter, Horatio Walker to Edmund Morris, 20 December 1909, AGO EMLB. In the 1909 exhibition, Muntz exhibited two watercolours, *Portrait of a Young Girl* (29) and *Portrait of a Child* (30).

44
Typed statement of Club Policy, undated (c. 1908).

45
Letter, James Wilson Morrice to Edmund Morris, 15 December 1907, AGO EMP.

46
This Greek Revival/Georgian building, by the architects Cumberland and Ridout, was erected in 1851-53. It still stands and is used by the Adelaide Court Theatre. For a discussion of the building see William Dendy and William Kilbourn, *Toronto Observed*. Toronto: Oxford University Press, 1986, pp.60-61. For a discussion of the neighbourhood as Toronto's artistic bohemia see Rosemary Donegan, "Whatever Happened to Queen St. West?" *FUSE*, Fall 1986, pp.16-17. Photos of the courtroom used by the Club, with its first exhibition installed, are in the Morris Papers, Manitoba Archives, Winnipeg.

47
Among the Canadian Art Club members, some such as Allward, Browne, Morris and Williamson were also members of the Arts and Letters Club. For a discussion of the early years of the latter club see Augustus Bridle, *The Story of the Club*. Toronto: Arts and Letters Club, 1945.

44
Exposé dactylographié des principes du Club, non daté (env. 1908).

qu'on leur imposait ici, et qui avaient conséquemment obtenu leur renommée sous des cieux plus cléments.[44]

Le Club créa également une catégorie de membres associés orientée vers le grand public. L'idée avait probablement été suggérée par Watson et empruntée à l'International Society of Sculptors, Painters and Gravers — une société britannique novatrice qu'il connaissait. Les membres associés devaient apporter une autre source de revenus destinés à défrayer les frais d'expositions. On comptait surtout les trouver parmi les journalistes, qui fourniraient au Club une publicité gratuite, et chez les riches collectionneurs qui auraient les moyens d'acheter les tableaux. Au cours de la première année, plus de 25 membres furent ainsi recrutés. Ils avaient pour président honoraire et trésorier des hommes influents, dotés d'un excellent sens des affaires. Le premier président honoraire fut D.R. Wilkie, responsable de la Banque Impériale du Canada. Les autres postes de direction étaient assumés par les membres artistes.

On décida rapidement que les expositions du Club auraient lieu une fois par an. Mais le Club caressait des ambitions nationales et espérait organiser des manifestations itinérantes dans les villes importantes du Dominion. Les coûts d'un tel projet étant trop élevés et le nombre de locaux appropriés étant rare à l'extérieur de Toronto et de Montréal, cet espoir fut peu à peu abandonné. Une exposition spéciale eut lieu auprès de l'Art Association of Montreal en février 1910, mais ce fut là tout le rayonnement du Club en dehors de Toronto.

45
Lettre de James Wilson Morrice à Edmund Morris, 15 December 1907, AGO EMP.
46
Oeuvre des architectes Cumberland et Ridout, cet édifice d'inspiration grecque et géorgienne fut érigé en 1851-53. Il a résisté au temps et abrite actuellement l'Adelaide Court Theatre. Pour une discussion sur ce bâtiment, consulter William Dendy and William Kilbourn, *Toronto Observed*. Toronto: Oxford University Press, 1986, pp.60-61. Pour plus de détails sur ce quartier bohème de Toronto, voir Rosemary Donegan, "Whatever Happened to Queen St. West?" *FUSE*, Fall 1986, pp.16-17. Certaines photographies de la salle d'audience occupée par le Club et prises à l'occasion de sa première exposition, se trouvent dans le fonds Morris, Manitoba Archives, Winnipeg.
47
Certains membres du Canadian Art Club, tels Allward, Browne, Morris et Williamson, appartenaient également à l'Arts and Letters Club. Pour une étude des débuts du Club en question, voir Augustus Bridle, *The Story of the Club*. Toronto: Arts and Letters Club, 1945.

On partit à la recherche de locaux destinés aux expositions. Il fut question de louer une salle dans le nouveau King Edward Hotel[45] mais, vers la fin de l'année 1907, on avait finalement opté pour la location de plusieurs salles situées à l'étage supérieur de l'ancienne cour d'assises du comté de York, au numéro 57 de la rue Adélaïde.[46] Au coeur du quartier bohème de Toronto, les locaux venaient de servir de studio au muraliste Frederick Challener. Après le départ du Club plusieurs années plus tard, l'Arts and Letters Club devait s'y installer.[47]

L'inauguration de la première exposition du Canadian Art Club eut lieu le 4 février 1908 en la présence de plus de deux cents invités triés sur le volet, si l'on en croit les chroniques mondaines. Au pinacle de cette pyramide sociale, le Lieutenant-gouverneur de l'Ontario, Sir William Mortimer Clark, prononça le discours d'ouverture.

Faisaient partie de l'exposition: W.E. Atkinson, Archibald Brown, Franklin Brownell, Edmund Morris, Horatio Walker, Homer Watson et Curtis Williamson ainsi que les trois artistes invités William Brymner, Maurice Cullen et Robert Harris. Ces artistes étaient principalement des modérés qui se plaçaient dans la tradition des écoles de Barbizon et de la Haye. Archibald Browne subissait l'influence des paysages nocturnes de Whistler, Maurice Cullen et James Wilson Morrice celle des impressionnistes français. Un peu plus de la moitié des participants étaient établis à Toronto tandis que les autres venaient de Montréal. Seuls Horatio Walker et James Wilson Morrice s'étaient expatriés — le

social and fashion notes in the newspapers, the crowd was very select. The man at the top of the social pyramid, the Lieutenant Governor of Ontario, Sir William Mortimer Clark, declared the show officially open.

The eleven artists included in the show (W.E. Atkinson, Archibald Browne, Franklin Brownell, Edmund Morris, Horatio Walker, Homer Watson and Curtis Williamson and three guests: William Brymner, Maurice Cullen and Robert Harris) were mainly artistic moderates, working within the Barbizon and Hague school traditions. Archibald Browne showed the influence of Whistler's nocturnes, and Maurice Cullen and James Wilson Morrice of French impressionism. Slightly more than half of the artists were based in Toronto and most of the rest came from Montreal. Only two, Horatio Walker and James Wilson Morrice, were expatriates, the former in New York, the latter in Paris. All were known and respected artists but only Walker, Watson and Morrice were considered "stars." Most had been trained abroad, especially at the Académie Julian in Paris, and most were well travelled and acquainted with European artistic traditions.

Most of the 54 works (50 oils and four pastels) on display were landscapes. Genre paintings and portraits made up the balance. Judging from their titles and the background of their creators, about three-quarters of their subjects were Canadian. One was even taken from Algonquin Park.[48] The non-Canadian subjects came from Holland, France and Britain.

48
Franklin Brownell, *Waterfall: Algonquin Park* (19).

The main speech of the opening, made by D.R. Wilkie, reveals the Club's aspirations and frame of reference. Wilkie defended the Club's secession and called on the example of recent secessionist groups abroad: The Ten and The Eight in New York, the Society of Twelve in London and the Cercle Volnez in Paris. At the same time, he was sensitive to the concerns of George Reid and William Brymner. He claimed that the Club was not in opposition or competition with the O.S.A. and R.C.A., but that its members had formed a new group "only to cultivate and develop their special aim."[49] The negative part of that aim was avoidance of "what is cheap and popular."[50] The positive part was:

49
The Canadian Art Club 1907-1911. Toronto: n.p., 1911, p.5.

50
Ibid., p.4.

> ...*to produce something that shall be Canadian in spirit, something that shall be strong and vital and big, like our Northwest land, something true to art in every particular...*[51]

51
Ibid.

Aside from its vitality and bigness, however, this Canadian spirit remained undefined. Whether it depended on subject matter, or style, or something else again was never stated. Wilkie further complicated the problem by insisting that the members of the Club preserved "the individual outlook."[52] Their Canadian spirit, he felt, was not threatened but "broadened by association with the art of the Old World."[53]

52
Ibid., p.5.

53
Ibid., p.4.

Wilkie then went on to appeal to national and civic pride. He posed a rhetorical question, "Why is there no art in Canada?" To this he replied that great art did exist but that it was not honoured at home. Canadian talent among the expatriates, for instance, had already "brought honour

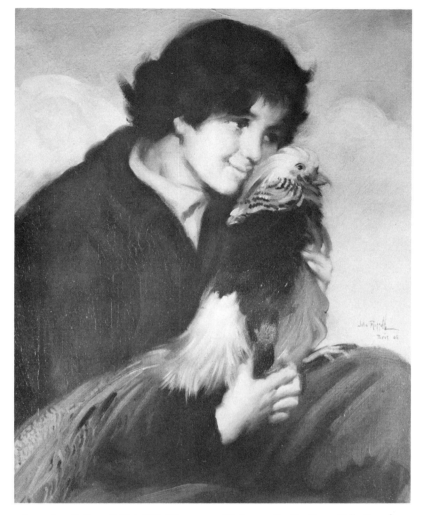

John W. Russell. *Boy with Bird*. 1906. Oil on canvas / Huile sur toile, 48 x 61 cm. Collection of Mrs. Joan E. Fry

premier à New York, l'autre à Paris. Tous étaient connus et respectés mais seuls Walker, Watson et Morrice avaient réellement atteint la notoriété. Presque tous avaient été formés à l'étranger—à l'Académie Julian de Paris surtout, et la plupart avaient beaucoup voyagé et connaissaient bien les traditions artistiques européennes.

La plupart des 54 toiles (50 peintures à l'huile et quatre pastels) représentaient des paysages, les autres étaient des tableaux de genre et des portraits. Si l'on en juge par les titres et la formation de leurs auteurs, près des trois-quarts des sujets étaient canadiens. L'un était même emprunté au parc algonquin.[48] La Hollande, la France et l'Angleterre avaient fourni les autres sujets.

48
Franklin Brownell, *Waterfall: Algonquin Park* (19).

Le discours d'ouverture que prononça D.R. Wilkie révèle les aspirations du Club et sa position. Wilkie défendit la sécession du Club et prit pour exemples les groupes étrangers qui avaient récemment proclamé leur différence: The Ten et The Eight à New York, la Society of Twelve à Londres et le Cercle Volnez à Paris. Mais il se montrait également sensible aux préoccupations de George Reid et de William Brymner. Il

to their native land and renown to themselves."[54] The task of bringing these talents home and building a supportive climate for art was being started by the Club but its completion still lay mainly ahead. "The time is now," Wilkie declared,

> ...when there is a general movement, a reaching out for something other than mere thoughts of money and money getting. People, to live truly and nobly, require the stimulus of beauty around them.... The watchword must be passed from one to the other...to pay more attention to the flowers by the wayside, so that, as a people, while we wish for material prosperity, we may not become altogether sordid in attaining that end....A city of the size and prosperity of Toronto, the centre of education and culture of the Dominion of Canada, should not permit itself to be outclassed by cities of lesser importance and pretensions in other countries.[55]

That such a goal was possible for Canada, claimed Wilkie, could be seen in the example of the United States, which only recently had developed "an art that is national in character, vital and big and that promises to outshine the art of the Old World."[56]

The press, for the most part, took the Club at its own estimation. Several newspapers printed Wilkie's speech almost verbatim. The opening was given extensive coverage and the general consensus was that the show had a very high standard, probably the highest ever seen in Toronto. Note was also made of the consciously artistic hanging of the show and the grouping of works by individual artists.[57] Walker, Watson and Williamson were clearly the public favourites and Morrice the respected but difficult "painter's painter."[58] The only broad reservations about the show came from *Saturday Night* which lauded its strength and "virility" but found nothing:

54
Ibid., p.6.

55
Ibid., pp.5,6.

56
Ibid., p.7.

57
The O.S.A. had followed the usual Victorian practice of covering the wall surface with paintings hung edge to edge. A little space between works had appeared by the turn of the century, but generally the O.S.A. jammed two to three times as many works on the walls as did the C.A.C. An emphasis on the artistic hanging of works and designing of total exhibition environments was then internationally fashionable. It was derived from ideas of Whistler and could be seen in the exhibitions of the Vienna Secession and the Venice Biennale.

58
On Morrice's reception in Canada see Rosalie Smith McCrea, *James Wilson Morrice and the Canadian Press*. Ottawa: Unpublished M.A. Thesis, Carleton University, 1980.

Clarence Gagnon. *Mont St. Michel.* 1907. Etching on paper/Gravure sur papier 19.7 x 24.8 cm. (Imp.). The Montreal Museum of Fine Arts

A. Phimister Proctor. *Charging Buffalo*. 1897. Bronze / Bronze, 30 x 19.6 x 41.2 cm. The Glenbow Museum

affirma que le Club n'était pas là pour faire opposition ou concurrence à l'O.S.A. ou à la R.C.A.; si ces membres avaient formé un nouveau groupe c'était seulement dans le but de cultiver et de développer leur objectif propre.[49] Sur la négative, il voulait éviter "tout ce qui est vulgaire et populaire"[50], mais dans l'affirmative, il visait

> *...une production canadienne dans son essence, quelque chose de fort, de vital et de grand à l'échelle de notre Nord-ouest, quelque chose enfin qui soit digne de l'Art dans chacune de ses fibres.[51]*

Mis à part sa vitalité et ses dimensions, ce caractère distinctif restait toutefois à définir. On ne sait s'il se situait dans le choix du sujet ou le style. Wilkie compliquait encore le problème en insistant que les membres du Club préservassent "leur vision individuelle."[52] Selon lui, l'esprit canadien s'ouvrait plus qu'il n'était menacé au contact de l'art européen.[53]

Wilkie fit ensuite appel à la fierté nationale et civique: "Pourquoi l'art n'existait-il pas au Canada?" Il rétorqua lui-même que l'Art digne de ce nom était bien vivant ici mais qu'il n'était pas reconnu. Les artistes canadiens qui s'étaient expatriés avaient par exemple fait honneur à leur pays d'origine et s'étaient fait une renommée.[54] Le Club s'était donné pour tâche de ramener ces artistes talentueux au bercail et d'établir un climat propice à la vie artistique, mais la réalisation de ce rêve était encore lointaine. Il faut agir maintenant, déclara Wilkie,

> *...profiter de ce mouvement général qui aspire à quelque chose de plus élevé que l'argent et les moyens d'en gagner davantage. Pour vivre dans un esprit de vérité et de noblesse, les gens ont besoin de la présence enlevante de la beauté autour d'eux. Qu'on se donne le mot d'ordre... arrêtons-nous aux fleurs qui croissent en bordure de route afin que nous, en tant que peuple, qui souhaitons la prospérité matérielle, ne sombrions pas dans le sordide quand nous y parvenons. Une ville des dimensions et de la richesse de Toronto, le centre éducatif et culturel du Dominion, ne devrait jamais permettre de se*

49
The Canadian Art Club 1907-1911.
Toronto: n.p., 1911, p.5.

50
Ibid., p.4.

51
Ibid.

52
Ibid., p.5.

53
Ibid., p.4.

54
Ibid., p.6.

...insistently typical of the country....The somewhat dark and forbidding character of much of the exhibit does somewhat suggest a land under a pall, through which the sun's rays penetrate only very sparingly and on state occasions, whereas the Canadian atmosphere is generally one of considerable illumination and definition.[59]

In spite of the exhibition's critical success, few sales seem to have materialized. D.R. Wilkie and Sir Edmund Walker bought a few works yet Newton MacTavish, visiting the show, commented, "I notice that only one or two pictures are marked 'sold'."[60]

When the Club's second exhibition opened, in March 1909, it was clear its ambition had grown. It had sponsored a one-man show by Archibald Browne in its gallery and several more were planned.[61] Membership had grown to include John Russell, a painter expatriated in Paris, as well as Walter Allward and A. Phimister Proctor, sculptors from Toronto and New York. Clarence Gagnon and Laura Muntz were both included as guests. There were 80 works in this exhibition which was accompanied by an illustrated catalogue. The opening ceremonies were as grand as before. Speeches were made by Wilkie and lay member E.F.B. Johnston. Morrice and Proctor arrived for the festivities. Equally important was the diplomatic presence of George Reid and the recently elected president of the O.S.A., Wyly Grier.

The works included in the second exhibition were similar to those in the first. About one-quarter of the works depicted non-Canadian subjects, most of which were concentrated in the works of Gagnon and Morrice. Morrice had upped his representation from two to eleven works and now both etchings (by Gagnon) and bronzes (by Proctor) were included.

The reaction of the press was, if anything, even more positive than before. A typical review bore the headline "Great Pictures by Native Born."[62] The critic of *The Globe* considered it not only "the best exhibition of paintings by Canadians ever seen in Toronto," but also of quality that "would do credit to any city in the world."[63] "Verily the Canadian Art Club has more than justified its foundation," said *The Mail and Empire.*[64] The works it exhibits, concluded *The Globe,* "must be recognized as a potent instrument in the artistic development of Canada."[65] Notice of the exhibition even transcended the Canadian press.

That July, the prestigious British magazine, *The Studio,* contained a short but enthusiastic review by the Club's own E.F.B. Johnston.[66] The only serious critical note in all this symphony of praise came, as before, from *Saturday Night* which repeated its earlier claim that the show was "not strictly of a national character."[67] James Mavor, too, while certainly supportive, withheld a final judgement. "It would, perhaps," he wrote:

...be too much or too premature to say that the coming of this group means the coming of a distinctly Canadian school, yet...meanwhile the exhibition is of sufficient distinction to challenge sympathetic attention.[68]

Sales in 1909 were somewhat better than the year before. This time a

59
"The Exhibition of the Canadian Art Club." *Saturday Night*, 22 February 1908, p.5.

60
Diary entry, Newton MacTavish, 8 February 1908. PAC NMP, MG30 D278, vol.1.

61
Browne's show was held in October-November 1908. Planned were shows by Morris in April 1909 and by Atkinson and Williamson in the fall of that year.

62
"Great Pictures by Native Born." *The Mail and Empire*, 1 March 1909, p.5.

63
"Canadian Art Club's Success." *The Globe*, 1 March 1909, p.2.

64
"Great pictures by Native Born."

65
"Some Noted Pictures by Famous Artists...." *The Globe*, 6 March 1909, magazine section, p.3.

66
E.F.B. Johnston, "Studio Talk: Toronto." *The Studio*, 14 September 1909, pp.154-158.

67
"The Canadian Art Club's Second Annual Exhibition." *Saturday Night*, 13 March 1909, p.11.

68
The Canadian Art Club 1907-1911. pp.21-22.

James Kerr-Lawson. *Piazza San Lorenzo, Florence.* 1908. Lithotint on paper/Lithographie en couleurs sur papier, 29.2 x 20.3 cm. (Imp.). Art Gallery of Ontario

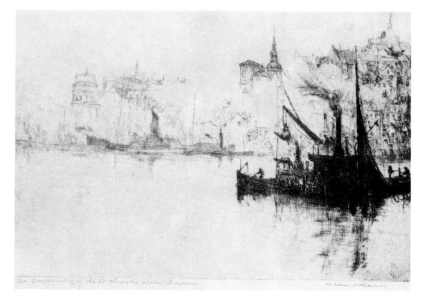

H. Ivan Neilson. *The Deepening of the St. Charles River, Quebec.* 1913. Etching on paper/Gravure sur papier, 20.3 x 30.5 cm. (Imp.). Burnaby Art Gallery. Photo: Nicole Savoie

55
Ibid., pp.5,6.

56
Ibid., p.7.

57
Fidèle aux pratiques victoriennes, l'O.S.A. avait couvert les murs de tableaux dont les cadres se touchaient bord à bord. Ils étaient légèrement plus espacés au tournant du siècle, mais en général, l'O.S.A. parvenait à montrer ainsi deux à trois fois plus d'oeuvres que la C.A.C. Le courant international à la mode voulait qu'on mît l'accent sur la présentation artistique et sur tout le décor des expositions. Cette vogue inspirée des idées de Whistler était à l'oeuvre aux expositions de la Sécession de Vienne et à la biennale de Venise.

58
Sur la manière dont Morrice était reçu au Canada, voir Rosalie Smith McCrea, *James Wilson Morrice and the Canadian Press.* Ottawa: Thèse de maîtrise non publiée, Carleton University, 1980.

59
"The Exhibition of the Canadian Art Club." *Saturday Night,* 22 February 1908, p.5.

60
Entrée de journal, Newton MacTavish, 8 February 1908. PAC NMP, MG30 D278, vol.1.

laisser surclasser par les cités de moindres importance et aspirations des autres pays.[55]

Un tel but était à la portée du Canada, d'après Wilkie. Il suffisait de prendre l'exemple des États-Unis qui venaient tout récemment d'établir "un art de caractère national, énergique, grand—qui promettait de supplanter l'art du vieux continent."[56]

Dans la plupart des cas, la presse accepta le jugement de Wilkie. Plusieurs journaux se contentèrent de reproduire textuellement son discours. Le vernissage fut largement couvert et tout le monde s'accorda pour dire que l'exposition était du plus haut calibre, probablement la meilleure jamais vue à Toronto. On mentionna encore la disposition savante des tableaux et le fait qu'ils avaient été regroupés selon les artistes.[57] Walker, Watson et Williamson remportaient nettement la faveur du public tandis que Morrice, bien que respecté, était perçu comme plus difficilement accessible: "le peintre des peintres".[58] Les seules réserves majeures vinrent du *Saturday Night* que loua la force et la vigueur de la collection mais ne trouva rien

> *...qui soit vraiment typique du pays... Le caractère sombre et inhospitalier de la plupart des tableaux tend à représenter un pays funèbre, qui n'est touché que dans les grandes occasions par la grâce d'un rare rayon de soleil, alors que l'atmosphère canadienne est en général largement éclairée et particulièrement bien définie.*[59]

En dépit de la réception chaleureuse des critiques, peu de ventes furent réalisées. D.R. Wilkie et Sir Edmund Walker firent l'acquisition de quelques oeuvres, mais selon Newton MacTavish, un ou deux tableaux seulement portaient la mention "vendu".[60]

Quand la seconde exposition ouvrit ses portes, en mars 1909, il était évident que les aspirations du Club avaient grandi. Il avait présenté dans

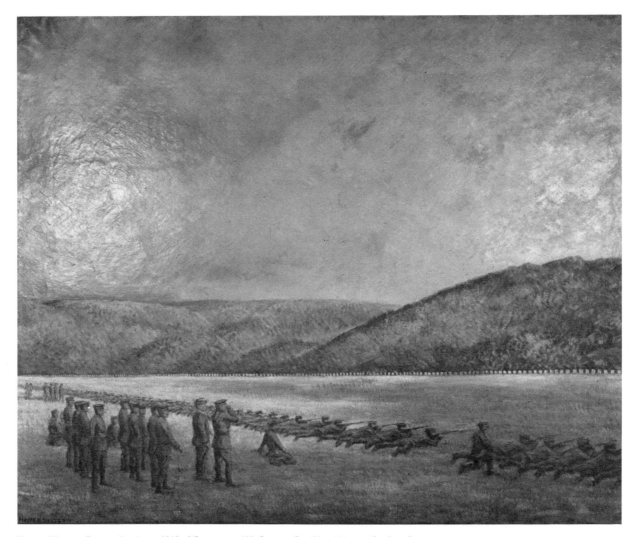

Homer Watson. *Camp at Sunrise*. c. 1915. Oil on canvas / Huile sur toile, 152 x 181 cm. The Canadian War Museum

major buyer emerged, the newly created Advisory Arts Council for the federal government. The Council purchased nine works from the exhibition, one apiece by Atkinson, Browne, Brownell, Morrice, Russell and Watson, and three by Proctor.[69]

By the time of its third exhibition in January 1910, the Club seems to have reached a state of maturity and was accepted as a regular part of the Toronto artistic scene. Over the next five years, five new painters (Ernest Lawson, James Kerr-Lawson, Henry Ivan Neilson, William H. Clapp and Marc-Aurèle de Foy Suzor-Coté) were added to the membership. Increasing numbers of other artists appeared as guest exhibitors. The lay membership increased more than fourfold and public attendance, in 1913, reached almost 2,500 people. A well-received exhibition was held in Montreal and, by 1911, the Club felt secure enough to publish a booklet which outlined its history and principles and contained the texts of reviews as well as several of Wilkie's opening speeches.[70]

69
Atkinson's *Willows, Evening* (2), Browne's *A Midsummer Night* (7), Brownell's *A Little Puritan* (13), Morrice's *Quai des Grands Augustins* (32), Russell's *Mme. de B. and Son* (67), Watson's *Nut Gatherers in the Forest* (74), and Proctor's *Indian Warrior* (47), *Standing Puma* (58), and *Prowling Panther* (51).

70
The Canadian Art Club 1907-1911.

61
L'exposition des oeuvres de Browne eut lieu en octobre-novembre 1908; celle de Morris était prévue pour avril 1909 et celles d'Atkinson et de Williamson pour l'automne de la même année.

62
"Great Pictures by Native Born." *The Mail and Empire*, 1 March 1909, p.5.

63
"Canadian Art Club's Success." *The Globe*, 1 March 1909, p.2.

64
"Great pictures by Native Born."

65
"Some Noted Pictures by Famous Artists...." *The Globe*, 6 March 1909, magazine section, p.3.

66
E.F.B. Johnston, "Studio Talk: Toronto." *The Studio*, 14 September 1909, pp.154-158.

67
"The Canadian Art Club's Second Annual Exhibition." *Saturday Night*, 13 March 1909, p.11.

68
The Canadian Art Club 1907 -1911. pp.21-22.

69
Willows, Evening d'Atkinson (2), *A Midsummer Night* de Browne (7), *A Little Puritan* de Brownell (13), *Quai des Grands Augustins* de Morrice (32), *Mme. de B. and Son* de Russell (67), *Nut Gatherers in the Forest* de Watson (74), et *Indian Warrior* (47), *Standing Puma* (58), and *Prowling Panther* (51) de Proctor.

sa propre galerie une exposition consacrée à Archibald Browne et plusieurs autres manifestations étaient prévues.[61] Le rang des membres avait grossi et comprenait désormais John Russell, peintre expatrié à Paris, ainsi que Walter Allward et A. Phimister Proctor, sculpteurs à Toronto et à New York, respectivement. Clarence Gagnon et Laura Muntz étaient tous deux invités. L'exposition comptait 80 tableaux et s'accompagnait d'un catalogue illustré. L'ouverture eut lieu avec tout le cérémonial d'usage. Les discours furent prononcés par Wilkie et le membre associé E.F.B. Johnston. Morrice et Proctor se joignirent aux festivités. Tout aussi importante était la présence diplomatique de George Reid et de Wyly Grier, récemment élu président de l'O.S.A.

Les oeuvres qui firent partie de la seconde exposition étaient semblables à celles de la première. Près d'un quart des tableaux étaient consacrés à des sujets non-canadiens et la plupart d'entre eux étaient de Gagnon et de Morrice. Ce dernier avait augmenté l'importance de sa participation en passant de deux à onze pièces, et désormais figuraient des gravures de Gagnon et des bronzes de Proctor.

L'accueil de la presse fut encore plus favorable. Une revue caractéristique arborait la manchette: "De grands tableaux par des artistes d'ici."[62] D'après *The Globe*, non seulement s'agissait-il de "la meilleure exposition de peintres canadiens jamais vue à Toronto" mais sa qualité était telle "qu'elle ferait honneur à n'importe quelle ville au monde."[63] *The Mail and Empire* renchérit: "En vérité, le Canadian Art Club a plus que justifié sa fondation."[64] Et *The Globe* de conclure, "on doit reconnaître que les oeuvres exposées joueront un rôle primordial dans le développement artistique du Canada."[65] L'exposition fut remarquée au-delà des frontières.

En juillet de cette année-là, une revue critique courte mais enthousiaste paraissait dans le prestigieux périodique anglais *The Studio* sous la plume de E.F.B. Johnston. La seule note discordante de ce concert d'éloges se trouva une fois encore dans le *Saturday Night* qui reprochait toujours à l'exposition de manquer de caractère national au sens strict.[67] Bien que tenant du Club, James Mavor portait aussi le jugement suivant:

> *..Il est peut-être prématuré d'affirmer que l'émergence de ce groupe signifie l'avènement d'une école proprement canadienne, cependant l'exposition se distingue suffisamment pour éveiller une attention favorable.*[68]

En 1909, le volume des ventes devait quelque peu grossir par rapport à l'année précédente. Un acheteur important voyait le jour avec la création récente d'un conseil consultatif des arts au service du gouvernement fédéral. Le Conseil fit l'acquisition de neuf oeuvres — une d'Atkinson, de Browne, de Brownell, de Morrice, de Russell et de Watson, et trois de Proctor.[69]

En janvier 1910, au moment de sa troisième exposition, le Club semblait avoir atteint sa pleine maturité et les milieux artistiques torontois l'avaient accepté à part entière. Au cours des cinq années suivantes, cinq nouveaux peintres (Ernest Lawson, James Kerr-Lawson, Henry Ivan

This outward appearance of success was maintained right through the Club's demise. The press continued its strong support of both the Club's nationalism and for the quality of its exhibitions. With the coming of the war, this support even increased. The terms used again and again to praise the Club's works were "bigness" and "virility." More interesting indicators of its achievement were the series of substantial articles on its members in Newton MacTavish's *Canadian Magazine*,[71] and its inclusion (the only Canadian content) in the final volume of *A History of Painting*, by the British critic Haldane MacFall.[72] By far the most important discussion is found in the article, "A Renaissance of Art In Canada," written in 1911 by MacTavish for the American magazine *Art and Progress*. MacTavish was the first writer to directly link the spirit of the Club with that of the Laurier period. He traced the various historical events that had helped to swell Canadian pride and noted:

> *After the national spirit of the country had been aroused, the attainments of Canadian artists abroad began to have significance. The people commenced to take interest in these artists because they were Canadians, and they in turn began to evince more interest in the country because it was Canada. And although this new impulse was felt some years before it was realized, it was with amazing spontaneity that it materialized four years ago in the formation of the Canadian Art Club....No claim is here made that there is in general any Canadian art distinct from other art. The purpose has been to show merely that Canadian artists have gained conspicuous distinction when placing their work against American and European standards and that there has been an awakening of national consciousness of this fact.*[73]

Final evaluations, not so much interesting for what they said but for who said them, came from the young Lawren Harris, A.Y. Jackson and Eric Brown. Harris reviewed the Club's exhibition for *The Yearbook of Canadian Art* in 1913. At a time when the Group of Seven's views were crystallizing, Harris called for more Canadian subjects but still admired the exhibition as a whole. The Club, he concluded, "has been of undoubted benefit to Canadian art. It has provided the needed stimulus."[74] Jackson never discussed the Club directly but didn't think much of the art that could be seen in Toronto at the time. Many years later, however, in his memoirs, he recalled his debts to such Montreal members as Morrice, Cullen and Clapp.[75] Eric Brown could still admire the Club's "virile" work. He concluded, nevertheless, that "a national school is not yet achieved."[76] He would find a national school very soon in the Group of Seven.

71
Articles appeared on Morris in June 1908, Browne in October 1908, Williamson in November 1908, Atkinson in June 1909, Morrice in December 1909, Russell in April 1911, Muntz in September 1911, Cullen in April 1912, Proctor in April 1915 and Allward in January 1919.

72
Haldane MacFall, *A History of Painting*. London: T.C. and E.C. Jack, 1911, vol.8, pp.293-294.

73
Newton MacTavish, "A Renaissance of Art in Canada." *Art and Progress*, September 1911, pp.322-323, 325.

74
Lawren S. Harris, "The Canadian Art Club." in *Yearbook of Canadian Art — 1913*, ed. by Arts and Letters Club of Toronto. Toronto: J.M. Dent and Sons Ltd., 1913, p.213.

75
A.Y. Jackson, *A Painter's Country*. Toronto: Clarke, Irwin and Co. Ltd., 1958, pp.19-20

76
Eric Brown, "Canadian Artists Show." *Ottawa Citizen*, 22 January 1910, p.42.

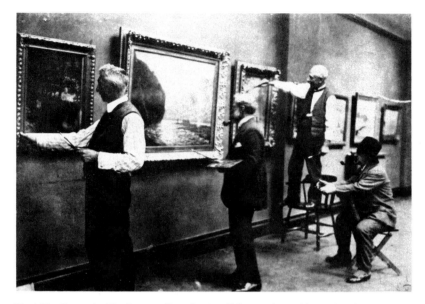

Varnishing Day at the/Vernissage au/Canadian Art Club, 1914. l. to r./de gauche à droite:
W.E. Atkinson, Homer Watson, Horatio Walker, Archibald Browne. Photo: Percy Atkinson

70
The Canadian Art Club 1907-1911.

71
Des articles parurent sur Morris en juin
1908, sur Browne en octobre 1908, sur
Williamson en novembre 1908, Atkinson
en juin 1909, Morrice en décembre 1909,
Russell en avril 1911, Muntz en septembre
1911, Cullen en avril 1912, Proctor en
avril 1915 et Allward en janvier 1919.

72
Haldane MacFall, *A History of Painting.*
London: T.C. and E.C. Jack, 1911, vol.8,
pp.293-294.

Neilson, William H. Clapp et Marc-Aurèle de Foy Suzor-Coté) se
joignirent au Club. D'autres artistes invités paraissaient aux exposi-
tions, toujours plus nombreux. Le total des membres associés avait plus
que quadruplé et l'on reçut près de 2 500 visiteurs en 1913. En 1911, une
exposition fut organisée avec succès à Montréal, et le Club se sentit
suffisamment établi pour publier une brochure qui retraçait son histoire
et énonçait ses principes; elle contenait également certaines revues
critiques et plusieurs des discours d'inauguration prononcés par Wilkie.[70]

Ce succès apparent devait se maintenir jusqu'à la toute fin du Club. La
presse continua à le soutenir vigoureusement, à la fois pour son nationa-
lisme et pour la qualité de ses expositions. À l'approche de la guerre, cet
appui se fortifia encore. Les termes de "grandeur" et de "vigueur"
réapparaissaient constamment dans les louanges qui étaient adressées
aux oeuvres du Club. Une meilleure indication encore de sa réussite, ce
fut la série d'articles de fond consacrés à ses membres et parue dans le
Canadian Magazine (qui appartenait alors à Newton MacTavish).[71] La
seule contribution de contenu canadien, elle fut reprise dans le volume
final de *A History of Painting*, du critique anglais Haldane MacFall.[72] Mais
la plus importante discussion figure dans l'article intitulé "A Renais-
sance of Art in Canada," écrit en 1911 par MacTavish et destiné à la
revue américaine *Art and Progress*. MacTavish est le premier critique qui
ait directement relié l'esprit du Club à l'époque de Laurier. Après avoir
retracé les divers événements historiques qui avait contribué à fortifier
la fierté canadienne, il note:

> *Après que l'esprit national du pays se fut éveillé, le succès que les artistes
> canadiens remportaient à l'étranger fut investi d'un certain sens. Les gens
> commencèrent à s'intéresser à eux parce qu'ils étaient canadiens; en retour,
> eux manifestèrent un regain de curiosité envers le pays parce qu'il s'agissait
> du Canada. Et, bien que ce nouvel élan fût ressenti bien avant sa pleine
> expression, c'est avec une spontanéité saisissante qu'il résulta — il y a quatre*

Edmund Morris. *Wolf Collar: Medicine Man*. 1909. Pastel on paper / Pastel sur papier, 63.9 x 50 cm.
Government of Alberta

73
Newton MacTavish, "A Renaissance of Art in Canada." *Art and Progress*, September 1911, pp.322-323, 325.

74
Lawren S. Harris, "The Canadian Art Club." in *Yearbook of Canadian Art — 1913*, ed. by Arts and Letters Club of Toronto. Toronto: J.M. Dent and Sons Ltd., 1913, p.213.

75
A.Y. Jackson, *A Painter's Country*. Toronto: Clarke, Irwin and Co. Ltd., 1958, pp.19-20

76
Eric Brown, "Canadian Artists Show." *Ottawa Citizen*, 22 January 1910, p.42.

ans — en la création du Canadian Art Club... Nous ne prétendons pas ici qu'il existe un art canadien en général qui se distingue des autres arts. Nous voulons seulement démontrer que les artistes canadiens se sont mis en évidence en plaçant leur oeuvre en marge des normes américaines et européennes, et que l'éveil d'une conscience nationale est dû à ce fait.[73]

D'autres examens sont à retenir, plus par leur origine que par leur contenu d'ailleurs. On les doit au jeune Lawren Harris, à A.Y. Jackson et à Eric Brown. En 1913, Harris couvrait l'exposition du Club pour le compte du *Yearbook of Canadian Art*. À cette époque où la pensée du Groupe des Sept se précisait, Harris réclamait certes un plus grand nombre de sujets canadiens mais il admirait l'exposition dans son ensemble. Il concluait que "le Club avait indubitablement servi l'art canadien et qu'il avait exercé l'effet stimulant dont on avait besoin."[74] Même s'il n'abordait jamais directement le sujet du Club, Jackson n'avait pas une opinion très favorable de ce qui se voyait à Toronto en ce temps-là. Il devait toutefois reconnaître beaucoup plus tard dans ses mémoires tout ce qu'il devait aux membres montréalais de la trempe de Morrice, de Cullen et de Clapp.[75] Eric Brown pouvait encore admirer la vigueur du Club mais admettait qu'une école nationale n'était pas encore née."[76] Il allait la trouver peu de temps après avec le Groupe des Sept.

PART II

For all the Club's achievements, it was a fragile creation, constantly racked with controversies, constantly in danger of falling apart. Because of its widely dispersed membership, with widely varying commitments to it, communication was always a problem. The burden of that problem fell on Edmund Morris.

Morris was the Club's main enthusiast and organizer and he served as its secretary from 1910 to 1913.[77] He was a fairly conventional painter, trained in New York and in Paris and influenced by the traditions of the Barbizon and the Hague schools, Whistler and Manet. Through his family, he had many ties to the Canadian west and was noted for his portraits of Indians. He had broad interests, a wide circle of acquaintances, boundless energy and a full range of social skills which enabled him to fire people up with enthusiasm and soothe injured feelings. Morris kept an extensive record of Club activities in various large and invaluable scrapbooks, now in the library of the Art Gallery of Ontario. He prepared a slim book, one of the first ever published, on early Canadian artists,[78] and extensively researched the painter Wyatt Eaton. In addition, he sat on the board of the new Art Museum of Toronto and also managed to do a lot of painting. When Morris drowned in an accident in August 1913, the Club lost its most important energizer. Archibald Browne, who replaced him as secretary, was competent only in the mundane parts of the job.

Morris always got things done but only, it seems, by stretching himself, the Club's finances and the members' loyalty very, very thin. Costs were high, sales never matched them, and attempts to economize or find new revenues often involved contentious issues of principle. Some of the members were also difficult personalities who sowed dissension and strained the Club's fabric even further.

One of the Club's most basic practical weaknesses was the wide dispersion of its members which raised the cost and lowered the quality of their communication. For a group as small as the Club, with few shared artistic ideas, this dispersion was critical. Toronto contained no more than about 40% of the members, Montreal about 20%. Fifteen percent lived elsewhere in Canada and as many as 25% were scattered across the U.S. and Europe. This placed a burden on the Toronto members and limited most of their contact with the others to occasional letters. Only some of the richer artists like Morris, Morrice, Walker and Watson could afford the travel necessary to share concerns and cement relations with regional members.[79] Most of the Montreal members never even saw the Club exhibitions, while Ernest Lawson and other New Yorkers regularly begged off coming to Toronto for lack of time or money.[80]

Of the Toronto members, only Morris and Homer Watson played much of a leadership role. If Morris was the Club's energizer, Watson was its steadiest worker and the one most concerned with long-term policy. He remained as president until 1913. He hated the politics involved, however, and once confessed to William Brymner that he

77
The main books on Morris are Geoffrey Simmins and Michael Parke-Taylor, *Edmund Morris "Kyaiyii."* Regina: Norman Mackenzie Art Gallery, 1984; Jean S. McGill, *Edmund Morris: Frontier Artist.* Toronto and Charlottetown: Dundurn Press Ltd., 1984; Edmund Morris, *The Diaries of Edmund Montague Morris...* Transcribed by Mary Fitz-Gibbon. Toronto: The Royal Ontario Museum, 1985.

78
Edmund Morris, *Art in Canada: The Early Painters.* Toronto: n.p., 1911. Morris's essay was also published in *Saturday Night*, 24 January 1911, pp.25-29.

79
Clarence Gagon complained about this in a letter to Morris dated 9 April 1913, AGO EMLB. He said he couldn't "afford to come up to Toronto, even if I were in Montreal. It is only 'un fils de famille' *[sic]* like Morrice who can afford to come and go as they wish."

80
Those Montreal members who do not seem to have made it to Toronto were Cullen, Gagnon, Hope, Suzor-Coté and Clapp. The New Yorkers who had to beg off were Lawson, Robinson, Crisp, Bridgman and several lay members.

DEUXIÈME PARTIE

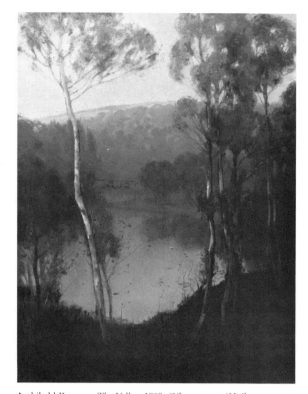

Archibald Browne. *The Valley.* 1909. Oil on canvas / Huile sur toile, 109.2 x 83.8 cm. The Agnes Etherington Art Centre. Photo: Harry Korol

77
Les principaux livres consacrés à Morris sont: Geoffrey Simmins and Michael Parke-Taylor, *Edmund Morris "Kyaiyii."* Regina: Norman Mackenzie Art Gallery, 1984; Jean S. McGill, *Edmund Morris: Frontier Artist.* Toronto and Charlottetown: Dundurn Press Ltd., 1984; Edmund Morris, *The Diaries of Edmund Montague Morris...* Transcribed par Mary Fitz-Gibbon. Toronto: The Royal Ontario Museum, 1985.

78
Edmund Morris, *Art in Canada: The Early Painters.* Toronto: n.p., 1911. L'étude de Morris fut également reprise dans le *Saturday Night*, 24 January 1911, pp.25-29.

79
Clarence Gagon exprime ses doléances dans une lettre adressée à Morris et datée du 9 avril 1913, AGO EMLB. Il remarque qu'il ne pourrait "afford to come up to Toronto, even if I were in Montreal. It is only 'un fils de famille' *[sic]* like Morrice who can afford to come and go as they wish."

80
Parmi les membres de Montréal qui semblent ne jamais avoir pu se rendre à Toronto, se trouvent Cullen, Gagnon, Hope, Suzor-Coté et Clapp. Les New Yorkais qui s'excusaient étaient Lawson, Robinson, Crisp, Bridgman ainsi que plusieurs membres associés.

Sans diminuer ce qu'il avait accompli, il faut admettre que le Club était une création fragile, perpétuellement secouée par les controverses et en danger constant d'effritement. Parce que ses membres étaient largement dispersés et parce que leur engagement envers le Club variait grandement, la communication était difficile. Et ce fut Edmund Morris qui écopa du fardeau.

Le membre le plus enthousiaste du Club et son principal organisateur, Morris remplit les fonctions de Secrétaire de 1910 à 1913.[77] Formé à New York et à Paris, influencé par la tradition des écoles de Barbizon et de la Haye, par Whistler et Manet, c'était un artiste assez conventionnel. Des liens de famille l'avaient profondément attaché à l'Ouest canadien et il était réputé pour ses portraits d'Indiens. Ses intérêts étaient aussi multiples que son cercle d'amis était vaste, son énergie infatigable, et son habileté à traiter avec autrui était telle qu'il savait à la fois soulever les foules et panser les blessures d'orgueil. Morris consigna soigneusement les activités du Club dans divers albums volumineux et inestimables qui sont déposés aujourd'hui à la bibliothèque de l'Art Gallery of Ontario. On lui doit aussi un mince ouvrage, l'un des premiers publiés sur les artistes des débuts de l'art canadien.[78] Il consacra également une recherche exhaustive au peintre Wyatt Eaton. De plus, il siégeait au conseil du nouvel Art Museum of Toronto et parvenait encore à peindre de nombreux tableaux. En 1913, il se noya accidentellement et le Club perdit avec lui le facteur le plus important de son dynamisme. Archibald Browne lui succéda mais sa compétence ne recouvrait que les aspects les plus superficiels de ses tâches.

Morris parvenait toujours à faire ce qu'il devait. Mais seulement, semble-t-il, après avoir taxé à l'extrême limite ses propres forces, les coffres du Club et la loyauté des membres. Les frais étaient élevés et les recettes ne suffisaient jamais à les couvrir. Parvenir à écomiser ou à recueillir des fonds se faisaient toujours d'après des principes épineux. La personalité difficile de certains membres contribuait encore à semer la zizanie et rendait l'existence du Club encore plus périlleuse.

Sur le plan pratique, l'une des faiblesses fondamentales du Club était la grande dispersion des membres, qui augmentait les frais de communication tout en affaiblissant la qualité des échanges. Pour un si petit groupe, qui ne partageait que quelques idées sur l'art, ce problème était critique. Toronto ne comptait pas plus de 40% des membres et Montréal près de 20%. Quinze pour cent vivaient dans le reste du pays et 25% au moins se retrouvaient éparpillés aux É.-U. et en Europe. La situation pesait sur les membres de Toronto et les contacts se limitaient aux lettres occasionnelles. Seuls les artistes les mieux nantis tels Morris, Morrice, Walker et Watson pouvaient se permettre de voyager pour partager leurs préoccupations et cimenter les relations avec leurs collègues établis dans les régions.[79] La plupart des membres de Montréal n'eurent jamais l'occasion de voir les expositions du Club; Ernest Lawson et les autres artistes résidant à New York s'excusaient régulièrement de ne pouvoir venir à Toronto faute de temps et d'argent.[80]

Horatio Walker. *Evening, Ile d'Orléans*. 1909. Oil on canvas/Huile sur toile, 71.8 x 91.4 cm.
Art Gallery of Ontario

longed to go home to his studio "to be happy and to work once again with a free mind."[81]

Among the Montreal contingent, the most influential was William Brymner. Brymner participated fully in Club affairs and was shrewd and careful in his judgements. In 1909, he became president of the R.C.A. and, with his loyalties thus divided, struggled to maintain peace between the Club and the Academy for fear that squabbling would destroy the credibility of both in the eyes of the government and private patrons. Among the New York artists, A. Phimister Proctor was initially wary but soon won over by Morris's enthusiasm. He visited Toronto and travelled with Morris on the prairies but still wasn't part of the inner circle. Horatio Walker, until he joined the Club, had "kept his distance from Toronto art circles."[82] His career in the U.S. was booming and, while he agreed with the Club's aims, his participation was initially half-hearted and condescending. Within several years, however, nationalist convictions were kindled. By 1911, he could declare that he was "a strong believer in the Club, and its missionary ability. *[sic]* for the good of art in Canada."[83] In 1913, he assumed the Club's presidency. James Kerr-Lawson, expatriated in Britain for 25 years and with few Canadian contacts, was delighted to join the Club but, of course, could not be a very active member. "It is true," he wrote to Morris:

I am, like so many of the best Canadians, only a Scotsman by the accident of birth. I had quite intended to enter the world by way of Canada but the dilatory proceedings of my parents made this impracticable. However, I think I made good the defect and...became intensely Canadian and have remained so ever since.[84]

James Wilson Morrice, the most important of the European expatriates,

81
Letter, Homer Watson to William Brymner, undated (Sunday, January 1910), AGO, Stone, Watson Letters, p.4.

82
David Karel, *Horatio Walker*. Quebec City: Musée du Québec, 1987, p.38.

83
Letter, Horatio Walker to Edmund Morris, 27 January 1911, AGO EMLB.

84
Letter, James Kerr-Lawson to Edmund Morris, 8 January 1912, AGO EMLB.

Homer Watson. *The Smugglers' Cove, Cape Breton Island, N.S.* 1909. Oil on canvas (laid down on masonite)/Huile sur toile (couchée sur masonite), 86.4 x 121.9 cm. The Beaverbrook Art Gallery

Parmi les membres torontois, seuls Morris et Homer Watson jouèrent des rôles importants. Si Morris savait insuffler son énergie au Club, c'est Watson qui en était le travailleur le plus assidu et c'est lui encore que préoccupaient le plus les politiques à long terme. Il devait occuper la présidence jusqu'en 1913. Il détestait toutefois les jeux de pouvoir et confia un jour à William Brymner qu'il brûlait de l'envie de s'en retourner à son studio "pour travailler de nouveau heureux et en toute liberté d'esprit."[81]

81
Lettre de Homer Watson à William Brymner, non datée (Sunday, January 1910), AGO, Stone, Watson Letters, p.4.

William Brymner était le plus membre le plus influent du contingent montréalais. Rusé et prudent dans ses jugements, il participa pleinement aux affaires du Club. En 1909, il devint président de la R.C.A. et, divisé dans ses loyautés, s'efforça de maintenir la paix entre le Club et l'académie, de peur que les tensions ne détruisent la crédibilité des deux aux yeux du gouvernement et des mécènes. Dans le milieu artistique new-yorkais, A. Phimister Proctor tout d'abord sur ses gardes fut vite conquis par l'enthousiasme de Morris. Bien qu'il visitât Toronto à plusieurs reprises et qu'il parcourût les Prairies en compagnie de son

James Wilson Morrice. *Return from School.* 1900-03. Oil on canvas / Huile sur toile, 46.4 x 73.7 cm.
Art Gallery of Ontario

had decidedly ambiguous feelings for the Club and its members. He warmed to Morris and some of the other members to the point that, in 1908, he proposed a western expedition to go and paint the "red-skins."[85] He also came to the second exhibition and posed with other members for a Club photograph. His sales through the Club were few, however, even when the works he exhibited were not his most recent and radical ones. Canadian collectors were respectful of Morrice's Paris reputation, but not enough to open their purses wide. Eventually he became discouraged and wrote to Morris complaining:

> *I am becoming doubtful about the advisability of sending pictures to Toronto. Nothing is sold (except to our friend MacTavish) — nobody understands them — and it involves great expense. I have not the desire to improve the taste of the Canadian public.*[86]

The Club had financial troubles from its very beginnings. As early as April 1907, Brymner advised Morris that a proper club could not be established with a $25 membership.[87] Such a low fee would only be feasible for a small group just from Toronto. Ambition ruled out Brymner's suggestion and raised the fee to $100. Soon it was reset at $25, as most of the Club's members could not afford the larger fee.[88] The members, as well, had to pay their own insurance and shipping costs which, especially from Europe, were high and which were not necessarily recouped through sales. Renting and remodelling courthouse rooms, printing a catalogue and holding an opening reception were all expensive undertakings. When sales from the first exhibition were few, Curtis Williamson noted that:

> *Club matters are in extremely bad condition. No one has paid anything and the rent is three months behind. There is also another bill pressing. Morrice will send $75. Browne hasn't sold anything and hasn't any money.*[89]

At this point, an effort was made to expand the number of lay memberships, sold for $10 each. By 1914, 123 people subscribed. The monies thus raised provided a cushion that permitted the Club to

85
Letter, James Wilson Morrice to Edmund Morris, 5 April 1908, AGO EMP.

86
Letter, James Wilson Morrice to Edmund Morris, 30 April 1907, AGO EMP.

87
Letter, William Brymner to Edmund Morris, 30 April 1907, AGO EMLB.

88
Letter, James Wilson Morrice to Edmund Morris, 22 February 1908, AGO EMP.

89
Letter, Curtis Williamson to Edmund Morris, 22 September 1908, AGO EMP.

James Kerr-Lawson. *Boston, Lincolnshire*. 1913. Oil on canvas/Huile sur toile, 99 x 137.2 cm. The Art Gallery of Windsor. Photo: M.J. Wilk

82
David Karel, *Horatio Walker*. Quebec City: Musée du Québec, 1987, p.38.

83
Lettre de Horatio Walker à Edmund Morris, 27 January 1911, AGO EMLB.

84
Lettre de James Kerr-Lawson à Edmund Morris, 8 January 1912, AGO EMLB.

85
Lettre de James Wilson Morrice à Edmund Morris, 5 April 1908, AGO EMP.

ami, il n'appartint jamais vraiment au rang des heureux élus. Jusqu'à ce qu'il se joignît au Club, Horatio Walker avait "gardé ses distances des cercles artistiques de Toronto."[82] Aux États-Unis, sa carrière était florissante et, bien qu'il épousât les objectifs du Club, sa participation fut d'abord condescendante et peu empressée. En quelques années pourtant, ses convictions nationalistes se ranimèrent. Et en 1911, il pouvait proclamer "sa foi en la mission du Club, pour le bien de l'art au Canada."[83] En 1913, il en acceptait la présidence. Alors exilé en Angleterre depuis 25 années et privé de contacts canadiens, James Kerr-Lawson était ravi de faire partie du Club mais ne pouvait vraiment s'engager très activement. Il écrivit à Morris:

Vrai, comme nombre de Canadiens, et des meilleurs! je ne suis écossais que par accident. J'avais pleinement l'intention de venir au monde par la voie du Canada mais les poursuites dilatoires de mes parents me l'interdirent. Je crois toutefois avoir remédié à cet inconvénient... suis devenu depuis intensément canadien et le demeure.[84]

Les sentiments de James Wilson Morrice, le plus important des artistes expatriés en Europe, étaient assurément ambigus envers le Club et ses membres. Il se laissa cependant amadouer par Morris et les autres et proposa en 1908 de partir en expédition dans l'Ouest afin de peindre "les peaux rouges."[85] Il vint également voir la seconde exposition et posa avec

Franklin Brownell. *Fishing Boats, Percé*. 1912. Oil on canvas / Huile sur toile, 39 x 52 cm. The Government of Ontario Art Collection. Photo: T.E. Moore

continue to function. The cushion was very thin, however, and what the Club felt it really needed was a government grant to offset expenses.

The O.S.A. and the R.C.A. already received such grants but because the Club was a private group, it wasn't eligible for them. Changing its status was a politically delicate issue that challenged the "official" nature of the other two societies and could cut into their grants. Something, nevertheless, had to be done. First the Club became a legal entity with a formal constitution and government charter of incorporation. The process took about six months and, by January 1910, was formally announced in *The Canada Gazette*.[90] The constitution formalized existing practice and the incorporation was not taken seriously by the members except as a means to an end. Although the latter provided for capital stock, shares, etc., it never was put into effect.

Further manoeuvring with the Ontario government dragged on for over three years, until a purchase plan was approved. The government bought five works from the Club exhibition in 1913 and another seven in 1914.[91] During this time, the federal government continued its purchases for the National Gallery. In 1910, it bought a Walker, *Oxen Drinking*, for a record price of $10,000. In 1911, it bought a Lawson, in 1912, a Gagnon and Morrice; in 1913, a Cullen; in 1914, a Brownell and Lawson; and in 1915, a Lawson, Brymner and Atkinson.[92] Club sales' records are incomplete and seem to show that private sales were few, averaging about six (from over 80 works per show). If sales were never great, the overall financial picture seems to have improved, with books in the last three years showing cash surpluses between $700 and $1000. This surplus may have been due to the rising sales of lay memberships. By 1915, E.F.B. Johnston claimed that the Club was flourishing financially.[93] The truth of this claim cannot be verified, and when the Club broke up several months later, its financial affairs were left in

90
The Canada Gazette, 1 January 1910, pp.1949-50.

91
In 1913 they bought Atkinson's *Old Town, Brittany* (4), Brownell's *Market in the West Indies* (17), Brymner's *Bonsecours Church* (23), Suzor-Coté's *Village of Cernay* (36) and Lawson's *Winding Road* (52). In 1914 they bought Atkinson's *Return of the Sheep* (83), and *Canal St. Martin, Paris* (86), Brownell's *Pier Rock, Percé* (1), and *Fishing Boat, Percé* (4), Clapp's *Landscape* (9 or 11), Cullen's *Laurentian Valley* (18 or 19), and Watson's *Grove at the Hill Top* (74).

92
1911 — Lawson's *Snow Bound Boats* (32), 1912 — Gagnon's *In the Laurentians, Winter* (29), and Morrice's *Dieppe, The Beach, Grey Effect* (46), 1913 — Cullen's *Ice Harvest* (38), 1914 — Brownell's *On the Beach, Basseterre* (3), and Lawson's *Winter* (28), 1915 — Lawson's *Misty Day* (105), Brymner's *Nude Figure* (43) and Atkinson's *January Thaw* (1).

93
Speech at the final exhibition opening. Cited in "Valcartier Paintings At Art Club's Show." *The Globe*, 7 October 1915, p.6.

les autres membres pour une photographie du Club. Bien que les toiles qu'il avait soumises n'aient été ni les plus récentes, ni les plus radicales, les ventes qu'il réalisa grâce au Club furent maigres. Les collectionneurs canadiens respectaient la réputation parisienne de Morrice, mais pas au point de déserrer pour lui les cordons de leur bourse. Éventuellement, il trouva la situation décourageante et se plaignit auprès de Morris :

> *Je me demande s'il est sage d'envoyer des tableaux à Toronto. Personne, sauf mon excellent ami MacTavish, n'achètera rien, personne ne m'y comprend, et ça risque de me coûter beaucoup d'argent. Je n'ai pas la moindre intention de continuer à améliorer le goût du public canadien.*[86]

Le Club éprouva des difficultés financières dès le tout début. En avril 1907, Brymner avisait Morris qu'un club convenable ne pouvait s'établir avec des droits de 25 $ par membre.[87] Une somme aussi dérisoire ne pouvait s'appliquer qu'à un petit groupe de Toronto. Mais l'ambition balaya la suggestion de Brymner et l'on fixa le montant à 100 $. On allait bientôt le rétablir à 25 $, la plupart des membres ne pouvant régler une somme exorbitante.[88] Les artistes devaient encore couvrir les frais d'assurance, et les ventes ne suffisaient pas toujours à recouvrer les coûts d'expédition élevés (d'Europe surtout). La location et la rénovation des locaux, l'impression des catalogues et les vernissages étaient des entreprises fort onéreuses. Après les maigres ventes de la première exposition, Curtis Williamson écrivit :

> *Les affaires du Club se portent très mal. Personne n'a versé un sou et le loyer est en retard de trois mois. Il reste encore une facture à régler. Morrice doit envoyer 75 $. Brown n'a rien vendu et il est sans argent.*[89]

86
Lettre de James Wilson Morrice à Edmund Morris, 30 April 1907, AGO EMP.

87
Lettre de William Brymner à Edmund Morris, 30 April 1907, AGO EMLB.

88
Lettre de James Wilson Morrice à Edmund Morris, 22 February 1908, AGO EMP.

89
Lettre de Curtis Williamson à Edmund Morris, 22 September 1908, AGO EMP.

Marc-Aurèle de Foy Suzor-Coté. *Village of Cernay, France.* 1899 Oil on canvas/Huile sur toile, 58.4 x 72.6 cm. Nipissing University College. Photo: Harry Korol

limbo. Bank inspectors did not discover that $452.79 sat in the Club's account until 1930. This discovery prompted an investigation of the Club's affairs. In the end costs were deducted and the remaining money was given to Browne, Watson and Williamson, all of whom needed it badly. The investigator's conclusion stands in sharp contrast to Johnston's rosy optimism. "From the charter in my possession," he wrote:

> ...it would appear to me that its terms had never been accepted upon, that no shares had been allocated, taken up or paid for; that what monies had supported the Club during its later years of activity had all come from Lay Members and the Ontario government and that the Artist Members were all behind in their fees, some of them years behind.[94]

Although the Club's finances were in disarray, they were not the immediate cause of its demise. Right from the beginning personal relations had been very stormy and had, several times, threatened to tear the Club apart. The tension produced by tight finances and high principles brought out the worst in some of the members' personalities, especially that of Curtis Williamson. If Morris, Watson and Brymner were the peacemakers, prepared to compromise for the Club to survive, Williamson was the high-minded firebrand. During the secession from the O.S.A., Williamson raised tempers high by taking a hard, unyielding line. In the latter half of 1909, the question arose of whether the Club should keep its courthouse rooms or exhibit in those of the Art Museum, on the top floor of the new Public Library. The O.S.A. and the R.C.A. had already agreed to use the same space. Some of the members felt that the Club could not afford to keep separate rooms and must, therefore, cut this drain on its finances. Morris, who was hardly impartial, argued that:

> These men who are in the Museum movement are all the city gives us to back us up, and to give them a black eye at the start will make the situation impossible.... The whole object of the Museum is to advance Canadian art and the feeling of the Council is strong, believing if the leading group of artists refuse to take part their object is defeated.[95]

Other members, led by Williamson, felt that sharing a common space with the other societies would sacrifice their independence and blur their public identity. Emotions became heated and members on both sides threatened to resign, but, in the end, with no financial alternatives in sight, they all agreed to throw in their lot with the Art Museum. When the 1910 exhibition opened, D.R. Wilkie remarked that:

> Under the mantle of the Art Museum, it is felt that the Club will be brought more prominently before the people and will form a stronger force in moulding national aims.[96]

Fifteen years later, however, Newton MacTavish concluded that the move to the Museum had "caused the loss of the Club's former independent spirit."[97]

Close on the heels of the Art Museum controversy came a second crisis. During the winter of 1910-1911, Williamson convinced the Montreal members that the works for the 1911 exhibition were not up to standard

94
Memorandum, C.E. Stone,
27 August 1930, AGO CACS.

95
Letter, Edmund Morris to Horatio
Walker, 8 November 1909, AGO
EMP.

96
The Canadian Art Club 1907-1911,
p.29.

97
MacTavish, *The Fine Arts in
Canada*, p.73.

Curtis Williamson. *Portrait of William Cruikshank*. c. 1911-12. Oil on canvas / Huile sur toile, 154 x 97.1 cm. Collection of Mr. Karl Allward. Photo: Harry Korol

90
The Canada Gazette, 1 January 1910, pp. 1949-50.

91
En 1913, le gouvernement fit l'acquisition des toiles suivantes: *Old Town, Brittany* d'Atkinson (4), *Market in the West Indies* de Brownell (17), *Bonsecours Church* de Brymner (23), *Village of Cernay* de Suzor-Coté (36) et *Winding Road* de Lawson (52). In 1914, *Return of the Sheep* (83) et *Canal St. Martin, Paris* (86) d'Atkinson, *Pier Rock, Percé* (1), et *Fishing Boat, Percé* (4) de Brownell, *Landscape* de Clapp (9 ou 11), *Laurentian Valley* de Cullen (18 ou 19), et *Grove at the Hill Top* de Watson (74).

92
1911 — de Lawson, *Snow Bound Boats* (32); 1912 — de Gagnon, *In the Laurentians, Winter* (29) et de Morrice, *Dieppe, The Beach, Grey Effect* (46); 1913 — de Cullen, *Ice Harvest* (38); 1914 — de Brownell, *On the Beach, Basseterre* (3) et de Lawson, *Winter* (28); 1915 — de Lawson, *Misty Day* (105), de Brymner, *Nude Figure* (43) et d'Atkinson, *January Thaw* (1).

93
Discours d'ouverture de la dernière exposition. Cité dans "Valcartier Paintings At Art Club's Show." *The Globe*, 7 October 1915, p. 6.

C'est à ce moment qu'on fit un effort pour augmenter le nombre de membres associés. En 1914, 123 personnes avaient payé leur cotisation de 10 $ et l'argent ainsi recueilli permit au Club de continuer à fonctionner. Mais la marge de manoeuvre était mince et le Club jugea qu'il avait désespérément besoin d'une subvention gouvernementale pour équilibrer son budget.

C'est avec des subsides que l'O.S.A. et la R.C.A. fonctionnaient mais parce qu'il s'agissait d'un groupe privé, le Club n'était pas admissible. Changer de statut était une manoeuvre politique délicate qui remettait en question le caractère "officiel" des deux autres sociétés et risquait de réduire le montant de leurs subventions. Il fallait agir. Le Club devint alors une personne morale, dotée d'une constitution en bonne et due forme et d'une charte gouvernementale qui la constituait en corporation. Le processus prit six mois environ au terme desquels—en janvier 1910— la nouvelle fut officiellement annoncée dans *The Canada Gazette*.[90] La constitution ne faisait que formaliser les pratiques en cours et les membres ne prirent pas au sérieux cette notion de corporation, si ce n'est que la fin justifiait les moyens. Bien que le Club eût pu théoriquement fonctionner avec un capital et des actionnaires, rien de ce système ne fut jamais mis en place.

Les pourparlers engagés avec le gouvernement ontarien devaient s'éterniser durant plus de trois années jusqu'à l'approbation d'un programme d'achat. Le gouvernement se porta acquéreur de cinq toiles en 1913 et de sept en 1914.[91] À la même époque, le fédéral continuait à acheter des oeuvres pour le Musée des beaux-arts. En 1910, il obtint un Walker, *Oxen Drinking*, pour le prix record de 10 000 $. En 1911, il acheta un Lawson; en 1912 un Gagnon et un Morrice; un Cullen en 1913; un Brownell et un Lawson en 1914; et un Lawson, un Brymner et un Atkinson en 1915.[92]

Les dossiers du Club sont incomplets mais il semblerait que les ventes privées se limitaient à une moyenne de six par exposition (pour un total de 80 oeuvres). Bien que le chiffre d'affaires n'ait jamais été très élevé, la situation financière semble toutefois s'être améliorée au cours des trois dernières années et les livres de comptes montrent alors des surplus de 700 à 1 000 $ (probablement dûs à l'augmentation des membres associés). En 1915, E. F. B. Johnston prétendait que le Club était prospère.[93] La véracité d'une telle déclaration ne peut être vérifiée et quand le Club se désintégra quelques mois plus tard, l'état de ses finances ne fut pas révélé. Les inspecteurs des banques ne découvrirent pas avant 1930 qu'il restait un solde de 452,79 $ au compte du Club et on fit enquête. Finalement, après déductions des frais, le montant résiduel fut distribué à Browne, à Watson et à Williamson, qui en avaient tous fort besoin. La conclusion de l'enquêteur contraste fortement avec l'optimisme souriant de Johnston:

À la lecture de la charte qui se trouve en ma possession, il appert que les termes n'en ont jamais été appliqués, et qu'aucune action n'a jamais été distribuée, détenue ou payée; que les fonds qui soutenaient le Club durant ses dernières années d'activité provenaient en totalité des membres asssociés et du

Arthur Crisp. *Box Party*. n.d. Oil on canvas/Huile sur toile, 33.7 x 76.3 cm. Art Gallery of Hamilton. Photo: Harry Korol

and that the exhibition should be cancelled. When a meeting was called to discuss the matter, Williamson behaved so outrageously that Watson demanded his resignation. When this was refused, Watson and four other members resigned instead.[98] Although their differences were eventually settled and the exhibition went on, some of the members were clearly worried. W.E. Atkinson, writing from England, complained:

> *I can't understand why he [Williamson] persists in raising grumbles continually — it will only throw us back and we may get the same cathartic we got last year....Another such will finish us![99]*

For most of the rest of the Club's existence Williamson kept a lower profile. In October 1915, however, he flared into prominence again by precipitating a final crisis that did indeed "finish" the Club. Sir Edmund Walker, chairman of both the Art Museum and National Gallery, had visited the Club's exhibition and then confided to his journal that:

> *...as usual, the paintings of those who are Canadians working abroad (or outside of the O.S.A.) were the only interesting feature, and this is the good quality of the body. But for this we might not see the work of Horatio Walker, James Wilson Morrice, Ernest Lawson, Arthur Crisp, Franklin Brownell, Clarence Gagnon, Suzor-Coté, etc.[100]*

Although Walker apparently said nothing to Williamson, either of the show or of possible purchases, his views of the Club seem to have been well known. Several weeks later, he received an abusive letter in which Williamson protested his limited view of the Club's achievement. "We have done a great deal more than that, Sir Edmund," Williamson wrote scathingly, "though you do not know it and, frankly, we never expected that you would."[101]

98
Letter, Homer Watson to William Brymner, cited by Geoffrey Simmins, *Reinterpreting the Canadian Art Club*, p.50.

99
Letter, W.E. Atkinson to Edmund Morris, 30 January 1911, AGO EMP.

100
Journal Entry, Sir Edmund Walker, 7 October 1915, UT EWP, Box 34, Vol.2, p.75.

101
Letter, Curtis Williamson to Sir Edmund Walker, 20 October 1915, UT EWP, Box 12.

94
Memorandum, C.E. Stone, 27 August
1930, AGO CACS.

gouvernement de l'Ontario, et que les cotisations des membres artistes étaient toutes en souffrance, certaines depuis plusieurs années.[94]

Mais que les finances du Club se soient trouvées dans un état lamentable, là ne fut pas la cause de son déclin. Dès le début, les relations personnelles avaient été orageuses au point de menacer l'existence du groupe en plusieurs occasions. Les tensions que produisaient une situation monétaire précaire et des principes élevés faisaient ressortir le pire côté de certains des membres, celui de Curtis Williamson en particulier. Si Morris, Watson et Brymner se faisaient les émissaires de la paix, prêts à toutes les concessions pour assurer la survie du Club, l'orgueilleux Williamson—lui—semait la discorde. Durant la période où ils se séparèrent de l'O.S.A., Williamson enflamma les passions en adoptant une ligne de conduite particulièrement dure. Durant la seconde moitié de 1909, on en vint à se demander si le Club devait conserver les salles qu'il occupait aux assises ou s'il ne devait pas plutôt exposer au Musée qui se trouvait à l'étage supérieur de la nouvelle bibliothèque municipale. L'O.S.A. et la R.C.A. avaient déjà accepté d'utiliser le même espace. Certains membres estimaient que le Club ne pouvait se permettre le luxe de se tenir à l'écart et qu'il devait cesser de taxer ainsi ses finances. Morris qu'on ne pouvait certes pas qualifier d'impartial soutint que:

> *Ces hommes qui font partie du mouvement en faveur du Musée sont toutes les ressources que la ville fournit à notre appui, les canarder dès le départ rendra la situation intenable... L'avancement de l'art canadien est l'objectif du Musée et la position du Conseil est ferme: il estime que si le groupe de tête des artistes refuse de participer, c'est leur objectif qui échouera.*[95]

95
Lettre d'Edmund Morris à Horatio
Walker, 8 November 1909, AGO EMP.

D'autres membres menés par Williamson jugeaient que partager les locaux avec d'autres sociétés, c'était sacrifier son indépendance et estomper son identité publique. Les têtes s'échauffèrent et des deux côtés, on menaça de démissionner. Finalement, faute de solution monétaire, tous acceptèrent de s'associer à l'Art Museum. En 1910, à l'occasion de l'ouverture de l'exposition, D.R. Wilkie notait:

> *placé sous la houlette de l'Art Museum, le Club fera sentir plus fortement sa présence et il constituera une force plus vigoureuse dans la définition des objectifs nationaux.*[96]

96
The Canadian Art Club 1907-1911, p.29.

Quinze ans plus tard, Newton MacTavish concluait pourtant que cette association avec le Musée avait "coûté au Club son indépendance d'esprit."[97]

97
MacTavish, *The Fine Arts in Canada*, p.73.

Tout de suite après cette controverse couvait une seconde crise. Durant l'hiver de 1910-11, Williamson réussit à convaincre les membres de Montréal que les oeuvres destinées à l'exposition de 1911 n'étant pas de qualité suffisante, l'événement devrait être annulé. Au cours d'une assemblée convoquée à ce sujet, le comportement de Williamson fut si scandaleux que Watson exigea sa démission. Comme il refusait, Watson et quatre autres membres soumirent la leur.[98] Éventuellement, l'ordre fut rétabli et l'exposition eut lieu comme prévu, mais certains membres se montraient nettement inquiets. W.E. Atkinson écrivit d'Angleterre:

98
Lettre de Homer Watson à William
Brymner, citée par Geoffrey Simmins,
Reinterpreting the Canadian Art Club, p.50.

> *Je n'arrive pas à comprendre pourquoi [Williamson] s'obstine à soulever le*

Over the next few months, similar letters were exchanged and Horatio Walker was dragged into the controversy. Neither of the Walkers wanted to continue the dispute but Williamson, it seems, was not easily disciplined. He rallied Archibald Browne to his cause and made only a grudging apology.[102] Horatio Walker, disgusted with the whole affair and probably tired of Club politics, then resigned the presidency. No one, presumably, was willing or able to replace him, and the Club simply ceased to function.

102
Letter, Horatio Walker to Sir Edmund Walker, 27 November 1915, UT EWP, Box 12.

99
Lettre de W. E. Atkinson à Edmund
Morris, 30 January 1911, AGO EMP.

100
Entrée de journal, Sir Edmund Walker,
7 October 1915, UT EWP, Box 34, Vol.2,
p.75.

101
Lettre de Curtis Williamson à Sir Edmund
Walker, 20 October 1915, UT EWP,
Box 12.

102
Lettre de Horatio Walker à Sir Edmund
Walker, 27 November 1915, UT EWP,
Box 12.

mécontement — il parviendra seulement à nous faire reculer et nous pourrions finir par écoper de la même purge que celle de l'an passé...Ce qui nous achèverait![99]

Presque jusqu'à la fin, Williamson se tint coi. En octobre 1915 cependant, il prit le devant de la scène et provoqua une crise qui donna le coup de grâce au Club. Sir Edmund Walker, qui était à la fois président de l'Art Museum et du Musée des beaux-arts s'était rendu à l'exposition du Club et avait confié à son journal que

... comme d'habitude, les oeuvres de ceux qui sont canadiens et qui travaillent à l'étranger (ou en dehors de l'O.S.A.) présentaient seules un intérêt, et c'est ce qui fait la qualité de l'ensemble. Sans elles, on ne remarquerait peut-être pas le travail d'Horatio Walker, de James Wilson Morrice, d'Ernest Lawson, d'Arthur Crisp, de Franklin Brownell, de Clarence Gagnon, de Suzor-Coté, etc.[100]

Bien que Walker n'ait apparemment rien dit à Williamson au sujet de l'exposition ou d'achats éventuels, ce qu'il pensait du Club était connu de tous. Plusieurs semaines plus tard, il reçut une lettre injurieuse de Williamson lui reprochant sa vision myopique des réussites du Club. "Nous avons accompli beaucoup plus que ça, Sir Edmund, bien que vous l'ignoriez et, en toute franchise, nous ne nous sommes jamais attendus à ce que vous le sachiez."[101]

Au cours des mois suivants, plusieurs lettres du même style furent échangées et Horatio Walker fut entraîné lui aussi dans la controverse. Aucun des Walkers ne souhaitaient poursuivre la discussion mais il semble que Williamson ait éprouvé quelque difficulté à s'assagir. Il rallia Archibald Browne à sa cause et ne consentit à faire quelques excuses qu'à contrecoeur.[102] Dégoûté de toute cette affaire et probablement fatigué par la politicaillerie du Club, Horatio Walker abandonna la présidence. On présume que personne ne voulut ou ne put le remplacer et le Club cessa tout bonnement de fonctionner.

Ernest Lawson. *Winter on the River*. 1907. Oil on canvas/Huile sur toile, 84 x 102 cm. Whitney Museum of American Art. Photo: Geoffrey Clements

PART III

A final factor that contributed to the Club's demise was, ironically, its success as a catalyst for artistic change. From 1900 through World War I, the Canadian artistic scene experienced an ever-mounting level of activity and change. The Club was the first group which presented any of this to the Canadian public. Though not all of the change can be attributed to the Club's example, its importance in the process cannot be doubted.

The most direct and obvious beneficiary of the Club's activity was, strangely enough, the Ontario Society of Artists. Following the 1907 secession, the O.S.A. underwent a shakeup, both in its leadership and its membership. Early in 1908, a new, more progressive executive came to power. Wyly Grier became the president, C.W. Jefferys the vice-president, and George Reid and Fred Brigden became members of the executive council. "We are...setting out upon a new career, based on internal reform...," declared Grier.[103] The first reform was a revision of the O.S.A.'s constitution and bylaws. The next was a more rigorous selection of works accepted for the annual exhibition. Several prominent older members were so upset by these changes that they submitted their resignations. Thomas Mower Martin, for instance, denounced them for:

> ...the injustice of throwing out the works of the older members when they are fully up to the standard on which they were made members, because of some new ideas on the subject of painting introduced by those who have since entered the Society.[104]

For every member lost, more and younger members were enrolled. J.E.H. Macdonald joined in 1909 and, within six years, Lawren Harris, Arthur Lismer, Tom Thomson and A.Y. Jackson were also members. Macdonald and Harris even sat on the executive council. The society's reforms were successful enough that, in 1912, when the Canadian Art Club made offers of membership to Grier, Jefferys and J.W. Beatty, they were declined.[105] Attendance and sales from the annual exhibition also started to increase. In 1915, over 5000 people attended, apparently establishing a new record, more than twice the greatest attendance for a Club exhibition.[106]

The O.S.A.'s encouragement of its future Group of Seven members was important in the short term because it re-established it as the centre of activity. Works produced by these members created a strong impression on the press. This showed up in scattered reviews of later Club exhibitions, in which writers expressed their desire for "colourful works of the more modern school."[107] The Club's record for encouraging young artists was certainly more ambiguous. One critic wrote of its leading members that:

> ...the first thing that strikes one about these men is that most of them are middle-aged — rather late in life to be the torchbearers of a new revolution.[108]

This rather damning judgement is only partly fair. The "revolution" led by the Club was more one of public consciousness than of art *per se*. The Club itself never claimed otherwise. It had, of course, artistic

103
Letter, E. Wyly Grier to R.F. Gagen, 10 March 1908, OA OSA, Box 1, MU2250.

104
Letter, Thomas Mower Martin to R.F. Gagen, 10 March 1908, OA OSA, Box 1, MU2250.

105
Letters, C.W. Jefferys, E.W. Grier and J.W. Beatty to Edmund Morris, 12, 15 and 18 January 1912, AGO EMLB.

106
President's Annual Report, Ontario Society of Artists, 1915, OA OSA, CUB 706 On8.8.

107
Irene B. Wrenshall, "The Field of Art." *Toronto Sunday World*, 3 May 1914, p.5.

108
Graham Campbell McInnes, "Art and Philistia...." *University of Toronto Quarterly*, July 1936, p.522.

TROISIÈME PARTIE

Ironiquement, un dernier facteur devait contribuer à la fin du Club: ce fut son succès même et le bouleversement artistique qu'il entraîna. Depuis 1900 et durant toute la première guerre mondiale, la vie artistique canadienne avait été témoin d'activités et de transformations croissantes. Le Club fut le premier groupe à représenter ce phénomène auprès du public canadien. Bien que tout ce changement ne puisse pas être uniquement attribué à l'exemple du Club, l'importance du rôle qu'il a joué ne saurait être sous-estimée.

Aussi étrange que cela puisse sembler, l'Ontario Society of Artists fut la première à bénéficier directement des activités du Club. Après la sécession de 1907, l'O.S.A. subit une profonde restructuration tant au niveau de ses dirigeants que de ses membres. Au début de 1908, un nouveau conseil d'administration, plus éclairé, prenait le pouvoir. Wyly Grier fut nommé président, C.W. Jefferys vice-président, et George Reid et Fred Brigden devinrent membre de l'exécutif. "Nous nous embarquons dans une nouvelle carrière, basée sur des réformes internes...." déclarait Grier.[103] La première de ces réformes fut la révision de la constitution et des réglements de l'O.S.A. La suivante exigeait une sélection plus rigoureuse des oeuvres admises à l'exposition annuelle.

Plusieurs artistes, membres importants et de longue date, furent tellement dérangés par ces changements qu'ils soumirent leur démission. Thomas Mower Martin, par exemple, dénonçait:

> *l'injustice qui consiste à rejeter les oeuvres des membres anciens, tout à fait conformes aux normes d'après lesquelles ils sont devenus membres — au nom de certaines idées nouvelles introduites par les derniers arrivés à la Société.*[104]

Mais pour chaque membre perdu, un nombre toujours croissant de nouveaux membres étaient recrutés. J.E.H. Macdonald, en 1909; en l'espace de six ans: Lawren Harris, Arthur Lismer, Tom Thomson et A.Y. Jackson. Macdonald et Harris siégèrent même au conseil exécutif. Les réformes de la Société remportèrent un succès tel qu'en 1912, lorsque le Canadian Art Club invita Grier, Jefferys et J.W. Beatty à se joindre à lui, ils se permirent de refuser.[105] Le succès des expositions annuelles et les recettes commencèrent à augmenter. En 1915, plus de 5 000 visiteurs défilèrent, établissant ainsi un nouveau record,[106] qui faisait plus que doubler le nombre précédemment atteint par le Club.

Le soutien que l'O.S.A. apportait aux membres du futur Groupe des Sept fut important à court terme et lui permit de se rétablir au centre des activités artistiques. Les oeuvres de ses membres firent une forte impression sur la presse. Dans les revues critiques consacrées aux expositions du Club, on relève ici et là le désir de voir les tableaux colorés de l'école moderne."[107] Le rôle du Club envers les jeunes artistes prêtait certainement à confusion. Un critique écrivit au sujet de ses membres les plus importants:

> *la première chose qui frappe au sujet de ces hommes, c'est que la plupart sont d'âge moyen — un peu trop vieux pour porter le flambeau d'une nouvelle révolution.*[108]

103
Lettre d'E. Wyly Grier à R.F. Gagen, 10 March 1908, OA OSA, Box 1, MU2250.

104
Lettre de Thomas Mower Martin à R.F. Gagen, 10 March 1908, OA OSA, Box 1, MU2250.

105
Lettres de C.W. Jefferys, d'E.W. Grier et de J.W. Beatty à Edmund Morris, 12, 15 and 18 January 1912, AGO EMLB.

106
President's Annual Report [Rapport annuel du président], Ontario Society of Artists, 1915, OA OSA, CUB 706 On8.8.

107
Irene B. Wrenshall, "The Field of Art." *Toronto Sunday World*, 3 May 1914, p.5.

108
Graham Campbell McInnes, "Art and Philistia...." *University of Toronto Quarterly*, July 1936, p.522.

preferences, especially for low-toned, atmospheric styles. It aimed at exhibiting artistic excellence, but this was so loosely defined it was a secondary ambition. Most critics agreed that the Club did succeed on both counts. They would also, likely, have questioned whether encouragement of young artists was the ultimate measure of success. Even in this regard, the Club was not completely wanting. A third of its exhibitors were as young as the member of the Group of Seven and some of them, like Clapp, Gagnon and Lawson, were then as artistically progressive. All, though, were from outside Toronto and thus had a lower artistic profile than the very visible members of the Group.

The Art Museum of Toronto (now the Art Gallery of Ontario) was another institution that was only coming into its own at the time of the Club's demise. Its maturation had been a very long and difficult one. During the 1890s, the O.S.A. tried without success to establish an art museum, and George Reid led another attempt in 1900. A museum committee was established and headed by Sir Edmund Walker, President of the Canadian Bank of Commerce. Its members were mainly prominent laymen such as D.R. Wilkie, E.F.B. Johnston, Sir Edmund

William H. Clapp. *The Three Bathers, Cuba.* 1915. Oil on canvas / Huile sur toile, 51.3 x 61.6 cm. The National Gallery of Canada

Ce jugement plutôt sévère n'est juste qu'en partie. La "révolution" que fit le Club portait plus sur l'éveil du grand public que sur l'art en soi. Le Club lui-même ne s'était jamais réclamé d'une autre lutte. Il avait bien entendu ses préférences pour les effets d'atmosphère et les gammes chromatiques assourdies; il aspirait à exposer des oeuvres de haute qualité artistique, mais tout était si vaguement défini que cela devenait secondaire. La plupart des critiques s'entendaient pour affirmer que le Club avait réussi sur tous les plans. Ils se seraient aussi probablement demandé si l'encouragement des jeunes artistes constituait la mesure ultime du succès. Et même à cet égard, le Club s'en sortait honorablement. Un tiers des artistes exposés étaient aussi jeunes que les membres du Groupe des Sept, et certains d'entre eux tels Clapp, Gagnon et Lawson étaient alors tout aussi avancés qu'eux sur le plan artistique. Tous cependant venaient de l'extérieur de Toronto et pâlissaient en regard des membres très remarqués du Groupe.

À l'époque, l'Art Museum of Toronto (maintenant l'Art Gallery of Ontario) était encore une institution en devenir. Son émergence avait été particulièrement longue et douloureuse. Au cours des années 1890, l'O.S.A. avait tenté en vain d'établir un musée des beaux-arts. George Reid avait lancé une seconde tentative en 1900. Un comité avait été établi, dirigé par Sir Edmund Walker—président de la Banque canadienne de commerce. La plupart de ses membres étaient des personnages importants tels D.R. Wilkie, E.F.B. Johnston, Sir Edmund Osler, James Mavor, Chester Massey, Sir Henry Pellatt et Frank Darling. Reid et Edmund Morris représentaient les artistes. Le comité avait tout d'abord projeté de bâtir sur un terrain appartenant à l'Université de Toronto. Plusieurs dons substantiels furent recueillis au cours des années suivantes, mais le montant total ne suffisait pas à l'acquisition d'un édifice ou d'une collection.

En 1903, Madame Goldwin Smith offrit sa maison, The Grange, à condition qu'elle et son mari en aient l'usufruit. On dut procéder à certains arrangements temporaires jusqu'à son extinction. Et en 1906, le comité organisait sa première exposition. Consacrée aux oeuvres des peintres de l'école de Glasgow, elle eut lieu dans les salles de l'O.S.A. qui donnaient sur King Street. Quand la nouvelle bibliothèque de référence des beaux-arts ouvrit ses portes, on disposait au troisième étage de plusieurs pièces spacieuses, éclairées par le haut et de belles proportions, et on les mit à la disposition du Musée. En 1909, on y présenta tout d'abord des "chefs d'oeuvre" européens empruntés aux collectionneurs de Toronto. L'exposition du Canadian Art Club eut lieu en janvier 1910. C'était la première manifestation du genre dans les nouveaux locaux du Musée. À la mort de Goldwin Smith en 1910, la Grange fut aménagée en musée. Un conservateur permanent fut nommé et, en quelques années, tout fut prêt. Le nouvel édifice remporta un vif succès et devint rapidement le point de mire des activités artistiques de l'endroit. Sa réussite fut telle qu'on dut procéder plusieurs fois à son agrandissement, en 1918 et en 1926.

Rivalisant moins directement avec le Club, mais également capables

Osler, James Mavor, Chester Massey, Sir Henry Pellatt and Frank Darling. Reid and Edmund Morris represented artists. The committee's original plan was to build on land owned by the University of Toronto. A few large donations were received during the next few years, but were insufficient for either a building or a collection.

In 1903, however, Mrs. Goldwin Smith offered her home, The Grange, as a museum, subject to her and her husband's life interest. Temporary arrangements had to be made in the interim before the bequest came into effect. In 1906, the committee organized its first exhibition, works by the Glasgow School of painters, in the King Street rooms of the O.S.A. When the new beaux-arts Public Reference Library opened, several large, skylit, well-proportioned rooms on the third floor were not immediately needed and were offered to the Museum. They opened with an exhibition of European "masterworks" from local Toronto collections in 1909. The Canadian Art Club exhibition, in January 1910, was the first society show in the Museum's new quarters. When Goldwin Smith died, in 1910, The Grange was remodelled to function as a museum. A permanent curator was appointed and, in a few years, everything was ready. The new museum was a great success and quickly became a major focus for local artistic activities. It was so successful that its quarters were expanded in 1918 and 1926.

Not in such direct competition with the Club but still able to divert attention from it were organizations like the Art Association of Montreal, the Royal Canadian Academy and the National Gallery of Canada. From 1909 through 1912, the A.A.M. was building a handsome new beaux-arts museum, designed by Edward and William Maxwell. Most of the city's serious collectors were involved in the process and memberships and public interest grew quickly.[109] In the first year the building opened, free attendance increased nearly ninefold.[110] Despite its national aims, links in Montreal, and its exhibition there, new Club members never really engaged the sympathies of the Montreal collecting community. In 1907, it was discussed that they should be invited to join but, in the end, only David Morrice and James Ross had even a minor Club connection.[111]

Relations between the R.C.A. and the members of the Club were always somewhat uneasy.[112] Both groups had national aspirations and more than two-thirds of the Club's exhibitors were also Associates or full Academicians. Delicate diplomacy was necessary to maintain a balance between their respective interests. The Academy continued as a major place for artists to exhibit. Its members concentrated their efforts on annual exhibitions and well-received representative exhibitions sent to the U.S. and England. A course of internal reform, started by George Reid in 1906 and then continued by Brymner, also broadened its interests. The most important of the latter was the National Gallery.

The Gallery and the Academy had been closely linked since their creation in 1880.[113] The government, however, had never adequately funded the Gallery. It became a somnolent institution, housing the

109
Many of the A.A.M. members were also involved in the Montreal Art Club, founded in 1912.

110
Pepall, *Building a Beaux-Arts Museum*, p.84.

111
Letter, Homer Watson to Edmund Morris, 11 June 1907, AGO EMLB. Letter, William Brymner to Edmund Morris, 11 November 1909, AGO EMP. In the latter there is some discussion of a misunderstanding that James Ross would pay for the Montreal exhibition out of his own pocket.

112
On the R.C.A. see Rebecca Sisler, *Passionate Spirits*. Toronto: Clarke, Irwin and Co. Ltd., 1980.

113
On the history of the gallery see Boggs, *The National Gallery*; Charles C. Hill, *To Found a National Gallery*. Ottawa: The National Gallery of Canada, 1980; Reid, *Our Own Country Canada*, chapter 10.

109
De nombreux membres de l'A.A.M. participaient également aux activités du Montreal Art Club fondé en 1912.

110
Pepall, *Building a Beaux-Arts Museum*, p.84.

111
Lettre de Homer Watson à Edmund Morris, 11 June 1907, AGO EMLB. Lettre de William Brymner à Edmund Morris, 11 November 1909, AGO EMP. Cette dernière lettre fait état d'un malentendu selon lequel James Ross croyait devoir payer de sa poche pour l'exposition de Montréal.

112
Au sujet de la R.C.A. voir Rebecca Sisler, *Passionate Spirits*. Toronto: Clarke, Irwin on and Co. Ltd., 1980.

113
Pour l'histoire de la galerie voir Boggs, *The National Gallery*; Charles C. Hill, *To Found a National Gallery*. Ottawa: The National Gallery of Canada, 1980; Reid, *Our Own Country Canada*, chapter 10.

d'en détourner l'attention, il y avait encore des organismes comme l'Art Association of Montreal, la Royal Canadian Academy et le Musée des beaux-arts du Canada. De 1909 à 1912, l'A.A.M. érigeait un bâtiment de belle allure destiné à accueillir le musée des beaux-arts et conçu par Edward et William Maxwell. La plupart des collectionneurs sérieux de la ville participèrent au projet, et le nombre de membres grossit rapidement en même temps que l'intérêt public.[109] Durant la première année d'ouverture du musée, les visites gratuites augmentèrent presque de neuf fois.[110] En dépit de ses objectifs nationaux, de ses liens avec Montréal, et des expositions organisées par lui, les membres du Club ne s'attirèrent jamais vraiment les sympathies des collectionneurs montréalais. On envisagea bien en 1907 de les inviter à se joindre au Club, mais finalement, seuls David Morrice et James Ross entretenaient-ils quelques liens avec lui.[111]

Les relations qui existaient entre la R.C.A. et les membres du Club restaient tendues.[112] Les deux groupes avaient des aspirations nationales et plus des deux-tiers des artistes qui exposaient avec le Club faisaient également partie de l'Academy à titre de membres associés ou de droit. Une grande diplomatie était nécessaire pour maintenir un certain équilibre entre leurs priorités respectives. L'Académie demeurait un lieu important d'exposition. Ses membres concentraient leurs efforts sur les événements annuels, et les expositions représentatives bien reçues étaient envoyées aux États-Unis et en Angleterre. Une série de réformes internes amorcées par George Reid en 1906 et poursuivie par Brymner contribua également à élargir le champ de ses intérêts. Le plus important d'entre eux était certainement le Musée des beaux-arts.

Le Musée et l'Académie étaient étroitement liées depuis leur création en 1880.[113] Le gouvernement n'avait toutefois jamais subventionné suffisamment le Musée, qui devint une institution léthargique; elle abritait toutes les toiles présentées pour l'admission des nouveaux académiciens ainsi que quelques oeuvres étrangères. L'Académie avait bien réclamé de temps à autres l'augmentation de ses subventions, mais on ne la lui avait jamais accordée et elle s'était fatiguée de toujours quémander. En 1906, George Reid soumit un rapport énergique au gouvernement; il faisait état des fonds insuffisants que recevait le Musée, de ses locaux et de son organisation lamentables. Il recommandait la création d'un conseil consultatif de membres associés et l'établissement d'un comité conjoint d'Académiciens chargés de rectifier la situation. Il recommandait enfin la nomination d'un conservateur à plein temps.

En avril 1907, le gouvernement réagit en créant le Conseil consultatif des Arts, composé de trois membres. Il eut d'abord à sa tête Sir George Drummond, suivi de Sir Edmund Walker. Le Conseil reçut des fonds de plus en plus importants et à intervalle régulier pour couvrir les activités du musée et l'enrichissement de sa collection. En 1910, Eric Brown fut engagé comme conservateur à plein temps. En 1912, le musée emménagea dans l'aile Est du nouveau Victoria Memorial Museum. Brown et Walker s'engagèrent activement à étoffer la collection européenne. En 1912, ils commencèrent à s'orienter vers l'acquisition

Academy's diploma painting collection and a few foreign works. The Academy had requested increased funding from time to time but never received it, and had grown tired of asking. In 1906, George Reid made a forceful report to the government on the gallery's poor funding, housing and general organization. He recommended the creation of an advisory council of interested laymen and a cooperating committee of Academicians to rectify the situation. He also advised the appointment of a full-time curator.

In April 1907, the government responded by creating the Advisory Arts Council, composed of three members. It was headed first by Sir George Drummond and then by Sir Edmund Walker. The Council received regular and increasing appropriations for both gallery activities and for development of the collection. In 1910, it hired a full-time curator, Eric Brown, and in 1912, moved into better quarters in the east wing of the new Victoria Memorial Museum. Brown and Walker were very active in building the European collection and, by 1912, were starting to focus their Canadian purchases on works by the members of the emerging Group of Seven. In 1913, the Gallery was formally recreated by an Act of Parliament which severed it completely from the R.C.A. Although its budget was slashed during the war, by then it had embarked on a new course and had forged strong links with the future in Canadian art.

de toiles canadiennes exécutées par les membres du jeune Groupe des Sept. En 1913, le Musée était officiellement recréée par la force d'une loi parlementaire qui la séparait complètement de la R.C.A. Bien que son budget ait été fortement réduit durant la guerre, le Musée s'était tracée une nouvelle voie et avait établi de solides liens avec ce qui devait représenter l'avenir de l'art canadien. ❧

CONCLUSION

What, in summary, can be said about the Canadian Art Club? How important was it for art during the Laurier period? How relevant is it today? Were its ideals misconceived and its efforts misdirected? How, in particular, does it compare to the Group of Seven?

The answers to these questions are not at all simple. This essay has tried to show the importance and priority of the Club as a stimulus for institutional change and national pride during the Laurier period. It never aimed for artistic change, though it was not hostile toward it, and in fact encouraged it through the influence of Cullen and Morrice on members of the Group of Seven. By the standard of its time, the Club achieved its aim of artistic excellence. Even today, nearly half its members merit major treatment in texts on Canadian art. With the exception of George Reid and Ozias Leduc, the major Canadian artists of the time all exhibited with it. On the other hand, most of the works it showed do seem more dated than those of the Group of Seven, more a part of the nineteenth than of the twentieth century. Their lack of colour accounts for much of this. In their earnestness, lack of cynicism and worship of nature, however, both the Club and the Group seem clearly part of the past.

When it comes to questions of nationality, the answers are equally complex. The Club's financial and political fragility prevented it from realizing all its national ambitions. Its artistic elitism gradually worked against it. Its emphasis on the "individual outlook" and vagueness over who or what was Canadian did not adapt well to later national mythologizing. This final weakness, though, is also the Club's greatest strength. By avoiding reductive definitions of nationality, yet demonstrating national pride, the Club becomes an attractive model for a pluralist, multicultural Canada.

CONCLUSION

En résumé, que dire du Canadien Art Club? En quoi a-t-il contribué à la vie artistique durant la période de Laurier? Peut-il encore nous intéresser aujourd'hui? Ses idéaux étaient-ils mal conçus? ses efforts mal orientés? Surtout, comment se compare-t-il au Groupe des Sept?

Il n'existe pas de réponses simples à toutes ces questions. Nous avons tenté de démontrer la toute première importance du Club, le rôle déterminant qu'il a joué dans le changement des institutions et l'effet stimulant qu'il a eu sur notre fierté nationale durant la période de Laurier. Il ne s'était jamais donné pour but de révolutionner l'art, bien qu'il ne fût pas hostile au changement et il y contribua même grâce à l'influence qu'exercèrent Cullen et Morrice sur le Groupe des Sept. Le Club parvint à atteindre son objectif d'excellence, selon les normes de son temps. Aujourd'hui encore, près de la moitié de ses membres occupent une place de choix dans les textes traitant d'art canadien. À l'exception de George Reid et d'Ozias Leduc, tous les artistes canadiens importants de l'époque exposèrent avec lui. Il faut admettre cependant que la plupart des oeuvres en question résistent moins bien à l'épreuve du temps que le Groupe des Sept. Par le traitement des couleurs, elles appartiennent plus au dix-neuvième qu'au vingtième siècle. Néanmoins, par leur honnêteté, leur absence de cynisme et leur culte de la nature, le Club et le Groupe se réclament tous deux clairement du passé.

Quand on aborde la question d'identité nationale, les réponses sont tout aussi complexes. La précarité financière et politique du Club l'empêcha de réaliser toutes ses aspirations nationales. Son élitisme artistique allait aussi graduellement lui nuire. L'importance qu'il accordait à une vision individuelle et sa perception vague de ce qui était proprement canadien se prêta peu à la mythologie nationale qui devait suivre. Cette dernière faiblesse est peut-être aussi la plus grande force du Club. En évitant toute définition réductrice de la notion de nationalité tout en faisant preuve de fierté nationale, le Club devient le modèle intéressant d'un Canada pluraliste et multiculturel.

CANADIAN ART CLUB BIOGRAPHIES

WALTER SEYMOUR ALLWARD (1876 - 1955). Most prominent Toronto sculptor of his generation. Born in Toronto. Trained as carpenter and architectural draughtsman. Studied painting with William Cruikshank and sculpture with Emanuel Hahn. Also studied sculpture in London and Paris. Showed influence of Auguste Rodin. Known for busts and public monuments: Boer War (Toronto), 1910, Baldwin and Lafontaine (Ottawa), 1912, Alexander Graham Bell (Brantford), 1917, Canadian War Memorial (Vimy Ridge), 1936, and William Lyon Mackenzie (Toronto), 1937. Founding member of Arts and Letters Club. A.R.C.A., 1903. R.C.A., 1914. Full member Canadian Art Club, 1909.

WILLIAM EDWIN ATKINSON (1862 - 1926). Pastoral landscape painter in tradition of Barbizon and Hague schools. Born in Toronto. Studied at Ontario School of Art with John Fraser and Robert Harris, at Pennsylvania Academy of Fine Arts with Thomas Eakins, 1883-84, and in Paris, at Académies Julian and Delance, 1889-90. Friend of Paul Peel and Curtis Williamson. Part of anti-Gauguin faction at Pont-Aven, 1890. Often worked later in Holland, Belgium and England. Based in Toronto. O.S.A., 1892 -1909. A.R.C.A., 1894. Founding member of Canadian Art Club, 1907.

GEORGE BRANT BRIDGMAN (1864-1943). Figure and landscape painter, lecturer and author of texts on anatomical drawing. Born near Byng, Haldimand County, Ontario. Son of portrait painter John Wesley Bridgman and supposed descendent of Chief Joseph Brant. Studied at Ontario School of Art and in Paris, at École des Beaux-Arts with Gérôme, c. 1883-87. A.R.C.A., 1891-92. Worked in Buffalo, N.Y., 1890's, and afterwards in New York, as lecturer at Art Students League. Gained wide reputation for books on anatomical illustration. Guest exhibitor with Canadian Art Club, 1912.

JOSEPH ARCHIBALD BROWNE (1864-1948). Landscape painter. Born in Liverpool, England of Scottish parents. Raised in Blantyre, Scotland. Apprenticed to a bank. Studied at Glasgow School of Art, with Robert Macaulay Stevenson, a follower of Corot, 1882-84, and briefly in Paris, 1888. Settled in Toronto and sold insurance. Took up art again and studied with William Cruikshank, late 1890s. A.R.C.A., 1898. R.C.A., 1919. O.S.A., 1907. Founding member of both Arts and Letters Club and Canadian Art Club. Later moved to Montreal and finally near Lancaster, Ontario.

PELEG FRANKLIN BROWNELL (1857-1946). Genre and landscape painter. Born in New Bedford, Massachusetts. Studied at Boston Museum of Fine Arts School with Thomas Wilmer Dewing and, in Paris, at Académie Julian, with Bouguereau and, later with Léon Bonnat. Settled in Ottawa, 1886, and taught thereafter at Ottawa School of Art. Worked in realist style but, after 1900, showed increasing impressionist influences. A.R.C.A., 1894. R.C.A., 1895. O.S.A., 1899-1907. Awarded bronze medal at Paris Salon, 1900. Founding member of Canadian Art Club, 1907.

WILLIAM BRYMNER (1855-1925). Figure and landscape painter. Born in Greenock, Scotland. Settled in Canada, 1857, and in Ottawa, 1870, where his father became Dominion Archivist. Studied architecture. Studied in Paris, at Académie Julian, with Bouguereau and Robert-Fleury, 1876-79, and worked in France and England until 1885. Returned to Montreal and was an important teacher at Art Association of Montreal, 1886-1921. A.R.C.A., 1883. R.C.A., 1886. O.S.A., 1886-91. Awarded gold medal at Pan American Exposition, Buffalo, 1901, and silver medal at Louisiana Purchase Exhibition, St. Louis, 1904. President of Royal Canadian Academy, 1909 - 1917. Guest exhibitor with Canadian Art Club, 1908, and full member, 1909.

WILLIAM HENRY CLAPP (1879-1954). Landscape painter. Born in Montreal. Studied at Art Association of Montreal with William Brymner and, in Paris, at Académies Julian and Colarossi, 1904-08. Returned to Montreal and worked there until 1917. Made several trips to Cuba. Strongly influenced by impressionism and neo-impressionism. Settled in California, 1917. Guest exhibitor with Canadian Art Club, 1912, and full member, 1913.

ARTHUR WATKINS CRISP (1881-1974). Genre and mural painter. Born in Hamilton, Ontario. Studied at Hamilton School of Art with John S. Gordon and, in New York, at Art Students League, with Robert Henri, John H. Twachtman, Kenyon Cox, etc. Friend of John W. Russell. Early works influenced by American impressionists and Ashcan School realists. Worked in New York. Known for many murals, mainly in U.S. Major Canadian mural, "The Spirit of the Printed Word," is in House of Commons Reading Room, Ottawa. Active in many American art societies. Later lived in Maine. Guest exhibitor with Canadian Art Club, 1915.

MAURICE GALBRAITH CULLEN (1866-1934). Landscape painter. Born in St. John's, Newfoundland. Raised in Montreal. Studied sculpture at Monument National with Louis-Philippe Hébert, 1884-87, and painting in Paris at Académie Julian and Ecole des Beaux-Arts, 1888-92. Met many other Canadians in Paris and was influenced by impressionism. Exhibited in the Salons. Worked both in Europe and in Canada, often with Morris, Brymner and Morrice, 1895-1902. Worked only in Canada thereafter. Taught at Art Association of Montreal and exhibited widely. Awarded bronze medal at Pan American Exposition, Buffalo, 1901. A.R.C.A., 1899. R.C.A., 1907. Guest exhibitor with Canadian Art Club, 1908-09, and full member, 1910.

CLARENCE ALPHONSE GAGNON (1881-1942). Landscape painter, etcher and illustrator. Born and raised in Montreal. Studied at Art Association of Montreal, with William Brymner, 1897-1900, and in Paris, at Académie Julian, 1904-05. Travelled in France and Italy. Returned to Canada, 1909, and migrated regularly thereafter between Montreal, Baie Saint Paul and Paris. Awarded gold medal at Louisiana Purchase Exhibition, St. Louis, 1904. A.R.C.A., 1910. R.C.A., 1922. Guest exhibitor with Canadian Art Club, 1909, and full member, 1910.

JAMES LILLIE GRAHAM (1873-c.1965). Landscape and animal painter. Born in Belleville, Ontario. Raised in Toronto. Studied at Art Association of Montreal with William Brymner and Edmond Dyonnet, 1894-98, in London, at Slade School, in Paris, at Académie Julian and also in Antwerp. Worked in Europe for over a decade and exhibited regularly in Canada. Later lived in Montreal, A.R.C.A., 1894. Awarded Jessie Dow Prize for painting at Art Association of Montreal, 1910. Guest exhibitor with Canadian Art Club, 1910-12.

CHARLES PAUL GRUPPE (1860-1940). Landscape painter. Born in Picton, Ontario. Raised in Rochester, N.Y. Mainly self-taught, both in Rochester and in Holland. Lived in Europe, 1889-1914, and was associated with Hague School. Exhibited and joined many art societies in America. Awarded two silver medals at Louisiana Purchase Exhibition, St. Louis, 1904. Had one-man show at Art Association of Montreal, 1913. Guest exhibitor with Canadian Art Club, 1913.

ROBERT HARRIS (1849-1919). Genre and portrait painter. Born in Wales. Settled in Charlottetown, 1856. Studied in Boston with William Rimmer and Thomas Wilmer Dewing, 1872-73, in Lon-

BIOGRAPHIES DU CANADIAN ART CLUB

WALTER SEYMOUR ALLWARD (1876-1955). Sculpteur torontois le plus important de sa génération. Né à Toronto. Formation de charpentier et de dessinateur industriel. Étudie la peinture avec William Cruikshank et la sculpture avec Emanuel Hahn. Étudie également la sculpture à Paris et à Londres. Influence de Rodin. Connu pour ses bustes et ses monuments publics: Boer War (Toronto) 1910, Baldwin et Lafontaine (Ottawa) 1912, Alexander Graham Bell (Brantford) 1917, Canadian War Memorial (Vimy Ridge) 1936, et William Lyon Mackenzie (Toronto) 1937. Membre fondateur de l'Arts and Letters Club, de l'A.R.C.A. en 1903, de l'A.R.C. Membre titulaire du Canadian Art Club, 1909.

WILLIAM EDWIN ATKINSON (1862-1926). Peintre de pastorales fidèles à la tradition des écoles de Barbizon et de la Haye. Né à Toronto. Étudie à l'Ontario School of Art avec John Fraser et Robert Harris; à la Pennsylvania Academy of Fine Arts avec Thomas Eakins (1883-84); et à Paris, aux Académies Julian et Delance (1889-90). Ami de Paul Peel et de Curtis Williamson. A participé à la faction anti-Gauguin de Pont-Aven en 1890. Travaillera souvent en Hollande, en Belgique et en Angleterre. Établi à Toronto. O.S.A., 1892-1909. A.R.C.A., 1894. Membre fondateur du Canadian Art Club, 1907.

GEORGE BRANT BRIDGMAN (1864-1943). Peintre paysagiste et figuratif, conférencier et auteur de textes sur le dessin anatomique. Né près de Byng, dans le comté de Haldimand en Ontario. Fils du portraitiste John Wesley Bridgman et descendant présumé du Chef Joseph Brant. Étudie à l'Ontario School of Art et à l'École des beaux-arts de Paris avec Gérôme de 1883 à 1887 environ. A.R.C.A., 1891-92. Travaille à Buffalo, N.Y. dans les années 1890 et se rend à New York où il exerce les fonctions de maître conférencier à l'Art Students League. Très renommé pour ses ouvrages sur les illustrations anatomiques. Artiste invité par le Canadian Art Club, 1912.

JOSEPH ARCHIBALD BROWNE (1864-1948). Paysagiste. Né à Liverpool de parents écossais. Élevé à Blantyre, Écosse. Apprentis-commis dans une banque. Étudie à la Glasgow School of Art sous la direction de Robert Macaulay Stevenson, admirateur de Corot (1882-84). Bref séjour à Paris en 1888. S'établit à Toronto et vend des polices d'assurance. Reprend la peinture, étudie avec William Cruikshank à la fin des années 1890. A.R.C.A., 1898. R.C.A., 1919. O.S.A., 1907. Membre fondateur à la fois de l'Arts and Letters Club et du Canadian Art Club. S'installa à Montréal puis près de Lancaster en Ontario.

PELEG FRANKLIN BROWNELL (1857-1946). Paysagiste et peintre de genre né à New Bedford, Massachusetts. Étudie à l'école du Boston Museum of Fine Arts sous Thomas Wilmer Dewing et à l'Académie Julian, d'abord sous Bouguereau puis sous Léon Bonnat. Établi à Ottawa en 1886, enseigne à l'Ottawa School of Art. Style réaliste qui subit l'influence grandissante des impressionnistes après 1900. Membre de l'A.R.C.A. en 1894, de la R.C.A. en 1895 et de l'O.S.A. de 1899 à 1907. Médaille de bronze au Salon de Paris en 1900. Membre fondateur du Canadian Art Club, 1907.

WILLIAM BRYMNER (1855-1925). Peintre paysagiste et figuratif. Né à Greenock, Écosse, il vient au Canada en 1857 et s'établit à Ottawa en 1870; son père occupe les fonctions d'archiviste du Canada. Étudie l'architecture, fréquente l'Académie Julian à Paris sous Bouguereau et Robert-Fleury (1876-79). Travaille en France et en Angleterre jusqu'en 1885. Retour à Montréal. Devient un maître respecté à l'Art Association of Montreal (1886-21). Membre de l'A.R.C.A. en 1883, de la R.C.A. en 1886 et de l'O.S.A. (1886-91). Médaillé d'or à la Pan-American Exposition à Buffalo en 1901. Médaillé d'argent à la Louisiana Purchase Exhibition à

Saint-Louis en 1904. Président de la Royal Canadian Academy (1909-1907). Artiste invité par le Canadian Art Club en 1908 et membre titulaire en 1909.

WILLIAM HENRY CLAPP (1879-1954). Paysagiste. Né à Montréal. Étudie à l'école de l'Art Association of Montreal sous la direction de William Brymner et aux Académies Julian et Colarossi à Paris (1904-1908). Retour à Montréal où il travaille jusqu'en 1917. Voyages à Cuba. Forte influence des impressionnistes et des néo-impressionnistes. S'établit en Californie en 1917. Artiste invité par le Canadian Art Club en 1912 et membre titulaire en 1913.

ARTHUR WATKINS CRISP (1881-1974). Peintre de genre et muraliste. Né à Hamilton, Ontario. Étudie à la Hamilton School of Art sous John S. Gordon; et à New York, à l'Art Students League, sous Robert Henri, John H. Twachtman, Kenyon Cox, etc.. Ami de John W. Russell. Influencé d'abord par les impressionnistes américains et les réalistes de l'école Ashcan. A travaillé à New York. Connu aux États-Unis pour ses murales. Oeuvre importante au Canada: "The Spirit of the Printed Word," qui se trouve dans la salle de lecture de la chambre des Communes à Ottawa. Activement engagé dans plusieurs sociétés américaines consacrées aux arts, finit ses jours dans le Maine. Artiste invité par le Canadian Art Club en 1915.

MAURICE GALBRAITH CULLEN (1866-1934). Paysagiste. Né à Saint-Jean de Terre-Neuve. Élevé à Montréal. Étudie la sculpture avec Louis-Philippe Hébert (1884-87), puis la peinture, à l'Académie Julian et à l'École des beaux-arts de Paris (1882-92). Fréquente de nombreux Canadiens à Paris et subit l'influence des impressionnistes. Expose dans les Salons. Travaille à la fois en Europe et au Canada, souvent en compagnie de Morris, de Brymner et de Morrice (1895-1902). Reste ensuite au Canada. Enseigne à l'Art Association of Montreal et participe à de nombreuses expositions. Médaillé de bronze à la Pan-American Exposition à Buffalo en 1901. Membre de l'A.R.C.A. en 1899, de la R.C.A. en 1907. Artiste invité par le Canadian Art Club (1908-1909) et membre titulaire en 1910.

CLARENCE ALPHONSE GAGNON (1881-1942). Paysagiste, graveur et illustrateur. Né et éduqué à Montréal. Étudie à l'école de L'Art Association of Montreal sous William Brymner (1897-1900) et à l'Académie Julian à Paris (1904-1905). Voyages en France et en Italie. Retour au Canada en 1909. Va-et-vient fréquents entre Montréal, Baie-Saint-Paul et Paris. Médaille d'or à la Louisiana Purchase Exhibition à Saint-Louis en 1904. Membre de l'A.R.C.A. en 1910, de la R.C.A. en 1922. Artiste invité par le Canadian Art Club en 1909 et membre titulaire en 1910.

JAMES LILLIE GRAHAM (1873-env.1965). Paysagiste et peintre animalier. Né à Belleville, Ontario. Éduqué à Toronto. Étudie à l'école de l'Art Association of Montreal sous William Brymner et Edmond Dyonnet (1894-98); à la Slade School à Londres; à l'Académie Julian et à Anvers. Travaille durant plus de dix ans en Europe et expose fréquemment au Canada. Vit ensuite à Montréal. Membre de l'A.R.C.A. en 1894. Prix Jessie Dow attribué par l'Art Association of Montreal en 1910. Artiste invité par le Canadian Art Club (1910-12).

CHARLES PAUL GRUPPE (1860-1940). Paysagiste. Né à Picton, Ontario et élevé à Rochester, N.Y. Formation autodidacte acquise à Rochester et en Hollande surtout. Séjour en Europe (1889-1914) et association avec l'école de la Haye. Nombreuses expositions. Adhère à de nombreuses sociétés artistiques aux États-Unis. Deux médailles d'argent à la Louisiana Purchase Exhibition à Saint-

don at the Slade School, with Alphonse Legros, 1877, and in Paris with Léon Bonnat, 1877-78. Introduced French academic realism to Toronto, 1879-83. Vice-President, O.S.A., 1880-81. R.C.A., 1880. Moved to Montreal, 1883, and became leading establishment portraitist. President of Royal Canadian Academy, 1893-1906. Guest exhibitor with Canadian Art Club, 1908-09.

HENRI HÉBERT (1884-1950). Sculptor. Born in Montreal. Son of Louis-Philippe Hébert. Raised in Montreal and in Paris. Studied with his father at Monument National and at Art Association of Montreal and, in Paris, at École des Arts Décoratifs and École des Beaux-Arts, 1896-1909. Returned to Montreal and taught at McGill University and Monument National. Known for portrait busts and public monuments, esp. Evangeline Monument (Grand Pré), 1920, Outremont War Memorial, 1925, and Lafontaine Monument (Montreal), 1930. A.R.C.A., 1912. R.C.A., 1922. Guest exhibitor with Canadian Art Club, 1913-15.

LOUIS-PHILIPPE HÉBERT (1850 - 1917). Most prominent Canadian sculptor of his generation. Born in Ste. Sophie d'Halifax, Quebec. Served, in Rome, as Papal zouave, 1869-71, and studied art and monuments there. Became religious wood carver, assistant to Napoléon Bourassa, 1873-79. Studied sculpture in Paris, 1879-80. On return to Canada began mature career. A.R.C.A., 1880. R.C.A., 1886. Known for Maisonneuve Monument (Montreal), 1895, Sir John A. Macdonald Monument (Ottawa), 1895, Queen Victoria Monument (Ottawa) 1901, King Edward VII Monument (Montreal), 1914, and for various figures on facade of National Assembly building (Quebec City). Guest exhibitor with Canadian Art Club, 1913-14.

WILLIAM R. HOPE (1863-1931). Landscape and marine painter. Born in Montreal into rich merchant family. Studied in Paris, 1880s, and painted in the Forest of Fontainebleau. Also studied in Holland and Italy. Travelled and worked extensively in Europe but was based in Montreal and St. Andrews, N.B. Exhibited with A.A.M. Awarded bronze medal at Louisiana Purchase Exhibition, St. Louis, 1904. A.R.C.A., 1895. R.C.A., 1902. Full member of Canadian Art Club, 1911.

EBENEEZER FORSYTH BLACKIE JOHNSTON (1850-1919). Lawyer, art collector and art critic. Born in Haddingtonshire, Scotland. Emigrated to Canada as a young man. Studied law at Osgoode Hall, Toronto. Called to Ontario Bar, 1880. Practised criminal law in Guelph and Toronto. Deputy Attorney-General of Ontario, 1885-89. Q.C., 1890. On board of Art Museum of Toronto. Lay member of Canadian Art Club. Author of many art reviews and essay on Canadian art in Shortt and Doughty's *Canada and its Provinces*.

JAMES KERR-LAWSON (1862-1939). Painter, muralist and lithographer. Born in Fifeshire, Scotland. Raised in Hamilton, Ontario. Studied in Toronto, at Ontario School of Art, 1879-80, in Rome at Accademia di Belle Arte, Académie de France and with Luigi Galli, 1880-81, and, in Paris, at Académie Julian, 1881-84. Friend of William Brymner. Worked in Ottawa, Toronto and Hamilton, 1885-87. A.R.C.A., 1885. O.S.A., 1885. Friend of Homer Watson. Returned to Europe and worked with Watson in Scotland, 1887-90. Travelled extensively in Europe and North Africa. Based in London and Florence. Friend of George Watts, Whistler and Bernard Berenson. Associated with Glasgow School of painters and International Society. Guest exhibitor with Canadian Art Club, 1912. Full member by 1914.

ERNEST LAWSON (1873-1939). Impressionist landscape painter. Born in Halifax, Nova Scotia. Lived in Kingston, Ontario, 1883-88.

Moved to United States, 1888. Studied in New York, at Art Students League, in Cos Cob, Connecticut with John Twachtman and J. Alden Weir, and in Paris, at Académie Julian, 1891-94. Tried to settle in Toronto but his impressionist style was rejected. Returned to U.S. and, by 1898, was settled in New York. Exhibited actively and became a member of The Eight. Awarded silver medal at Louisiana Purchase Exhibition, St. Louis, 1904. Exhibited in Armory Show, New York, 1913. Painted occasionally in Nova Scotia. Guest exhibitor with Canadian Art Club, 1911, and elected full member the same year.

LAURA ADELINE MUNTZ LYALL (1860-1930). Portraitist. Born in England. Settled in Muskoka, 1870. Taught school. Studied in Toronto, with J.W.L. Forster; in England, 1887, and in Paris, at Académie Colarossi, c. 1893-98. Also in Holland and Italy. A.R.C.A., 1895. O.S.A., 1891-1908. Settled in Toronto and specialized in portraits of mothers and children. Awarded medals at Pan-American Exposition, Buffalo, 1901, and Louisiana Purchase Exhibition, St. Louis, 1904. Married C.W.B. Lyall, 1915. Guest exhibitor with Canadian Art Club, 1909.

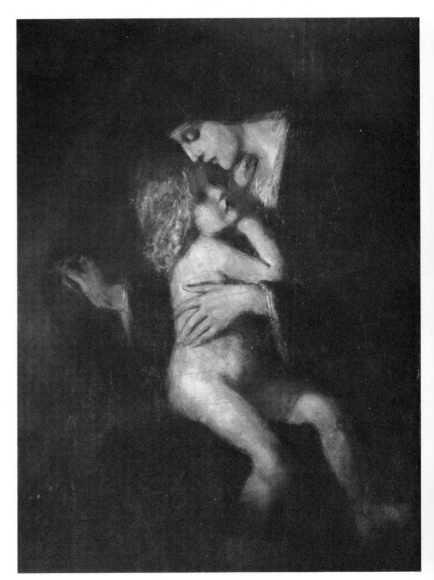

Laura Muntz Lyall. *Madonna and Child*. n.d. Oil on canvas/Huile sur toile, 99 x 76.2 cm. Collection of Sandra Lyall Smagalon. Photo: Harry Korol

Louis en 1904. Exposition exclusivement consacrée à ses oeuvres en 1913, sous l'égide de l'Art Association of Montreal. Artiste invité par le Canadian Art Club en 1913.

ROBERT HARRIS (1849-1919). Portraitiste et peintre de genre. Né au Pays de Galles et établi à Charlottetown en 1856. Étudie à Boston sous William Rimmer et Thomas Wilmer Dewing (1872-73); à Londres, à la Slade School sous Alphonse Legros (1877); et à Paris, sous Léon Bonnat (1877-78). Introduit le réalisme académique français à Toronto entre 1879 et 1883. Vice-président de l'O.S.A. (1880-81). Membre de la R.C.A. (1880). S'installe à Montréal en 1883 et devient portraitiste officiel de l'"'establishment". Président de la R.C.A. (1893-1906). Artiste invité par le Canadian Art Club (1908-1909).

HENRI HÉBERT (1884-1950). Sculpteur originaire de Montréal. Fils de Louis-Philippe Hébert. Éduqué à Montréal et à Paris. Étudie sous la direction de son père au Monument National puis à l'école de l'Art Association of Montreal; à Paris, à l'École des arts décoratifs et à l'École des beaux-arts (1896-1909). De retour à Montréal, enseigne à l'Université McGill et au Monument National. Connu par ses portraits, ses bustes et ses monuments publics (la statue d'Évangéline, Grand-Pré, 1920; le monument aux morts d'Outremont, 1925; et le monument Lafontaine de Montréal, 1930). Membre de l'A.R.C.A. en 1912 et de la R.C.A. en 1922. Artiste invité par le Canadian Art Club (1913-15).

LOUIS-PHILIPPE HÉBERT (1850-1917). Sculpteur le plus célèbre de sa génération. Né à Sainte-Sophie d'Halifax au Québec. Sert à Rome comme zouave papal (1869-71) et y étudie les arts et les monuments. Devient sculpteur sur bois, assistant de Napoléon Bourassa (1873-79). Étudie la sculpture à Paris (1879-80). De retour au Canada, entame sa carrière. Membre de l'A.R.C.A. en 1880 et de la R.C.A. en 1886. On lui doit les monuments de Maisonneuve (Montréal, 1895), de Sir John A. MacDonald (Ottawa, 1895), de la Reine Victoria (Ottawa, 1901), du Roi Edouard VII (Montréal, 1914) et les effigies de plusieurs personnages qui figurent sur la façade de l'Assemblée Nationale à Québec. Artiste invité par le Canadian Art Club (1913-14).

WILLIAM R. HOPE (1863-1931). Paysagiste et peintre de marines. Né à Montréal d'une famille de riches marchands. Étudie à Paris dans les années 1880 et peint dans la forêt de Fontainebleau. Étudie également en Hollande et en Italie. Voyage et travaille activement en Europe mais retourne à Montréal et à St-Andrews au Nouveau-Brunswick. Expose sous l'égide de l'Art Association of Montreal. Médaille de bronze à la Louisiana Purchase Exhibition à Saint-Louis, 1904. Membre de l'A.R.C.A. en 1895 et de la R.C.A. en 1902. Membre titulaire du Canadian Art Club en 1911.

EBENEEZER FORSYTH BLACKIE JOHNSTON (1850-1919). Avocat, collectionneur et critique d'art. Né à Haddingtonshire en Écosse. Émigre adolescent au Canada. Étudie le droit à Osgoode Hall, à Toronto. Admis au Bareau de l'Ontario en 1880. Pratique le droit criminel à Guelph et à Toronto. Procureur général adjoint de l'Ontario (1885-89). Avocat de la Reine en 1890. Siège au conseil de l'Art Museum de Toronto. Membre associé du Canadian Art Club. Auteur de nombreuses revues critiques et essais traitant de l'art canadien et publiés dans *Canada and its Provinces* de Shortt and Doughty.

JAMES KERR-LAWSON (1862-1939). Peintre, muraliste et lithographe. Né à Fifeshire en Écosse. Élevé à Hamilton en Ontario. Étudie à Toronto, à l'Ontario School of Art (1879-80); à Rome, à l'Accademia di Belle Arte; à l'Académie de France sous Luigi Galli (1880-81); et, à Paris, à l'Académie Julian (1881-84). Ami de

William Brymner. Travaille à Ottawa, à Toronto et à Hamilton (1885-87). Membre de l'A.R.C.A. en 1885, de l'O.S.A. en 1885. Ami de Homer Watson, retourne en Europe et travaille avec lui en Écosse (1887-90). Voyages nombreux en Europe et en Afrique du nord. Réside à Londres et à Florence. Ami de George Watts, de Whistler et de Bernard Berenson. Est associé à la Glasgow School et à l'International Society. Artiste invité par le Canadian Club en 1912; membre titulaire, 1914.

ERNEST LAWSON (1873-1939). Paysagiste impressionniste. Né à Halifax, Nouvelle-Écosse. Vit à Kingston en Ontario (1883-88). S'établit aux États-Unis en 1888. Étudie à New York, à l'Art Students League; à Cos Cob au Connecticut sous John Twachtman et J. Alden Weir; et à Paris, à l'Académie Julian (1891-94). Essaie de s'établir à Toronto, qui rejette son style impressionniste. Retourne aux États-Unis et s'installe à New York en 1898. Nombreuses expositions. Devient membre des Eight. Médaille d'argent à la Louisiana Purchase Exhibition à Saint-Louis (1904). Tableaux exposés à l'Armory Show, à New York (1913). Peint parfois en Nouvelle-Écosse. Artiste invité par le Canadian Art Club en 1911, est élu membre titulaire la même année.

LAURA ADELINE MUNTZ LYALL (1860-1930). Portraitiste née en Angleterre. Vient s'établir à Muskoka en 1870. Enseigne. Étudie à Toronto sous J.W.L. Forster; en Angleterre, en 1887; à Paris, à l'Académie Colarossi aux environs de 1893-98; en Hollande et en Italie. Membre de l'A.R.C.A. en 1895, de l'O.S.A. (1891-1908). Établie à Toronto, se spécialise dans les portraits de mères et d'enfants. Médaillée à la Pan-American Exposition à Buffalo (1901), et à la Louisiana Purchase Exhibition à Saint-Louis (1904). Épouse C.W.B. Lyall en 1915. Artiste invitée par le Canadian Art Club en 1909.

NEWTON McFAUL MacTAVISH (1875-1941). Journaliste, éditeur et critique d'art. Né en Écosse, émigre au Canada dans les années 1890. Étudie à l'Université McGill. Reporter pour *The Globe* de 1896 à 1906. Directeur du *Canadian Magazine* (1906-26). Ami de nombreux artistes, écrit beaucoup à leur sujet. Auteur de *The Fine Arts in Canada* paru en 1925 et de *Ars Longa*, en 1938. S'installe à Ottawa et se joint à la Commission du service civil en 1926. Siège au conseil de la Galerie nationale du Canada.

JAMES MAVOR (1854-1925). Économiste politique et écrivain intéressé à de nombreux domaines. Né à Stranraer en Écosse. Étudie au Anderson's College et à l'Université de Glasgow. Nommé Professeur au St. Mungo's College en 1889. Ami de Lord Kelvin, de William Morris et du Prince Peter Kropotkin. Actif parmi les socialistes et dans les milieux artistiques écossais. Professeur à l'Université de Toronto en 1892, met sur pied un département de sciences politiques. Célèbre pour son *Economic History of Russia* (1914). Défenseur des Doukhobors au Canada. Soutient plusieurs jeunes écrivains tels Ernest Thompson Seton et Marjorie Pickthall. Associé à l'Art Museum de Toronto et au Royal Ontario Museum. Auteur de l'autobiographie *My Windows on the Street of the World* (1923).

JAMES WILSON MORRICE (1865-1924). Paysagiste et peintre figuratif. Né à Montréal d'une riche famille anglophone. Étudie à l'Université de Toronto (1882-86). Étudie le droit à Toronto et est admis au Barreau de l'Ontario (1886-89). Parcourt l'Europe et étudie à l'Académie Julian à Paris. Se fait de nombreux amis dans les cercles anglo-américains de Paris. Voyages fréquents en Europe et en Afrique du Nord. Jusqu'en 1914, revient fréquemment au Canada où il expose ses oeuvres. Ami de Cullen, de Morris et de Brymner vers 1900. Médaille d'argent à la Pan-American Exposition à Buffalo en 1901. Acquisitions de ses oeuvres par le Gouver-

NEWTON McFAUL MacTAVISH (1875-1941). Journalist, editor and art critic. Born in Scotland. Emigrated to Canada in 1890s. Studied at McGill University. Reporter for *The Globe*, 1896-1906. Editor of *The Canadian Magazine*, 1906-26. Friendly with many Canadian artists and wrote widely about them. Author of *The Fine Arts in Canada*, 1925, and *Ars Longa*, 1938. Moved to Ottawa and joined Civil Service Commission, 1926. On board of National Gallery of Canada.

JAMES MAVOR (1854-1925). Political economist and writer on many topics. Born in Stranraer, Scotland. Studied at Anderson's College and University of Glasgow. Appointed Professor, St. Mungo's College, 1889. Friend of Lord Kelvin, William Morris and Prince Peter Kropotkin. Active in socialist and Scottish art circles. Appointed professor, University of Toronto, 1892. Built up department of Political Science. Famous for his *Economic History of Russia*, 1914. Champion of the Doukhobors in Canada. Sponsored young writers such as Ernest Thompson Seton and Marjorie Pickthall. Active with Art Museum of Toronto and Royal Ontario Museum. Wrote autobiography, *My Windows on the Street of the World*, 1923.

JAMES WILSON MORRICE (1865-1924). Landscape and figure painter. Born in Montreal to a rich Anglophone family. Studied at University of Toronto, 1882-86. Studied law in Toronto, articled and was called to the Ontario bar, 1886-89. Travelled in Europe and began to study painting at Académie Julian. Developed wide range of friendships in Anglo-American art circles in Paris. Travelled often through Europe and North Africa. Exhibited and returned regularly for visits to Canada until 1914. Friendly with Cullen, Morris and Brymner by 1900. Awarded silver medal at Pan-American Exposition, Buffalo, 1901. Work bought by French Government, 1904-1905. Influenced by Matisse after 1909. Cut most of his ties with Canada after World War I. Founding member of Canadian Art Club, 1907.

EDMUND MONTAGUE MORRIS (1871-1913). Landscape painter and Indian portraitist. Born in Perth, Ontario. Lived in Fort Garry, Manitoba, 1872-77, where father was Lieutenant Governor. Settled in Toronto, 1877. Studied art with William Cruikshank and at Toronto Art Students League, 1889-91. Studied in New York, at Art Students League with William Merritt Chase and Kenyon Cox, 1891-92, and in Paris, at Académie Julian and École des Beaux-Arts, 1893-94. Returned to Toronto, 1896, and befriended Brymner, Cullen and Walker. A.R.C.A., 1898. Awarded bronze medal at Pan-American Exposition, Buffalo, 1901. Painted in Scotland and Holland, 1902. O.S.A., 1905-07. Often painted on Canadian prairies. Active with Arts and Letters Club and served on board of Art Museum of Toronto. Founding member and secretary, Canadian Art Club, 1907. Drowned in St. Lawrence River, near Quebec City, August 1913.

HENRY IVAN NEILSON (1865-1931). Landscape painter and etcher. Born in Cap Rouge, Quebec. Raised in northern Quebec and Labrador. Became marine engineer. Worked on C.P.R. ships sailing to the Orient. Studied at Glasgow School of Art, 1897, and in Paris, at Académie Délécluze, and in Brussels at St. Gilles Academy. Worked in Scotland and exhibited in Scottish exhibitions. Returned to Canada, 1910. Settled mainly in Quebec City, with a few short periods in Toronto before 1920. A.R.C.A., 1915. Later taught and was principal of Ecole des Beaux-Arts, Quebec City. Guest exhibitor with Canadian Art Club, 1914, and full member, 1915.

SIR EDMUND BOYD OSLER (1845-1924). Financier. Born in Bond Head, Ontario, the son of a clergyman. Brother of surgeon, Sir William Osler. Opened stockbroking firm of Osler and Hammond and was active in railway promotion. Member of Parliament, 1896-1917. President of Dominion Bank, 1901. Director of many companies. Philanthropist, especially to University of Toronto, Toronto General Hospital and Royal Ontario Museum. Knighted in 1912. Served on board of Art Museum of Toronto. Collector of Canadian paintings. Succeeded D.R. Wilkie as honorary president of Canadian Art Club, 1914-15.

ALEXANDER PHIMISTER PROCTOR (1860-1950). Animal sculptor. Born in Bozanquit, Ontario. Raised in Michigan, Iowa and Colorado. Studied in New York, at National Academy of Design and Art Students League, late 1880s. Awarded medal for animal, cowboy and Indian figures at World's Columbian Exposition, Chicago, 1893. Studied in Paris, at Académie Julian, 1893-94, and twice, independently, late 1890's. Awarded gold medal at Paris World's Fair, 1900 and Louisiana Purchase Exhibition, St. Louis, 1904. Won many public monument commissions in U.S. Full member of Canadian Art Club, 1909.

BOARDMAN ROBINSON (1876-1952). Cartoonist, illustrator, muralist and painter. Born in Somerset, Nova Scotia. Raised in Canada and in England. Studied at Massachusetts Normal Art School and in Paris, at Académie Colarossi and École des Beaux-Arts. Strongly influenced by Degas, Forain and Japanese prints. Worked as cartoonist and illustrator for many New York newspapers and magazines from 1907. Sympathetic with socialist causes and worked with John Reed. Later was known for murals, 1920s and '30s. Taught at Art Students League and in Colorado. Guest exhibitor with Canadian Art Club, 1913.

JOHN WENTWORTH RUSSELL (1879-1959) Portrait, figure and still-life painter. Born in Binbrook, Ontario. Studied at Hamilton Art School with John S. Gordon, in New York at Art Students League, c. 1900-05, and in Paris, independently. Lived in Paris for many years and exhibited there and in Canada. Settled in Toronto, c. 1930, and ran own art school. Full member of Canadian Art Club, 1909-10, but soon resigned.

MARC-AURÈLE DE FOY SUZOR-COTÉ (1869-1937). Landscape painter. Born in Arthabasca, Quebec. Trained with local religious decorator and went to Paris to study singing, 1889. Switched to painting and studied at Académies Julian and Colarossi and École des Beaux-Arts. Lived in Paris for many years and exhibited in salons. Work showed shifting influence from academic realism to Barbizon realism to impressionism. Settled in Montreal, 1908, and specialized in scenes of snow-covered river banks. A.R.C.A., 1911. R.C.A., 1914. Guest exhibitor with Canadian Art Club, 1913 and full member, 1914.

SIR BYRON EDMUND WALKER (1848-1924). Banker, collector, museum official. Born near Caledonia, Upper Canada. Raised in Hamilton. Mainly self-educated. Entered banking, 1861, and Canadian Bank of Commerce, 1868. President of C.B. of C., 1907-1924. Knighted 1910. Active with University of Toronto, Mendelssohn Choir, Guild of Civic Art, Champlain Society, National Battlefields Commission. Founder of Royal Ontario Museum. First president and board chairman of Art Museum of Toronto, 1900-1924 and National Gallery of Canada, 1909-1924. Collector of prints, paintings, rare books, oriental ceramics and fossils.

nement français (1904-1905). Influencé par Matisse après 1909. Rompt ses attaches avec le Canada après la première guerre mondiale. Membre fondateur du Canadian Club en 1907.

EDMUND MONTAGUE MORRIS (1871-1913). Paysagiste et portraitiste qui se consacre aux Indiens. Né à Perth, Ontario. Vit à Fort Garry, Manitoba (1872-77) où son père est Lieutenant-gouverneur. S'établit à Toronto en 1877. Étudie sous William Cruikshank et à la Toronto Art Students League (1889-91). Étudie à l'Art Students League de New York sous William Merritt Chase et Kenyon Cox (1891-92); à l'Académie Julian et à l'École des beaux-arts de Paris (1893-94). Retourne à Toronto en 1896 et se lie d'amitié avec Brymner, Cullen et Walker. Membre de l'A.R.C.A. en 1898. Médaillé de bronze à la Pan-American Exposition à Buffalo en 1901. Peint en Écosse, en Hollande (1902). Membre de l'O.S.A. (1905-1907). Représente les Prairies canadiennes. Participe activement à l'Arts and Letters Club et siège au conseil de l'Art Museum of Toronto. Membre fondateur et secrétaire du Canadian Art Club en 1907. Se noie dans le Saint-Laurent près de Québec en août 1913.

HENRY IVAN NEILSON (1865-1931). Paysagiste et graveur. Né à Cap-Rouge, Québec. Élevé dans le nord du Québec et au Labrador. Devient ingénieur des constructions navales et travaille sur les navires du Canadien Pacifique qui font l'Orient. Étudie à la Glasgow School of Art en 1897, à l'Académie Délécluze à Paris et à l'Académie Saint-Gilles à Bruxelles. Travaille et expose ses oeuvres en Écosse. Revient au Canada en 1910. Réside principalement à Québec et fait de brefs séjours à Toronto avant 1920. Membre de l'A.R.C.A. en 1915. Enseigne et devient directeur de l'école des Beaux-Arts de Québec. Artiste invité par le Canadian Art Club en 1914 et membre titulaire en 1915.

SIR EDMUND BOYD OSLER (1845-1924). Financier. Né à Bond Head, Ontario, fils de pasteur. Frère de l'éminent médecin, sir William Osler. Ouvre la firme de courtage Osler & Hammond et participe activement à la promotion des chemins de fer. Membre du Parlement (1896-1917). Président de la Dominion Bank en 1901. Directeur de nombreuses compagnies. Philantrope qui a beaucoup contribué à l'Université de Toronto, au Toronto General Hospital et au Royal Ontario Museum. Siège au Conseil de l'Art Museum of Toronto. Collectionneur de tableaux canadiens. Succède à D.R. Wilkie comme Président honoraire du Canadian Art Club de 1914 à 1915.

ALEXANDER PHIMISTER PROCTOR (1860-1950). Sculpteur animalier. Né à Bozanquit, Ontario. Élevé au Michigan, en Iowa et au Colorado. Étudie à la National Academy of Design and Art et à l'Art Students League à New York à la fin des années 1880. Médaillé pour ses sculptures d'animaux, de cow-boys et d'Indiens à la World's Columbian Exposition à Chicago en 1893. Étudie à l'Académie Julian à Paris (1893-94), et à deux reprises à la fin des années 90. Médaillé d'or à la Foire universelle de Paris en 1900 et à la Louisiana Purchase Exhibition à Saint-Louis en 1904. Est fréquemment commissionné et érige de nombreux monuments publics aux États-Unis. Membre titulaire du Canadian Art Club en 1909.

BOARDMAN ROBINSON (1876-1952). Créateur de bandes dessinées, illustrateur, muraliste et peintre. Né à Somerset, Nouvelle-Écosse. Élevé au Canada et en Angleterre. Étudie à la Massachusetts Normal Art School, à l'Académie Colarossi et à l'École des beaux-arts à Paris. Fortement influencé par Degas, Forain et les estampes japonaises. À partir de 1907, travaille pour de nombreux journaux et magazines new-yorkais. Penche pour la cause socialiste et s'associe avec John Reed. Se fait ensuite connaître pour ses murales dans les années vingt et trente. Enseigne à l'Art Students

League et au Colorado. Artiste invité par le Canadian Art Club en 1913.

JOHN WENTWORTH RUSSELL (1879-1959). Portraitiste, artiste figuratif et peintre de nature morte. Né à Binbrook, Ontario. Élève de John S. Gordon à la Hamilton Art School. Étudie à l'Art Students League à New York (1900-1905), et à Paris. Réside longtemps à Paris et y expose ses oeuvres ainsi qu'au Canada. S'établit à Toronto aux environs de 1930 et dirige sa propre école. Membre titulaire du Canadian Art Club en 1909. Démissionne en 1910.

MARC-AURÈLE DE FOY SUZOR-COTÉ (1869-1937). Paysagiste. Né à Arthabasca, Québec. Aide Maxime Rousseau à décorer l'église de l'endroit et acquiert ainsi sa formation. Étudie le chant à Paris en 1889. Retourne à la peinture et s'inscrit aux Académies Julian et Colarossi ainsi qu'à l'École des beaux-arts à Paris. Réside longtemps dans la capitale et participe à de nombreuses expositions. Passe du réalisme académique au réalisme de Barbizon et à l'impressionnisme. S'établit à Montréal en 1908 et se spécialise dans les paysages enneigés. Membre de l'A.R.C.A. en 1911, de la R.C.A en 1914. Artiste invité par le Canadian Art Club en 1913, membre titulaire en 1914.

SIR BYRON EDMUND WALKER (1848-1924). Banquier, collectionneur et conseiller de la Galerie nationale. Né à Caledonia, Canada-O. Élevé à Hamilton et peu scolarisé, devient commis de banque en 1861. Entre au service de la Banque canadienne de commerce en 1868. Occupe le poste de président (1907-24). Est fait Chevalier en 1910. Activités multiples (Université de Toronto, Mendelssohn Choir, Guild of Civic Art, Société Champlain, National Battlefields Commission). Fondateur du Royal Ontario Museum. Premier président, et président du conseil de l'Art Museum of Toronto (1900-1924) et de la Galerie nationale du Canada (1909-1924). Collectionneur de gravures, de peintures, de livres rares, de céramiques orientales et de fossiles.

HORATIO WALKER (1858-1938). Peintre animalier et de la vie paysanne. Né à Listowel, Ontario. S'établit à Toronto en 1873. Élève de Robert F. Gagen. Travaille pour les studios de photographie Notman & Fraser et rencontre Homer Watson. S'installe à Rochester, N.Y. en 1876, puis à New York pour de nombreuses années, aux environs de 1880. Voyage en Europe au début des années 1880. Forte influence de Millet. Expose ses oeuvres aux États-Unis, devient membre de nombreuses sociétés artistiques et remporte beaucoup de médailles. A une résidence secondaire sur l'île d'Orléans au Québec, et se fait apprécier des collectionneurs. Au sommet de sa carrière, devient membre du Canadian Art Club en 1907. Succède à Watson au poste de président du Club de 1913 à 1915. Membre de la R.C.A en 1913.

HOMER RANSFORD WATSON (1855-1936). Paysagiste. Né à Doon, Ontario. Doit subvenir aux besoins de sa famille dès 1866. Travaille à Toronto au service de Notman & Fraser (1874-75), et reproduit certaines oeuvres appartenant à l'École Normale de Toronto. Visite New-York de 1876 à 1877, rencontre George Inness et subit l'influence de la Hudson River School. Expose pour l'O.S.A., l'A.R.C.A. (1880), la R.C.A. (1882). Ses oeuvres sont achetées par la Reine Victoria en 1880 et Oscar Wilde voit en lui le Constable canadien (1882). Travaille en Angleterre et en France (1887-89). Se lie d'amitié avec les membres du New English Art Club. Retourne à Doon et développe un style plus monumental. Nombreuses expositions au Canada, aux États-Unis, en Angleterre. Remporte plusieurs médailles. Membre fondateur et premier président du Canadian Art Club (1907-13). Président de la R.C.A. (1918-21).

HORATIO WALKER (1858 - 1938). Peasant and animal painter. Born in Listowell, Ontario. Moved to Toronto, 1873. Studied art with Robet F. Gagen. Worked for Notman and Fraser photographic firm and met Homer Watson. Moved to Rochester , N.Y., 1876. Settled in New York, c. 1880 and lived there many years. Travelled to Europe, early 1880s. Strongly influenced by Millet. Exhibited widely in U.S., joined many societies and won many medals. Had summer home on Ile d'Orléans, Quebec, and developed a following among Montreal collectors. Was at height of reputation when he joined Canadian Art Club, 1907. Succeeded Watson as president of the Club, 1913-15. R.C.A., 1913.

HOMER RANSFORD WATSON (1855-1936). Landscape painter. Born in Doon, Ontario. Had to help support family after 1866. Worked in Toronto for Notman and Fraser, 1874-75, and copied works in Toronto Normal School collection. Visited New York, 1876-77, met George Inness and was influenced by Hudson River School tradition of landscape painting. Exhibited at O.S.A. A.R.C.A., 1880. R.C.A., 1882. Work bought for Royal Collection, 1880. Described by Oscar Wilde as "the Canadian Constable," 1882. Worked in Britain and France, 1887-89. Friendly with members of New English Art Club. Returned to Doon and developed more monumental style. Exhibited widely in Canada, U.S. and Britain and won several medals. Founding member and first President of Canadian Art Club, 1907-13. President of Royal Canadian Academy, 1918-21.

DANIEL ROBERT WILKIE (1846-1914). Banker. Born in Quebec City. Educated there at Morrin College. Started career with Quebec Bank, 1862. Entered service of Imperial Bank of Canada 1875, and was its president, 1906-14. Was director of many companies and president of Canadian Bankers' Association. Also active on many charitable, musical and theatrical boards of directors, including that of Art Museum of Toronto. Honorary president of Canadian Art Club, 1907-14.

ALBERT CURTIS WILLIAMSON (1867-1944). Portrait and genre painter. Born in Brampton, Ontario, into a rich family. Studied in Toronto, at Ontario School of Art, with J.W.L. Forster, c. 1887-89, and in Paris, at Académie Julian and with Fernand Cormon, 1889-92. Sketched in Barbizon and exhibited in Paris salons. Worked in Toronto, 1892-95. O.S.A., 1892. A.R.C.A., 1894. Worked in Europe, mainly in Holland, 1895-1905. Specialized in peasant genre subjects. Won silver metal at Louisiana Purchase Exhibition, St. Louis, 1904. Returned to Toronto, 1905. R.C.A., 1907. Founding member of both Arts and Letters Club and Canadian Art Club.

DANIEL ROBERT WILKIE (1846-1914). Banquier originaire de Québec et formé au Collège Morrin. Entame sa carrière à la Banque du Québec en 1862. Entre au service de la Banque Impériale du Canada en 1875. Occupe le poste de président de 1906 à 1914. Directeur de nombreuses compagnies et président de l'Association canadienne des banquiers. S'occupe d'un grand nombre d'oeuvres de charité, de musique, de théâtre. Siège au conseil de l'Art Museum de Toronto. Président honoraire du Canadian Art Club de 1907 à 1914.

ALBERT CURTIS WILLIAMSON (1867-1944). Portraitiste et peintre de genre. Né d'une riche famille à Brampton, Ontario. Étudie à l'Ontario School of Art de Toronto, sous J.W.L. Forster (env. 1887-89), à l'Académie Julian à Paris sous Fernand Cormon (1889-92). Dessine à Barbizon et expose dans les salons parisiens. Travaille en Europe, en Hollande surtout, de 1895 à 1905. Se spécialise dans les sujets de la vie paysanne. Médaillé d'argent à la Louisiana Purchase Exhibition à Saint-Louis en 1904. Retourne à Toronto en 1905. Membre de la R.C.A. en 1907. Membre fondateur de l'Arts and Letters Club et du Canadian Art Club.

BIBLIOGRAPHY / BIBLIOGRAPHIE

ARCHIVAL SOURCES/SOURCES

Montréal. McGill University, McCord Museum Library. Clarence Gagnon, William Brymmer and Aurèle Suzor-Coté papers./ Fonds Clarence Gagnon, William Brymner et Aurèle Suzor-Coté.

Montréal. Museum of Fine Arts Library/Bibliothèque du Musée des beaux-arts de Montréal. Artists' clippings files/ Dossiers contenant les coupures de journaux consacrées aux artistes.

Ottawa. National Gallery of Canada Library. Artists' clippings files./Bibliothèque du Musée des beaux-arts du Canada. Dossiers contenant les coupures de journaux relatives aux artistes.

Ottawa. National Gallery of Canada Library. Canadian Art Club file./Bibliothèque du Musée des beaux-arts du Canada. Dossier du Canadian Art Club.

Ottawa. Public Archives of Canada, Manuscript Division. Newton MacTavish papers./ Archives publiques du Canada. Division des manuscrits. Fonds Newton MacTavish.

Toronto. Art Gallery of Ontario, E.P. Taylor Reference Library. Artists' clippings files./Dossiers contenant les coupures de journaux consacrées aux artistes.

Toronto. Art Gallery of Ontario, E.P. Taylor Reference Library. Canadian Art Club Scrapbooks and Edmund Morris Letterbooks./Albums du Canadian Art Club et Recueils de la correspondance d'Edmund Morris.

Toronto. Art Gallery of Ontario, E.P. Taylor Reference Library. Catalogues of the Canadian Art Club AnnualExhibitions, 1908-1915./Catalogues des expositions annuelles du Canadian Art Club, 1908-1915.

Toronto. Art Gallery of Ontario, E.P. Taylor Reference Library. Geoffrey Simmins, "Reinterpreting the Canadian Art Club: A Documentary Approach." Manuscript for University of Toronto term paper/Travail de fin de session, 1983.

Toronto: North York Public Library, The Canadiana Collection. Newton MacTavish Papers/Fonds Newton MacTavish.

Toronto. Ontario Archives. Ontario Society of Artists' Papers/Fonds de l'Ontario Society of Artists.

Toronto. University of Toronto, Thomas FisherRare Book Library. James Mavor Papers/Fond James Mavor.

Toronto. University of Toronto, Thomas FisherRare Book Library. Sir Edmund Walker Papers/Fonds Edmund Walker.

Winnipeg. Provincial Archives of Manitoba, Still Images Section. Edmund Morris/Collection Edmund Morris.

BOOKS AND CATALOGUES
LIVRES ET CATALOGUES

Anderson, Dennis R. *Ernest Lawson Retrospective*. New York: A.C.A. Galleries, 1976.

Antoniou, Sylvia. *Maurice Cullen 1866-1934*. Kingston: Agnes Etherington Art Centre, 1982.

Armstrong, Tom, et al. *200 Years of American Sculpture*. New York: Whitney Museum of American Art, 1976.

Arts and Letters Club of Toronto, ed. *Yearbook of Canadian Art -1913*. Toronto: J.M. Dent and Sons Ltd., 1913.

Bayer, Fern. *The Ontario Collection*. Toronto: Fitzhenry and Whiteside, 1984.

Berry-Hill, Henry and Sidney. *Ernest Lawson: American Impressionist 1873-1939*. Leigh-on-Sea, England: F. Lewis Publishers, Ltd. 1968.

Boggs, Jean Sutherland. *The National Gallery of Canada*. London: Thames and Hudson, 1971.

Bradfield, Helen Pepall. *Art Gallery of Ontario: The Canadian Collection*. Toronto: McGraw-Hill Co. of Canada Ltd., 1970.

Braide, Janet. *William Brymner 1855-1925: A Retrospective*. Kingston: Agnes Etherington Art Centre, 1979.

Bridle, Augustus. *The Story of the Club*. Toronto: The Arts and Letters Club, 1945.

Broder, Patricia Janis. *Bronzes of the American West*. New York: Harry N. Abrams, Inc., 1973.

Brown, Milton W., Hunter, Sam, et al. *American Art*. New York: Prentice Hall/Abrams, 1979.

Brown, Robert Craig and Cook, Ramsay. *Canada 1896-1921*. Toronto: McClelland and Stewart Ltd., 1974.

Buchanan, Donald W. *James Wilson Morrice: A Biography*. Toronto: The Ryerson Press, 1936.

Buchanan, Donald W. *The Growth of Canadian Painting*. Toronto and London: William Collins Sons and Co. Ltd., 1950.

The Canadian Art Club 1907-1911. Toronto: n.p., 1911.

Clarence Gagnon, R.C.A./J.W. Beatty, R.C.A., O.S.A.. Toronto: The Art Gallery of Toronto, 1942.

Cloutier, Nicole. *James Wilson Morrice 1865-1924*. Montreal: The Montreal Museum of Fine Arts, 1985.

Colgate, William. *Canadian Art: Its Origin and Development*. Toronto: The Ryerson Press, 1943.

Crisp, Arthur. *Art Students League 1900-1903*. New York: The Creative Team Inc., 1975.

Dendy, William and Kilbourn, William. *Toronto Observed: Its Architecture, Patrons and History*. Toronto: Oxford University Press, 1986.

Ernest Lawson 1873-1939. Ottawa: The National Gallery of Canada, 1967.

Farr, Dennis. *English Art 1870-1940*. Oxford: The Clarendon Press, 1978.

Farr, Dorothy. *Horatio Walker 1858-1938*. Kingston: Agnes Etherington Art Centre, 1977.

Glazebrook, G.P. de T. *Sir Edmund Walker*. Toronto: Oxford University Press, 1933.

Greenshields, E.B. *The Subjective View of Landscape Painting*. Montreal: Desbarats and Co., 1904.

Greenshields, E.B. *Landscape Painting and Modern Dutch Artists*. New York: The Baker and Taylor Co., 1906.

Grover, Rachel. *James Mavor and His World*. Toronto: Thomas Fisher Rare Book Library, University of Toronto, 1975.

Hammond, M.O. *Painting and Sculpture in Canada*. Toronto: The Ryerson Press, 1930.

Harper, J. Russell. *Homer Watson R.C.A., 1855-1936*. Ottawa: The National Gallery of Canada, 1963.

Harper, J. Russell. *Painting in Canada: A History*. Toronto: University of Toronto Press, 1966.

Harper, J. Russell. *Early Painters and Engravers in Canada*. Toronto: University of Toronto Press, 1970.

Hill, Charles C. *To Found a National Gallery: The Royal Canadian Academy of Arts 1880-1913*. Ottawa: The National Gallery of Canada, 1980.

Hills, Patricia. *Turn-of-the-Century America*. New York: Whitney Museum of America Art, 1977.

Housser, F.B. *A Canadian Art Movement: The Story of the Group of Seven*. Toronto: The Macmillan Co. of Canada Ltd, 1926.

Hubbard, Robert H. *The National Gallery of Canada, Catalogue of Paintings and Sculpture, Vol. III: Canadian School*. Toronto: University of Toronto Press, 1957.

Hubbard, Robert H. *An Anthology of Canadian Art*. Toronto: Oxford University Press, 1960.

Hurdalek, Marta H. *The Hague School: Collecting in Canada at the Turn of the Century*. Toronto: Art Gallery of Ontario, 1984.

Jouvancourt, Hugues de. *Clarence Gagnon*. Montreal: Editions La Frégate, 1970.

Jouvancourt, Hugues de. *Suzor-Coté*. Montreal: Stanké, 1978.

Karel, David. *Horatio Walker*. Quebec City: Musée du Québec, 1987.

Kimbrough, Sara Dodge. *Drawn From Life*. Jackson: University Press of Mississippi, 1976.

Laing, G. Blair. *Memoirs of an Art Dealer*. Toronto: McClelland and Stewart Ltd., 1979.

Lamb, Robert J. *James Kerr-Lawson: A Canadian Abroad*. Windsor: Art Gallery of Windsor, 1983.

Leeuw, Ronald de, et al. *The Hague School, Dutch Masters of the Nineteenth Century*. London: Royal Academy of Arts, 1983.

McCrea, Rosalie Smith. *James Wilson Morrice and the Canadian Press 1888-1916: His Role in Canadian Art*. Ottawa: Unpublished M.A. Thesis, Carleton University, 1980.

Macdonald, Colin S. *A Dictionary of Canadian Artists*, Vol.1-6. Ottawa: Canadian Paperbacks Publishing Ltd., 1967-1982.

MacFall, Haldane. *A History of Painting*. Vol.8. London: T.C. and E.C. Jack, 1911.

McGill, Jean S. *Edmund Morris: Frontier Artist*. Toronto and Charlottetown: Dundurn Press Ltd., 1984.

McInnes, Graham. *A Short History of Canadian Art*. Toronto: The Macmillan Co. of Canada Ltd., 1939.

McMann, Evelyn de R. *Royal Canadian Academy of Arts: Exhibitions and Members 1880-1979*. Toronto: University of Toronto Press, 1981.

MacTavish, Newton. *The Fine Arts in Canada*. Toronto: The Macmillan Co. of Canada Ltd., 1925.

MacTavish, Newton. *Ars Longa*. Toronto: The Ontario Publishing Co. Ltd., 1938.

Miller, Muriel. *Homer Watson, the Man of Doon*. Toronto: The Ryerson Press, 1938.

Morgan, Henry James, ed. *The Canadian Men and Women of the Time*. Toronto: William Briggs, 1912.

Morris, Edmund M. *The Diaries of Edmund Montague Morris: Western Journeys 1907-1910*. Transcribed by Mary Fitz-Gibbon. Toronto: The Royal Ontario Museum, 1985.

Murray, Joan. *Ontario Society of Artists: 100 Years*. Toronto: Art Gallery of Ontario, 1972.

Murray, Joan. *Impressionism in Canada: 1895-1935*. Toronto: Art Gallery of Ontario, 1973.

Nasgaard, Roald. *The Mystic North: Symbolist Landscape Painting in Northern Europe and North America 1890-1940*. Toronto: University of Toronto Press, 1984.

O'Brien, Mern. *Ernest Lawson (1873-1939) From Nova Scotia Collections*. Halifax: Dalhousie Art Gallery, 1983.

Ostiguy, Jean-René. *Marc-Aurèle de Foy Suzor-Coté: Winter Landscape*. Ottawa: The National Gallery of Canada, 1978.

Page, Frank E. *Homer Watson, Artist and Man*. Kitchener: Commercial Printing Company, 1939.

Pepall, Rosalind M. *Building a Beaux-Arts Museum: Montreal 1912*. Montreal: The Montreal Museum of Fine Arts, 1986.

Price, F. Newlin. *Horatio Walker, LL.D. S.A.A. N.A. R.I. R.C.A.*. New York and Montreal: Louis Carrier and Co., 1928.

Proctor, Alexander Phimister. *Sculptor in Buckskin: An Autobiography*. Hester Elizabeth Proctor, ed. Norman: University of Oklahoma Press, 1971.

Reade, R.C. *Archibald Browne, R.C.A.: An Appreciation*. Montreal: Privately printed, 1925.

Reid, Dennis. *The Group of Seven*. Ottawa: The National Gallery of Canada, 1970.

Reid, Dennis. *A Concise History of Canadian Painting*. Toronto: Oxford University Press, 1973.

Reid, Dennis. *Our Own Country Canada*. Ottawa: The National Gallery of Canada, 1979.

Retrospective Exhibition of the Work of Franklin Brownell, R.C.A.. Ottawa: The National Gallery of Canada, 1922.

A Retrospective Exhibition: The Hon. Arthur Crisp, N.A. and Mary Ellen Crisp. Hamilton: Art Gallery of Hamilton, 1963.

Robson, Albert H. *Canadian Landscape Painters*. Toronto: The Ryerson Press, 1932.

Robson, Albert H. *Clarence A. Gagnon, R.C.A., LL.D.*. Toronto: The Ryerson Press, 1932.

Simmins, Geoffrey and Parke-Taylor, Michael. *Edmund Morris "Kyaiyii" 1871-1913*. Regina: Norman Mackenzie Art Gallery, 1984.

Sisler, Rebecca. *Passionate Spirits: A History of the Royal Canadian Academy of Arts 1880-1980*. Toronto and Vancouver: Clarke, Irwin and Co. Ltd., 1980.

Thom, Ian M. *The Prints of Clarence Gagnon*. Victoria: Art Gallery of Greater Victoria, 1981.

Wallace, W. Stewart and McKay, W.A. *The Macmillan Dictionary of Canadian Biography*. Toronto: The Macmillan Co. of Canada, 1978.

Wilkinson, Anne. *Lions in the Way: A Discursive History of the Oslers*. Toronto: The Macmillan Co. of Canada Ltd., 1956.

Williamson, Moncrieff. *Robert Harris (1849-1919)*. Ottawa: The National Gallery of Canada, 1973.

Wistow, David. *Canadians in Paris 1867-1914*. Toronto: Art Gallery of Ontario, 1979.

Wodehouse, Robert F. *A Check List of The War Collection of World War I, 1914-1918 and World War II, 1939-1945*. Ottawa: The National Gallery of Canada, 1968.

CONTEMPORARY EXHIBITION REVIEWS
arranged chronologically. Unless otherwise noted, all reviews are from Toronto publications.

CRITIQUES DE L'ÉPOQUE CONSACRÉES AUX EXPOSITIONS
et présentées par ordre chronologique. Sauf avis contraire, elles sont toutes issues de publications torontoises.

1908 M.L.A.F. "A New Picture Gallery." *Toronto Daily Star*, 3 February 1908, p. 6.

"Fine Pictures by Canadians." *Toronto Daily Star*, 4 February 1908, p.3.

"Canadian Art is Given Fresh Stimulus." *Toronto World*, 4 February 1908, p.7.

"New Art Club is Organized." *The Globe*, 4 February 1908, p.6.

Frank Lillie Pollock. "Strong Work of New Art Club." *The Mail and Empire*, 4 February 1908, p.4.

"The New Art Movement." *The Globe*, 5 February 1908, p.6.

"The Canadian Art Club." *The Globe*, 8 February 1908, p.12.

E.F.B. Johnston. "The Canadian Art Club, A Review of the Exhibition." *The Mail and Empire*, 8 February 1908.

"The Canadian Art Club." *Saturday Night*, 15 February 1908, p.10.

"The Exhibition of the Canadian Art Club." *Saturday Night*, 22 February 1908, p.5.

Newton MacTavish. "The Front Window: The Little Company of Eight." *The Canadian Magazine*, March 1908, pp.480–482.

1909 James Mavor. "The Canadian Art Club." Unidentified clipping, March 1909, p.17.

Amenuenis. "The Canadian Art Club." *Acta Victoriana*, March 1909, pp.464.–471.

"At the Canadian Art Club Exhibition." *Canadian Courier*, March 1909, p.9.

"The Canadian Art Exhibition." *Toronto Daily Star*, 1 March 1909, p.7.

"Canadian Art Club's Success." *The Globe*, 1 March 1909, p.2.

"Great Pictures by Native Born." *The Mail and Empire*, 1 March 1909, p.5.

"Canadian Art on Exhibition." *The News*, 2 March 1909, p.7.

E.F.B. Johnston. "True Spirit of Painting." *Toronto Daily News*, undated clipping, March 1909.

"Some Noted Pictures by Famous Artists at the Exhibition of the Canadian Art Club." *The Globe*, 6 March 1909, magazine section, p.3.

"The Canadian Art Club's Second Annual Exhibition." *Saturday Night*, 13 March 1909, p.11.

1910 "Art Club Opening Night." *The Globe*, 8 January 1910, p.5.

"Canadian Art Club Exhibition." *Toronto Daily Star*, 8 January 1910, p.11.

"Exhibition of Canadian Art." *The News*, 8 January 1910, p.3.

"Annual Exhibition of Canadian Art Opened." *Toronto World*, 8 January 1910, p.9.

"Picture Show Formally Opened." *The Mail and Empire*, 8 January 1910, p.6.

"Noble Pictures by Native Born." *The Mail and Empire*, 10 January 1910, p.41.

"Notable Pictures at Art Club's Exhibition." *The Globe*, 15 January 1910, magazine section, p.6.

P.O.D. "The Canadian Art Club Exhibition." *Saturday Night*, 22 January 1910, p.5.

Eric Brown. "Canadian Artists' Show." *Ottawa Citizen*, 22 January 1910, p.42.

"Canadian Works of Art Exhibited Are of High Order." *Montreal Daily Star*, 15 February 1910, p.10.

"Canadian Art: Meritorious Exhibition by Native Painters Opened in the Art Gallery." *Montreal Witness*, 15 February 1910.

A.C. "A Visit to the Canadian Art Club's Exhibition in Art Gallery." *Montreal Daily Star*, 18 February 1910, p.6.

1911 "Art Club Holds Its Exhibition." *The Mail and Empire*, 4 March 1911, p.5.

M.L.A.F. " Fine Paintings by Canadians." *Toronto Daily Star*, 4 March 1911, p.11.

"The Canadian Art Club's Fourth Annual Exhibition." *The News*, 4 March 1911, p.18.

"An Art Exhibition," *The Canadian Courier*, 11 March 1911, p.9.

P.O.D. "The Canadian Art Club's Exhibition." *Saturday Night*, 11 March 1911, pp.25, 29.

"Lecture by Prof. Mavor: Art and Artists Described at Exhibition." *The Globe*, 17 March 1911.

"Notable Pictures at the Canadian Art Club's Fourth Annual Exhibition." *The Globe*, 18 March 1911, p.3.

"Art and Artists." *The Globe*, 18 March 1911, p.14.

"Canadian Art Club." *The Mail and Empire*, 27 March 1911.

1912 J.D. Logan. "Canadian Art Club Advances in Craftsmanship and Vision." Unidentified clipping, February 1912.

"Canadian Art Club Fifth Annual Exhibit." *The News*, 8 February 1912, p.12.

"Canadian Art Club Exhibition." *Toronto World*, 9 February 1912, p.10.

M.L.A.F. "Big Canvases By Canadian Artists." *Toronto Daily Star*, 9 February 1912, p.7.

"The Canadian Art Club." *The Evening Telegram*, 12 February 1912, p.20.

"Art Club Gives Fine Exhibition." *The Mail and Empire*, 17 February 1912, p.10.

"The Annual Exhibition of the Canadian Art Club." *Saturday Night*, 17 February 1912, p.31.

M.L.A.F. "Canadian Life By Canadian Artists." *Toronto Star Weekly*, 17 February 1912.

"Canadian Art Club Exhibition." *Montreal Daily Star*, 17 February 1912, p.10.

"Canadian Art Club's Fifth Exhibition." *The News*, 24 February 1912, p.3.

1913 "Art Club Opens Annual Exhibit." *The News*, 10 May 1913, p.14.

"Fine Pictures at the Canadian Art Club Show." *The Globe*, 10 May 1913, p.20.

Hector Charlesworth. "The Canadian Art Club, 1913." *Saturday Night*, 24 May 1913, p.6.

1914 "Landscapes Shown by the Canadian Art Club." *The Globe*, 2 May 1914, p.11.

"Art Club Shows Fine Paintings." *The Mail and Empire*, 2 May 1914, p.5.

Irene B. Wrenshall. "The Field of Art." *Toronto Sunday World*, 3 May 1914, p.5.

Hector Charlesworth. "The Canadian Art Club, 1914." *Saturday Night*, 9 May 1914, p.5

1915 "Splendid Opening of Art Exhibition." *The Mail and Empire*, 7 October 1915, p.4.

"Valcartier Paintings At Art Club's Show." *The Globe*, 7 October 1915, p.6.

"Canadian Art Club: Eighth Annual Show." *Evening Telegram*, 7 October 1915, p.19.

"Art Exhibition Open At Library." *Toronto World*, 7 October 1915, p.3.

"Canadian Art Club Holds Private View of Pictures." *The News*, 7 October 1915, p.4.

Hector Charlesworth. "Canadian Art Club Exhibition, 1915." *Saturday Night*, 16 October 1915, p.5.

★67. Mother and Son

Horatio Walker
★68. Ploughing, The First Gleam
★69. A Sty - Boy Feeding Pigs
70. Indian Summer: Shepherd and
 Sheep

71. Moonrise

Homer Ransford Watson
72. Cobalt
★73. Pioneers Crossing the River
★74. Nut Gatherers in the Forest
75. The Stumpers

Albert Curtis Williamson
76. Doris
77. Dutch Vrouw
78. A Vaudeville Girl
79. A Witch
80. A Derelict

THIRD ANNUAL EXHIBITION, 7TH - 27TH JANUARY, 1910
TROISIÈME EXPOSITION ANNUELLE, 7 - 27 JANVIER 1910

William E. Atkinson
1. Spring Freshet
2. The Pool
3. After the Rain
4. Solitude
5. The Golden Hour
★6. Dutch Moonlight
★7. The Cascade
8. Dutch Canal
9. Moorland Stream
10. The Windmill

J. Archibald Browne
11. Spring Song
★12. The Valley
★13. Autumn Glory
14. Twilight Pastoral
15. Harbour Lights
16. The Little White Sail
17. The Silver Sea
18. Twixt Sea and Sky
19. Bewitchment
20. The Ravine

Franklin Brownell
★21. Harvest Field
22. The Statuette (lamplight)
23. Azalea (decorative panel/panneau
 décoratif)
24. Habitant Cottage and Garden
25. View of Ottertail Mountains, B.C.

William Brymner
26. Portrait of Misses Dorothy and
 Irinie Vaughn

27. The Wave
28. On the Atlantic Coast

Maurice G. Cullen
★29. Brittany Landscape
30. Winter Night, Quebec
31. Stormy Night, Montreal

Clarence A. Gagnon
32. Autumn Scene, Baie St. Paul
33. Landscape
34. Early Winter Moonrise
35. The Plage, Dinard
36. Les Deux Plages, Parame et
 St. Malo

James L. Graham
37. By the Birch Grove
38. Pasture Field
39. The Stable
40. Group of Deer

James W. Morrice
41. Canadian Village
42. St. Anne de Beaupre, Winter
43. A Pardon, Brittany
44. Notre Dame, Paris
45. The Salute, Venice
46. Venice, The Grand Canal

Edmund M. Morris
★47. Coming Storm, Alberta
48. The Foothills, A Scout
49. The Porcupine Hills
★50. Wolf Collar - A Medicine Man

51. Spring Chief, of the Blackfoot
52. Little Shield, of the Blackfoot
53. Water Chief, of the Blackfoot

A. Phimister Proctor
54. Buffalo Head
55. Moose
56. American Buffalo
★57. The Challenge, Elk
58. Tiger (plaster cast for Princeton
 bronzes)

Horatio Walker
★59. Evening, Ile d'Orleans
60. Du Nornest
★61. The Enchanted Sty, Circe and
 Friends of Ulysses
★62. Oxen Drinking

Homer Ransford Watson
★63. The Source
64. Stumpers
65. Passing Squall, The St. Lawrence
 Gulf
66. Grey Headland, Cape Breton
67. The Broken Field
68. A Ravine Farm
★69. Woodland Terrace - Memory of Ile
 d'Orleans
★70. The Lone Cattle Shed
71. The Cottage - Apple Tree
72. The Frosted Oak
73. Autumn Drouth

CANADIAN ART CLUB EXHIBITION AT ART ASSOCIATION OF MONTREAL
14TH FEBRUARY - 12TH MARCH 1910

EXPOSITION DU CANADIAN ART CLUB À L'ART ASSOCIATION OF MONTREAL
14 FÉVRIER - 12 MARS 1910

William E. Atkinson
★1. Groote Kerke, Dordrecht
2. The Pool
3. Spring Freshet
4. After the Rain
5. Solitude
6. Golden Hour
★7. The Cascade
8. Dutch Canal
9. Moorland Stream
10. The Windmill
11. Autumn

J. Archibald Browne
12. Spring Song
★13. The Valley
★14. Bewitchment
15. Slumbering Waters

16. Romance
17. The Ravine
18. The Day's Awakening
19. The Little White Sail
20. Twixt Sea and Sky
21. Lake Couchiching
22. Evensong
23. Twilight Pastoral

Franklin Brownell
★24. Harvest Field
25. The Statuette (Lamplight)
26. Azalea (decorative panel)
27. Habitant Cottage and Garden
28. View of Ottertail Mountains, B.C.

William Brymner
29. Vaughan Sisters

★30. The Wave
31. On the Atlantic Coast

Maurice G. Cullen
32. Quebec (Night Effect)

Clarence A. Gagnon
33. Autumn Scene, Baie St. Paul
34. River Seine, at St. Marime
35. La Plage, Dinard
36. Mountain Stream, Winter
37. Street Scene, Dinan, Brittany

James W. Morrice
38. Canadian Village
★39. Ste. Anne de Beaupre, Winter
40. A Pardon, Brittany
41. Notre Dame, Paris

42. La Salute, Venice
43. Venice, Grand Canal

Edmund M. Morris
*44. Coming Storm, Alberta
45. In the Foothills, A Scout
*46. Head Chief IronShield of Blackfoot
47. Chief Bull Plume of the Piegans
48. Big Darkness
49. Maguinnis, A Cree
50. Cove Fields, Quebec

BRONZES

A. Phimister Proctor
*51. Indian Chief, Equestrian
52. Trumpeting Elephant
53. Standing Puma
54. Charging Panther
55. Brown Bear Head (Alaska)
56. Cub Bear and Rabbit
57. Cub Bear
58. Dog with Bone
59. Bison Head
60. Moose

*61. Elk
62. Buffalo
63. Tiger (working model for Princeton)
64. Tiger (working model for Princeton)

WATERCOLOURS/AQUARELLES

65. Hunting Panther, Alberta
66. Mountain Lion in Repose
67. Peak in Cascade Range
68. Mountain Stream, Alberta
69. Snow Clad Peaks, Banff
70. Falls, Bow River, Banff
71. In the Rockies, Alberta
72. Grizzly Bear, Evening
73. Mountain Rams, B.C.
74. Buffalo on Trail, Saskatchewan
75. Lake Louise, B.C.
76. Antelope, Plains of Alberta

Horatio Walker
*77. Enchanted Sty

*78. Evening, Ile d'Orleans
79. Ice Harvest

Homer Ransford Watson
80. Pioneers Crossing River
81. Evening
*82. Lifting Mists, Smugglers Cove, C.B.
83. Passing Squall, St. Lawrence Gulf
*84. Lone Cattle Shed
*85. Woodland Terrace
86. Birchwood Glade
87. Dry Creek
88. The Orchard
89. Frosted Oak

Albert Curtis Williamson
90. Portrait of my Father
91. Portrait of Archibald Browne
92. Study in Scarlet
93. Newfoundland Landscape
94. Doris
95. A Derelict
96. Old Woman Laren

FOURTH ANNUAL EXHIBITION, 3RD - 25TH MARCH, 1911
QUATRIÈME EXPOSITION ANNUELLE, 3 - 25 MARS 1911

William E. Atkinson
1. Shepherd's Return, Normandy
2. Cloudy Day, Dartmoor
*3. The Valley, Autumn
*4. Winter

J. Archibald Browne
*5. Indian Summer
6. Twilight's Restful Hour
*7. The Passing of Summer
8. Veiled Sunset
9. Pastoral
10. Opal Sea
11. Crosby Sands (near Liverpool)
12. Silver Sea

Franklin Brownell
13. Au Fenetre
*14. Pasture Elms
15. Landscape

William Brymner
*16. "Sea Foam"
*17. Summer

Clarence A. Gagnon
18. In the Laurentians, Twilight
19. Street Scene, Dinan, Brittany
*20. Winter, Village of Baie St. Paul, Quebec
*21. Grey Day, Winter, Baie St. Paul
22. Street Scene Moonlight, Dinan

ETCHINGS/GRAVURES

23. Old Windmill, St. Valery sur Somme
24. Rue a Caudebia en Caux. Normandy

25. Street by Moonlight, Pont de l'Aiche
26. Old Windmill, St. Brice, Brittany

James L. Graham
27. Landscape, Autumn Morning on Humber Flats
28. Interior of Cathedral
29. Landscape and Cattle

Ernest Lawson
30. Church at Woodinn
31. May Party, Central Park
32. Snowbound Boats

James W. Morrice
*33. Dutch Pier
34. Chrysanthemums
35. Grand Canal, Venice
36. The Salute, Venice

Edmund M. Morris
*37. Landscape, Old Fort Edmonton
38. Plains of Alberta, Blackfoot Lodges
39. Ojibway Encampment, Thunder Bay District
40. Chief Nepahpenais of Saulteaux
*41. A Saulteaux Brave
42. Landscape
43. Blackfoot Lodges
44. Chateau Frontenac, Quebec
45. The Dufferin Terrace, Quebec

SCULPTURES

A. Phimister Proctor
*46. Tigers (for Princeton)
47. Moose Family (relief)

WATERCOLOURS/AQUARELLES

48. Sketches - Cascade Range
49. Sketches - Rocky Mountains, Alberta
50. Sheep Mountain, Alberta
51. Cliffs and Glaciers, B.C.
52. Cliffs, Rocky Mountains, Alberta
53. Glacier Lake, Cascade Mountains
54. Sketches of Animals
55. Group of Sketches
56. Elk on the Alert
57. Startled Doe
58. Doe Feeding
59. Cochrane Lake, Alberta
60. Mountain Side
61. Cathedral Peaks
62. Yarrow Creek, Alberta
63. Bow River, Alberta
64. In the Blackfoot Reservation

Horatio Walker
65. Sow and Pigs
66. The First Snow
*67. Woman Milking Morning
68. Boy and Calf

Homer Ransford Watson
*69. Abandoned Trawler
*70. Spring in the Woods
71. After the Storm
72. Clearing Land, Night Fall
73. Birch Glade
74. The Cottage
75. Winter Evening
76. A Road

FIFTH ANNUAL EXHIBITION, 8TH - 27TH FEBRUARY, 1912
CINQUIÈME EXPOSITION ANNUELLE, 8 - 27 FÉVRIER 1912

Walter S. Allward
*1. Sketch Model of Bell Telephone Memorial (for Brantford)

William E. Atkinson
2. Dartmoor Hills - September
3. Ironworker's Home, Devon

4. Dispersing Clouds
5. Normandy Avenue, France
6. Breton Farm

OTHER MAGAZINES AND NEWSPAPERS
AUTRES JOURNAUX ET MAGAZINES

Athill, Philip. "The International Society of Sculptors, Painters and Gravers." *The Burlington Magazine*, January 1985, pp.21-29

"Art Club's New President." *Saturday Night*, 17 May 1913, p.3.

Boultbee, W.M. "Edmund Morris, Painter." *The Canadian Magazine*, June 1908, pp.121-127.

Caffin, Charles H. "The Art of Horatio Walker." *Harper's Monthly Magazine*, November 1908, pp.947-956.

"Canadian Artists Honored." *Saturday Night*, 11 February 1911, p.3.

"Canadian Artists in Paris." *Saturday Night*, 14 December 1907, p.5.

"Chester D. Massey's Paintings." *Saturday Night*, 23 April 1910, p.17.

Ciolkowska, Muriel. "A Canadian Painter: James Wilson Morrice." *International Studio*, September 1913, pp.176-182.

Donegan, Rosemary. "What Ever Happened to Queen St. West?" *FUSE*, Fall 1986, pp.10-22.

Forster, J.W.L. "Art and Artists in Ontario." Vol.IV of *Canada: An Encyclopedia of the Country*. J. Castell Hopkins, ed. Toronto: The Linscott Publishing Co., 1898, pp.347-352.

Gagen, Robert F. "History of Art Societies in Ontario." Vol.IV of *Canada: An Encyclopedia of the Country*. J. Castell Hopkins, ed. Toronto: The Linscott Publishing Co., 1898, pp.360-365.

Hale, Katherine. "Walter S. Allward, Sculptor." *The Canadian Magazine*, January 1919, pp.783-788.

"The Horatio Walker Exhibition." *Saturday Night*, 24 April 1915, p.3.

"Horatio Walker in His Studio." *Toronto Daily Star*, 13 May 1913, p.8.

Ingram, William H. "Canadian Artists Abroad." *The Canadian Magazine*, January 1907, pp.218-222.

Johnston, E.F.B. "Art and the Work of Archibald Browne." *The Canadian Magazine*, October 1908, pp.529-536.

Johnston, E.F.B. "The Art of W.E. Atkinson." *The Canadian Magazine*, June 1909, pp.145-151.

Johnston, E.F.B. "Studio Talk: Toronto." *The Studio*, 14 September 1909, pp.154-158.

Johnston, E.F.B. "Painting and Sculpture in Canada." Vol.XII of *Canada and Its Provinces*. Adam Shortt and Arthur G. Doughty, eds. Toronto: T. and A. Constable, 1913, pp.593-640.

Jordan, Katherine A. *Sir Edmund Walker: Print Collector*. Toronto: Art Gallery of Ontario, 1974.

Joynes, Agnes. "Phimister Proctor, N.A." *Saturday Night*, 29 January 1938.

Lochnan, Katharine A. "The Walker Journals: Reminiscences of John Lavery and William Holman Hunt." *RACAR*, Vol. IX, 1982, pp.57-63.

Logan, J.D. "Philippe and Henri Hébert: A Life-Dream Realized." *The Canadian Magazine*, September 1920, pp.425-427.

Lowery, Carol. "Within the Sanctum: Newton MacTavish as Art Critic." *Vanguard* November 1985, pp.10-14.

MacFall, Haldane. "Art at the Outposts of Empire." *Saturday Night*, 3 September 1912, p.3.

McFarlane, Arthur E. "The Work of Walter Allward." *Maclean's*, November 1909, pp.27-33.

McInnes, G. Campbell. "Art and Philistia: Some Sidelights on Aesthetic Taste in Montreal and Toronto, 1880-1910." *University of Toronto Quarterly*, July 1936, pp.516-524.

MacTavish, Newton. "The Art of John Russell." *The Canadian Magazine*, April 1911, pp.557-565.

MacTavish, Newton. "Laura Muntz and Her Art." *The Canadian Magazine*, September 1911, pp.419-426.

MacTavish, Newton. "A Renaissance of Art in Canada." *Art and Progress*, September 1911, pp.318-325.

MacTavish, Newton. "Maurice Cullen: A Painter of the Snow." *The Canadian Magazine*, April 1912, pp.537-544.

Morris, Edmund. "Art in Canada: The Early Painters." *Saturday Night*, 24 January 1911, pp.25,29.

Mortimer-Lamb, Harold. "The Art of Curtis Williamson, R.C.A." *The Canadian Magazine*, November 1908, pp.65-71.

"That National Gallery of Ours." *Saturday Night*, 3 August 1912, p.3.

Nelson, W.H. de B. "Phimister Proctor: Canadian Sculptor." *The Canadian Magazine*, April 1915, pp.495-501.

"The Pictures of J. Kerr-Lawson." *Saturday Night*, 20 June 1914, p.4.

"Preparing for Toronto's Art Gallery." *Saturday Night*, 20 November 1909, p.11.

Sherwood, W.A. "A National Spirit in Art." *The Canadian Magazine*, October 1894, pp.497-501.

Sherwood, W.A. "The National Aspect of Canadian Art." Vol. IV of *Canada: An Encyclopedia of the Country*, J. Castell Hopkins, ed. Toronto: The Linscott Publishing Co., 1898, pp.366-370.

"A Successful Canadian Sculptor." *Saturday Night*, 8 January 1910, p.9.

"A Toronto Art-Lover's Picture Gallery." *Saturday Night*, 26 February 1910, p.9.

Vauxcelles, Louis. "The Art of J.W. Morrice." *The Canadian Magazine*, December 1909, pp.169-176.

WORKS EXHIBITED IN CANADIAN ART CLUB EXHIBITIONS 1908 - 1915
EXPOSITIONS DU CANADIAN ART CLUB 1908 - 1915
OEUVRES EXPOSÉES

The spelling of titles and other inconsistencies in the original catalogues have usually not been corrected. Occasionally, works were added to the exhibitions at the last moment. These works are listed here, if mentioned in reviews. The sign ★ indicates that the work was reproduced in the catalogue.

Dans la majorité des cas, l'orthographe fantaisiste de certains titres et autres erreurs présentes dans les catalogues originaux n'ont pas été corrigées. Parfois, les oeuvres ont été ajoutées au tout dernier moment; elles figurent dans la liste qui suit si elles étaient mention-nées dans les revues critiques. L'astérisque signale que l'oeuvre est reproduite dans le catalogue.

FIRST ANNUAL EXHIBITION, 4TH - 27TH FEBRUARY, 1908
PREMIÈRE EXPOSITION ANNUELLE, 4 - 27 FÉVRIER 1908

William E. Atkinson
1. Groote Kirke: Dort
2. Showery Day
3. Still Evening
4. Sand Cart: Devon
5. Flemish Trees
6. Silvery Moonlight
7. After the Frost
8. Dutch Farm

J. Archibald Browne
9. Romance
10. Summer Moon
11. "In the Key of Blue"
12. The Red Moon
13. Rosedale
14. Faery Pool
15. Early Autumn Morning
15a. Brodick, Scotland

Franklin Brownell
16. Fishwife of Calvados
17. Harvest Fields
18. An October Hillside
19. Waterfall: Algonquin Park
20. Morning in June

William Brymner
21. October Day
22. The Spinner
23. Comrades

Maurice G. Cullen
24. The Water Carriers
25. Winter Sunset: Cove Fields

Robert Harris
26. Study of a Head
27. Old German

Edmund M. Morris
28. A Northern River
29. The Mourner
30. Bull Plume
31. Crowfoot's War Chief
32. Iron Shield: Blackfoot Head Chief
33. Cap Tourmente
34. Old Scottish Mills
35. Wolfe's Cove
36. Bout de l'Isle
37. Willows

James W. Morrice
38. PeasantsWashing Clothes: France
39. Morning: Off Coast of S. Augustine

Horatio Walker
40. The Wood Cutters

Homer Ransford Watson
41. The Struggle
42. March Morning
43. Wheat Field
44. Leaning Birch
45. The Dry Creek
46. Evening: Grand River
47. The Fallen Beech

Albert Curtis Williamson
48. Impressions of Newfoundland
49. Impressions of Newfoundland
50. Impressions of Newfoundland
51. Portrait of Archibald Browne
52. Interior
53. Old Japp
54. Old Woman of Normandy

SECOND ANNUAL EXHIBITION, 1ST - 20TH MARCH, 1909
SECONDE EXPOSITION ANNUELLE, 1er - 20 MARS 1909

William E. Atkinson
1. November
★2. Evening, Willows
3. The Pool
4. The Garden
5. Rest
6. Subsiding Flood

J. Archibald Browne
7. A Midsummer Night
8. The Valley
★9. Slumbering Waters
10. Purple

Franklin Brownell
★11. The Winnower
12. Smoky Evening, October
13. Little Puritan
14. Lamplight
15. Mt. Field, Evening
16. A Passing Shower

Maurice G. Cullen
17. Quebec from Levis
18. A Winter Stream

ETCHINGS/GRAVURES

Clarence A. Gagnon
19. Mont St. Michael
20. Rue des Cordeliers, Dinan
21. Jour de l'Horloge

22. Rue des Petits Degres
23. Port de Bourgoyne, Moret
24. Rue a Nemours
25. Canal du Loing, Moret
26. Overhauling Boats, St. Malo
27. A Picardy Road

Robert Harris
28. Portrait of Judge Cassels, Ottawa

Laura Muntz
29. Portrait of a Young Girl
30. Portrait of a Child

James W. Morrice
★31. Public Gardens, Venice
★32. Quai desGrands Augustins, Paris
33. Regatta, St. Malo
34. Port of Venice
35. Venice
36. Venetian Fete
37. Nocturne, Venice
38. Circus, Montmartre, Paris
39. St. Malo
40. Beach, St. Malo
41. Citadel, Quebec

Edmund M. Morris
42a. Scotch Valley
 b. Evening, Beaupre
★43. Big Darkness: An Assiniboine
44. A Saulteaux Chief

45. A Plainsman
46. A Cree

BRONZES

A. Phimister Proctor
★47. Indian Warrior
★48. Elephant Trumpeting
49. Panther with Kill
50. Leaping Tarpon
51. Prowling Panther
52. Polar Bear
53. Head of Alaskan Brown Bear
54. Cub and Rabbit
55. Bear Cub
56. Young Fawn
57. Dog with Bone
58. Standing Puma

WATERCOLOURS/AQUARELLES

59. Grizzly Bear
60. Antelope on Plains of Alberta
61. Bison on Trail, Saskatchewan
62. In Selkirk Range, B.C.
63. Hunting Panther, Alberta
64. Mountain Rains, Rocky Mountains, B.C.

John Wentworth Russell
65. Boy with Pheasant
66. Nude Boy with Dog

7. Old Mill, Brittany
*8. Breton Cottage
9. Canal, St. Martin - Evening, Paris
*10. Twilight - Normandy

WATERCOLOURS/AQUARELLES

11. Normandy Creek
12. River at Moonrise -The Packbridge - Devon
13. Return of the Sheep, Normandy

J. Archibald Browne
*14. Noontide
15. Waning Day
16. In the Gloaming
17. Moonlight
18. Starlight
19. Night
20. Low Tide
21. The Lighthouse
*22. The Deserted Keep
23. The Sandbar

George B. Bridgman
*24. The Magic Circle

William Brymner
*25. Feeding Chickens

William Henry Clapp
26. Landscape
27. Morning

Maurice Cullen
*28. Winter Evening - Montreal

Clarence A. Gagnon
*29. In the Laurentians, Winter
30. The Yellow House - Winter - Canada
31. St. Malo from the Cliffs of St. Briac
32. Monastery of St. Francis, Assisi
*33. Late Summer Afternoon - Les Andelys on the Seine

James L. Graham
34. In Pasture at Twilight
*35. At Nightfall in the Barnyard

William Hope
*36. Gray Day

Ernest Lawson
37. Unfinished Cathedral
38. Melting Ice
39. Summer
40. Summer - Boys Bathing

James Kerr Lawson
41. Aci Reale
42. Santa Venere
43. San Pancrazio
44. Lidda
45. Piarre Cappuceini

James W. Morrice
*46. Dieppe -The Beach - Grey Effect
47. Promenade - Dieppe
48. Dordrecht
49. Symphony in Pink
*50. Blue Umbrella
51. Old Holton House - Sherbrooke Street, Montreal

Edmund M. Morris
*52. Saskatchewan - landscape
53. Coming Storm - Country of the Crees
54. Encampment of Chief Star Blanket
55. Cree Lodges
*56. Evening in the File Hills
57. Northern Lights
58. Toronto Bay
59. Night at Hanlan's Point
60. An Idyll
61. The Citadel, Quebec
62. Evening - The Citadel
63. Dunes of Holland

A. Phimister Proctor
*64. American Bison

Horatio Walker
*65. Man Felling Tree
66. Sheepshearing

Homer Ransford Watson
67. The Source
68. The Rolling Surf - Louisburg
69. The Truants
70. A Shady Lane
71. The Way to the Sawmill

Albert Curtis Williamson
*72. Portrait of D.R. Wilkie
*73. Portrait of William Cruikshank
74. An Old Dutchman
75. Shades at Night

SIXTH ANNUAL EXHIBITION, 9TH - 31ST MAY, 1913
SIXIÈME EXPOSITION ANNUELLE, 9 - 31 MAI 1913

Walter S. Allward
*1. Sketch Model for King Edward Memorial, Ottawa

William E. Atkinson
2. Old Bridge on the Thames
3. Group of Oil Sketches
4. Old Town, Brittany, Night Effect
5. Woodland, near Dartmoor, Devonshire
6. Interior of Old Sheep Shed
*6a. Lanriec, Brittany

J. Archibald Browne
7. Spring's Awakening
8. Summer Eve
9. The Waning Light
10. Departing Day
*11. Risen Moon
12. After the Shower (Crosby Sands, near Liverpool)
13. Across the Bay
14. Summer Cloud
15. Thames Barge

Franklin Brownell
*16. Fisherman of the Caribbean
17. A Market in the West Indies
18. Nevis at Evening, British West Indies
19. Beach at St. Kitts
20. La Marina, San Juan, Porto Rico
21. Harbour, Charlotte Amalie, Danish West Indies
22. Serenade, Souvenir of Porto Rico

William Brymner
23. Bonsecours Church and Market
*24. Old Cottage at St. Eustache, Evening

William Henry Clapp
25. Decorative Landscape
*26. Louisa
27. Old Houses, Berthier
28. Red Couch

Marc-Aurele de Foy Suzor-Cote
29. Bright Canadian Winter Night
30. The Brook, November, Canada
31. Wet October Evening, Canada
32. Sugar Camp
33. Indian Hunting in the Woods
34. Mauve and Gold
35. A Coast Village, Brittany, France
36. Village of Cernay, France

* Sculpture - A Habitant - Statuette of same man

Maurice G. Cullen
37. Winter Sun Glow
*38. Ice Harvest

Clarence A. Gagnon
39. The Campo, Sienna
40. Green Sleigh, Snow Scene
41. Late Afternoon in the Alps
*42. Thunder Cloud, St. Malo
43. EarlyMorningMist,ChateauGaillard

Charles Paul Gruppe
*44. The Loggers
45. November Afternoon
46. Going to Pasture
47. The Old Lane

Henri Hebert
48. L'Abbe Melancon
*49. Mr. Lasalle

Louis Philippe Hebert
*50. Martine Messier

Ernest Lawson
*51. Willows in Winter
51a. Garden
52. Winding Road
53. Aqueduct in Spring
54. ChurchatStatenIsland, EarlyMorning
55. Evening

James Kerr Lawson
*56. Boston
57. Winter in Kent

James W. Morrice
*58. Beach, Pouldu
59. Venice, Night
60. Palazzo Dario, Venice
61. Mountain Hill, Quebec
62. Niege, Feneitre
63. Terrace, Capri
64. Le Quai des Grands Augustins

Edmund M. Morris
★65. In Country of Crees, Saskatchewan
66. In Foot Hills - Assiniboine Lodges
67. Evening, in the Foot Hills
68. Landscape, Saskatchewan
69. Nepahpenais - Chief of the Saulteaux
70. A Cree
71. Coast of Ile d'Orleans, Quebec
72. Landscape, Inverary, Argyllshire
73. Neidpath Castle

A. Phimister Proctor
★74. Lions of the Desert (relief)

75. Bison, Model for Q Street Bridge, Washington
76. Fawn
77. Bison

Boardman Robinson
79. Study of Torso
80. Model, Nude
81. Gulliver, Before Liliputians
82. The Turk
★83. The Widow

Horatio Walker
★84. Milking, Evening

Homer Ransford Watson
★85. Evening after the Rain
86. Passing Wind Storm
87. Road to the Village
88. Old Ontario Town
89. Side Line Cabin
90. Fire in the Windfall
91. Midsummer Day
92. Sugar Maples

Albert Curtis Williamson
Portrait study of a Negro Girl

SEVENTH ANNUAL EXHIBITION, 1ST - 30TH MAY, 1914
SEPTIÈME EXPOSITION ANNUELLE, 1er - 30 MAI 1914

Franklin Brownell
1. Pier Rock, Perce
2. Caribbean Market
3. On the Beach
4. Fishing Boat, Perce
5. Peons, Porto Rico
6. Landscape, Fitzroy

William Brymner
★7. After Glow
★8. Le Cours - Martiques

William Henry Clapp
★9. Landscape
10. A Turn of the Road
11. Landscape
13. Thought

Marc-Aurele de Foy Suzor-Cote
★14. Les Fumees, Port de Montreal
★15. Isolement

Maurice G. Cullen
16. The Willows
★17. On the North River
18. A Laurentian Valley
19. A Laurentian River

Clarence A. Gagnon
20. Daybreak, Lake of Geneva
21. Clearing in the Woods
★22. Early Winter Scene
23. The Valley Under Snow
24. The Schoolhouse

SCULPTURE

Henri Hebert
25. Life is full of Thorns
26. Bust Portrait - Mr. Montpetit

Louis Philippe Hebert
27. Le Moyne de St. Helene

Ernest Lawson
28. Winter
29. Moonlight
30. Spring

Edmund M. Morris (deceased)
★31. Cape Diamond from the St. Lawrence
★32. Cornfield, St. Ann de Beaupre, Quebec
33. Coast of Ile d'Orleans
34. Buffalo Willows
35. Cove Fields, Quebec
36. Willows, Haddingtonshire, Scotland
37. Cap Tourment, Ile d'Orleans
38. A Cree

James W. Morrice
★39. Une Parisienne
★40. The Surf, Dieppe
41. On the Beach, Parame

Henry Ivan Neilson
★42. Golden Autumn, Jacques Cartier River, Quebec
43. Dawn, Grand Lac Helene, Quebec
44. An Autumn Woodland
★45. Iona, Scotland
46. A Fishing Village, Scotland

ETCHINGS/GRAVURES

47. Schooner, Quebec
48. The Harbour, Quebec
49. Deepening of St. Charles River, Quebec
50. Sou le Cap Street, Quebec
51. Champlain Street, Quebec
52. The Ramparts, Quebec
53. Old Houses, Quebec
54. Louise Basin, Quebec (proof)
55. Cap Rouge Village, Co. Quebec
56. Montcalm Headquarters, Quebec
57. Old Wood Bridge, Riviere au Pin, Quebec
58. In Harbour, Quebec

SCULPTURES

A. Phimister Proctor
59. Standing Lion
60. Walking Lioness (relief)
61. Indian Head

62. Indian Head ("Weasel Head")
63. Princeton Tiger

WATERCOLOURS/AQUARELLES

64. Timberline, Cascade Range
65. Plains of Alberta
66. "Rocks," Cascade Range

Horatio Walker
★67. The Royal Mail
68. Autumnal
★69. The First Snow

Homer Ransford Watson
70. River Drivers
★71. Woodman's House
72. Ravine Road
★73. Glade of Oak Trees
74. Grove of the Hill Top
75. Woods in May
76. In the Wood Lot
77. Mid-Ontario Vista
78. On Ile d'Orleans, Quebec
79. Woodland
80. Oaks and Pines in the Clearing

William E. Atkinson
81. La Route, Brittany, France
82. End of October
★83. Return of the Sheep
84. Grey Day, Holland
85. Grey Autumn
★86. Canal St. Martin, Paris
87. Brittany Village
88. Ville Close, Concarneau, France

J. Archibald Browne
89. Autumn Glory
★90. The Tryst
91. The Golden Moon
★92. The Pleasure Fleet
93. Anchored
94. Crosby from the Shore of the Mersey

EIGHTH ANNUAL EXHIBITION, 7TH - 30TH OCTOBER, 1915
HUITIÈME EXPOSITION ANNUELLE, 7 - 30 OCTOBRE 1915

William E. Atkinson
★1. January Thaw
★2. Gathering in the Flock

3. Farm, Pont Aven
4. Market Day, Pont Aven
5. Woodland

6. Moon Effect
7. Coombe Brook, Devon
8. The Lane

9. Cottage
10. March Evening
11. Lone House, Dartmoor
12. Old Bridge, Dartmoor
13. Evening, Dartmoor
14. Near River Marne, France
15. Washing
16. Nocturne, Paris
17. Pont des Arts, Paris
18. Woodlant Cot
19. Sheep Pasture
20. Old Houses, France
21. Wood Interior
22. Pont Aven, France

Franklin Brownell
★23. Habitants Watering Horses
24. A Trout Stream
★25. Boat Landing, St. Thomas, Dutch West Indies
26. In June
27. Street, Charlotte Amalie, Dutch West Indies
28. A Camper
29. The Brook
30. Autumn Woodland
31. Habitant Cottage

J. Archibald Browne
★32. Sundown
★33. Lake Ontario Stonehookers
★34. A Symphony
35. Nocturne
36. The Cloud
37. After Rain
38. Silvery Twilight
39. The Village
40. Melting Snow
41. Marshland
42. Looking toward Ste. Anne de Beaupre

William Brymner
★43. Nude Figure
44. A Child
★45. Incoming Tide, Louisburg, C.B.
★46. Coast at Louisburg
47. Cap Sante, from Portneuf, Quebec
48. The Faubourg, Portneuf
49. Above the Valley
50. Sunday Summer
51. Pine Wood
52. A Ravine

Arthur Crisp
53. The Bathers
★54. Sunny Breakfast Room

55. Pelleas and Melisande
56. Pagliacci
★57. Headliners

Maurice G. Cullen
★58. Montreal Harbour
★59. Solitude
60. First Snow
★61. The Gully
62. Brittany Washerwoman
63. Winter Sunset
64. March
65. Sketch
66. Sketch

Marc-Aurele de Foy Suzor-Cote
★67. Village Street, Quebec, Winter
★68. Sugar Bush in Autumn
69. July Breeze
70. After a Shower
71. Ploughed Field
72. October Evening
73. November Evening
74. Village Street in Spain
75. Summer Evening
76. Sun Setting
77. The Cloud

Clarence A. Gagnon
78. Twilight in the Laurentians - Winter

Henri Hebert
79. Study in bronze
80. Appollo - head in plaster

James W. Morrice
81. Westminster, London
★82. Doge's Palace, Venice
83. Night, Dordrecht
★84. Market Place, St. Malo
85. On the Beach, Parame
86. Head of Boy

Henry Ivan Neilson
87. An October Day
88. Sandy Point, Lower St. Lawrence
89. Black Rapid, Jacques Cartier River, Quebec
90. Wayside Gossip
★91. A Fresh Breeze
92. Moonrise - Kirkcudbright Harbour
★93. A Summer Breeze

Horatio Walker
★94. Lime Burners at Night
95. An Autumn Pastoral

Homer Ransford Watson
96. Birth of an Army - Sunrise at Valcartier
97. The Review
98. The Ranges
★99. The Saw Mill
★100. In Grand River Park
101. Late Afternoon in the Fields

Ernest Lawson
★102. Ox Team - Maine
★103. Brook in Maine
104. Sea Gulls
105. Misty Day
106. Winter
★107. Shadow of the Bridge
108. Young Trees
109. Winding Road

LITHOGRAPHS/LITHOGRAPHIES

James Kerr Lawson
110. Lion of St. Mark
111. Bridge, Venice
112. Palazzo Labia, Venice
113. Piazza del Popolo, Rome
114. Temple of Vesta, Rome
115. Randazzo, Sicily
116. Baptistry, Florence
117. Piazza San Lorenzo, Florence
118. Piazza San Firenze, Florence
119. The Grandmother
120. The Oil Seller
121. The Water Carrier
122. The Old Horse
123. Tetuan
124. The Spanish Beggar
125. Boston
126. Boston
127. Stratford-on-Avon

William Henry Clapp
128. A Cuban River
129. Three Bather, Cuba
130. Cuban Farm
131. Bathers, Cuba
132. The Arroya Pool
133. Nereva Gerona
134. El Rio
135. Casa Villa

Albert Curtis Williamson
136. Portrait of an Old Lady
137. Portrait (Fred Mercer, Esq.)

CANADIAN ART CLUB
WORKS EXHIBITED / OEUVRES EXPOSÉES
THE EDMONTON ART GALLERY

William E. Atkinson (1862-1926)
Shepherd, Sheep and Stream, Evening 1906
watercolour and gouache/aquarelle et gouache
99 x 80 cm
The Estate of/Succession de/William Edwin Atkinson, Toronto

William E. Atkinson (1862-1926)
Willows, Evening 1908
oil on cardboard/huile sur carton
101.4 x 77 cm
Collection of The National Gallery of Canada/Collection du Musée des beaux-arts du Canada
At/à C.A.C., 1909, #2, as/comme *Evening, Willows*

William E. Atkinson (1862-1926)
Return of the Sheep, Normandy 1911
watercolour/aquarelle
c. 51 x 39 cm
The Estate of/Succession de/William Edwin Atkinson, Toronto
At/à C.A.C., 1912, #13

William E. Atkinson (1862-1926)
The Old Town, Brittany, Night Effect 1913
oil on canvas/huile sur toile
46 x 58 cm
The Government of Ontario Art Collection, Queen's Park, Toronto
At/à C.A.C., 1913, #4

William E. Atkinson (1862-1926)
(Untitled) (Moonlit Landscape) n.d.
watercolour on paper/aquarelle sur papier
39 x 52 cm
Collection of the Art Gallery of Hamilton, gift of Mr. Ian Flann, 1985
Similar subject/même genre de tableau at/à C.A.C., 1910, #6, as/comme *Dutch Moonlight*

J. Archibald Browne (1864-1948)
The Valley 1909
oil on canvas/huile sur toile
109.2 x 83.8 cm
Collection of the Agnes Etherington Art Centre, Queen's University, Kingston, Ontario, gift of the Honourable A.C. Hardy, 1944
At/à C.A.C., 1910, #12

J. Archibald Browne (1864-1948)
Bewitchement c. 1910
oil on canvas/huile sur toile
91 x 63 cm
Collection of D.R. Wilkie, Toronto
At/à C.A.C., 1910, #19

J. Archibald Browne (1864-1948)
Sundown 1914
oil on canvas/huile sur toile
155 x 107 cm
Collection of The Mackenzie Art Gallery
At/à C.A.C., 1915, #32

Peleg Franklin Brownell (1857-1946)
View of Mount Nevis from St. Kitts, 1911
oil on canvas/huile sur toile
41 x 61.3 cm.
Collection: Art Gallery of Ontario

Peleg Franklin Brownell (1857-1946)
Fishing Boats, Percé 1912
oil on canvas/huile sur toile
39 x 52 cm
The Government of Ontario Art Collection, Queen's Park, Toronto, Ontario
At/à C.A.C., 1914, #4

Peleg Franklin Brownell (1857-1946)
Percé Rock c. 1912
oil on canvas/huile sur toile
50.2 x 52.1 cm
The Government of Ontario Art Collection, Queen's Park, Toronto, Ontario
At/à C.A.C., 1914, #1, as/comme *Pier Rock, Percé*

Peleg Franklin Brownell (1857-1946)
Cascade Mountain n.d.
oil on canvas/huile sur toile
45 x 37 cm
Private/Collection/privée
Similar subject/même genre de tableau at/à C.A.C., 1909, #15, as/comme *Mt. Field, Evening* and/et, 1910 #25 as/comme *View of Ottertail Mountains, B.C.*

Peleg Franklin Brownell (1857-1946)
Street Scene, West Indies 1915
oil on canvas/huile sur toile
37 x 44 cm
Private/Collection/privée
Similar subject/même genre de tableau at/à C.A.C., 1915, #27, as/comme *Street, Charlotte Amalie, Dutch West Indies*

William Brymner (1855-1925)
The Vaughan Sisters 1910
oil on canvas/huile sur toile
102 x 128 cm
Collection of the Art Gallery of Hamilton, gift of Mrs. H.H. Leather, 1962
At/à C.A.C., 1910, #26

William H. Clapp (1879-1954)
In the Orchard, Quebec 1909
oil on canvas/huile sur toile
73.9 x 92.2 cm
Collection of the Art Gallery of Hamilton, gift of W.R. Watson, 1956

William H. Clapp (1979-1954)
The Three Bathers, Cuba 1915
oil on canvas/huile sur toile
51.3 x 61.6 cm
Collection of The National Gallery of Canada/Collection du Musée des beaux-arts
At/à C.A.C., 1915, #129

Arthur W. Crisp (1881-1966)
Box Party 19 n.d.
oil on canvas/huile sur toile
33.7 x 76.3 cm
Collection of the Art Gallery of Hamilton, gift of the artist/don de l'artiste
Similar subject/même genre de tableau at/à C.A.C., 1915, #57, as/comme *Headliners*

Maurice Cullen (1866-1934)
Petty Harbour, Newfoundland c. 1912
oil on canvas/huile sur toile
56.2 x 71.4 cm
Collection of The Edmonton Art Gallery

Maurice Cullen (1866-1934)
North River in Spring c. 1913
oil on canvas/huile sur toile
61 x 81 cm
Collection of Mr. and Mrs. Sam Pollock, Montreal
At/à C.A.C., 1914, #17, as/comme *On the North River*

Maurice Cullen (1866-1934)
Laurentian Hills c. 1914
oil on canvas/huile sur toile

58.4 x 72.6 cm
Collection of Nipissing University College
At/à C.A.C., 1914, #18

Clarence Gagnon
Canal du Loing, Moret 1907
etching on paper/gravure sur papier
14.6 x 21.4 cm (Imp.)
Collection of the Montreal Museum of Fine Arts/Collection du Musée des beaux-arts de Montréal, purchase/acquisition, Shepherd Fund and Dr. and Mrs. Martin/Fonds Shepherd et Dr. et Mme Martin
At/à C.A.C., 1909, #25

Clarence Gagnon (1881-1942)
Mont St. Michel 1907
etching on paper/gravure sur papier
19.7 x 24.8 cm (Imp.)
Collection of the Montreal Museum of Fine Arts/Collection du Musée des beaux-arts de Montréal, purchase/acquisition, Shepherd Fund and Dr. and Mrs. Martin/Fonds Shepherd et Dr. et Mme Martin
At/à C.A.C., 1909, #19

Clarence Gagnon (1881-1942)
Winter, Village of Baie St. Paul, Quebec 1910
oil on canvas/huile sur toile
72 x 91 cm
Collection of Power Corporation of Canada
At/à C.A.C., 1911, #20

James Lillie Graham (1873-c.1965)
Landscape and Cattle 1908
oil on canvas/huile sur toile
92 x 64 cm
Collection of Mr. James W. Graham, Indianapolis, Ind.
Similar subject/même genre de tableau at/à C.A.C., 1911, #29

Charles Paul Gruppe (1860-1940)
November Afternoon in the Pasture c. 1890-1910
oil on canvas/huile sur toile
59 x 48 cm
Collection of The Margaret Woodbury Strong Museum, Rochester, N.Y.

James Kerr-Lawson (1862-1939)
Piazza San Firenze, Florence 1908
Lithotint on paper/lithographie en couleurs sur papier
29.5 x 18.1 cm (Imp.)
Collection of the Art Gallery of Ontario, gift of Mrs. W.H. Cawthra, 1944
At/à C.A.C., 1915, #118

James Kerr-Lawson (1862-1939)
Piazza San Lorenzo, Florence 1908
Lithotint on paper/lithographie en couleurs sur papier
29.2 x 20.3 cm (Imp.)
Collection of the Art Gallery of Ontario, gift of Mrs. W.H. Cawthra, 1944
At/à C.A.C., 1915, #117

James Kerr-Lawson (1862-1939)
San Geremia and Palazzo Labia, Venice 1908
Lithotint on paper/lithographie en couleurs sur papier
31.8 x 19.1 cm (Imp.)
Collection of The Edmonton Art Gallery
At/à C.A.C., 1915, #112

James Kerr-Lawson (1862-1939)
Boston Lincolnshire 1913

oil on canvas/huile sur toile
99 x 137.2 cm
Collection of the Art Gallery of Windsor
At/à C.A.C., 1913, #56

Ernest Lawson (1873-1939)
Winter on the River 1907
oil on canvas/huile sur toile
84 x 102 cm
Collection of the Whitney Museum of
American Art, New York, N.Y., gift
of Gertrude Vanderbilt Whitney
Similar subject/même genre de tableau
at/à C.A.C., 1911, #32, as/comme
Snowbound Boats (The National Gallery
of Canada)

Ernest Lawson (1873-1939)
Cathedral Heights c. 1912
oil on canvas/huile sur toile
63.8 x 76.5 cm
Collection of the Columbus Museum of
Art, Columbus, Ohio, gift of Ferdinand
Howald, 1931
Similar subject/même genre de tableau
at/à C.A.C., 1912, #37, as/comme
Unfinished Cathedral

Ernest Lawson (1873-1939)
Early Spring c. 1913-14
oil on canvas/huile sur toile
51 x 62 cm
Collection of the Everson Museum of
Art, Syracuse, N.Y.
Similar subject/même genre de tableau
at/à C.A.C., 1914, #28, as/comme *Winter*
(The National Gallery of Canada)

Laura Muntz Lyall (1860-1930)
Mother and Child c. 1900
oil on canvas/huile sur toile
21.1 x 27 cm
Collection of The Edmonton Art Gallery

Laura Muntz Lyall (1860-1930)
Madonna And Child n.d.
oil on canvas/huile sur toile
99 x 76.2 cm
Collection of Sandra Lyall Smagalon,
Toronto

James Wilson Morrice (1865-1924)
Notre Dame c. 1898
oil on canvas/huile sur toile
19 x 24.1 cm
Collection of The McMichael Canadian
Collection, gift of Col. R.S. McLaughlin
Similar subject/même genre de tableau
at/à C.A.C., 1910, #44

James Wilson Morrice (1865-1924)
The Citadel, Quebec c. 1900
oil on canvas/huile sur toile
49 x 65.3 cm
Collection of the Musée du Québec/
Collection du Musée du Québec
At/à C.A.C., 1909, #41

James Wilson Morrice (1865-1924)
Return from School 1900-03
oil on canvas/huile sur toile
46.4 x 73.7 cm
Collection of the Art Gallery of Ontario,
gift from the Reuben and Kate Leonard
Canadian Fund, 1948
At/à C.A.C., 1910, #42, as/comme
St. Anne de Beaupré, Winter

James Wilson Morrice (1865-1924)
Port of Venice c. 1905
oil on canvas/huile sur toile
50.5 x 61 cm

Collection/of The Montreal Museum
of Fine Arts/du Musée des beaux-arts
de Montréal, Donation/Miss Leila
Hosmer Perry/Bequest
At/à C.A.C., 1909, #34

James Wilson Morrice (1865-1924)
The Old Holton House, Montreal c. 1908-10
oil on canvas/huile sur toile
61x 73.6 cm
Collection/of The Montreal Museum
of Fine Arts/du Musée des beaux-arts
de Montréal, Fonds/John W. Tempest/
Fund
At/à C.A.C., 1912, #51

James Wilson Morrice (1865-1924)
Quai des Grand-Augustins, Paris c. 1910-11
oil on canvas/huile sur toile
60.9 x 50.2 cm
Collection/of The Montreal Museum
of Fine Arts/du Musée des beaux-arts
de Montréal, Donation/William J.
Morrice/Bequest
At/à C.A.C., 1913, #64

Edmund M. Morris (1871-1913)
Indians Descending the Pic River c. 1906
oil on canvas/huile sur toile
74.9 x 99.1 cm
The Government of Ontario Art
Collection, Queen's Park, Toronto,
Ontario
At/à C.A.C., 1908, #28, as/comme
A Northern River

Edmund M. Morris (1871-1913)
Wolf Collar: Medicine Man 1909
pastel on paper/sur papier
63.9 x 50 cm
Collection of the Government of Alberta
At/à C.A.C., 1910, #50

Edmund M. Morris (1871-1913)
Chief Water Chief (Okena) 1909
pastel on paper/sur papier
63.9 x 50.2 cm
Collection of the Government of Alberta
At/à C.A.C., 1910, #53, as/comme *Water
Chief of the Blackfeet*

Edmund M. Morris (1871-1913)
Big Darkness (Opazatonka) c. 1910
pastel on paper/sur papier
63.9 x 50.1 cm
Courtesy of the Saskatchewan Property
Management Corporation. Assiniboine
Gallery, Legislative Building, Regina,
Saskatchewan
At/à C.A.C., 1910, #48

Edmund M. Morris (1871-1913)
Chief Nepahpenais - Night Bird c. 1910
pastel on paper/sur papier
63.9 x 50.1 cm
Courtesy of the Saskatchewan Property
Management Corporation. Assiniboine
Gallery, Legislative Building, Regina,
Saskatchewan
At/à C.A.C., 1911, #40

Edmund M. Morris (1871-1913)
Landscape, Old Fort Edmonton c. 1910
oil on canvas/huile sur toile
85.1 x 112.3 cm
Collection of The Glenbow Museum,
Calgary, Alberta
At/à C.A.C., 1911, #37

Edmund M. Morris (1871-1913)
*(Untitled Landscape) (Sketch of Dufferin
Terrace, Quebec)* c. 1911

oil on canvas/huile sur toile
10 x 35 cm
Collection of The Edmonton Art Gallery
Similar subject/même genre de tableau
at/à C.A.C., 1911, #45

Edmund M. Morris (1871-1913)
Cape Diamond from the St. Lawrence n.d.
oil on canvas/huile sur toile
61 x 76 cm
Collection of D.R. Wilkie, Toronto
At/à C.A.C., 1914, #31

Henry Ivan Neilson (1865-1931)
*The Deepening of the St. Charles River,
Quebec* 1913
etching on paper/gravure sur papier
20.3 x 30.5 cm (Imp.)
Collection of the Burnaby Art Gallery
At/à C.A.C., 1914, #48

Henry Ivan Neilson (1865-1931)
The Louise Basin 1913
etching on paper/gravure sur papier
32.8 x 46.3 cm (Imp.)
Collection of the Musée du Québec/
Collection du Musée du Québec
At/à C.A.C., 1914, #54

Henry Ivan Neilson (1865-1931)
The Ramparts, Quebec n.d.
etching on paper/gravure sur papier
16.5 x 22.8 cm (Imp.)
Collection of the Musée du Québec/
Collection du Musée du Québec
At/à C.A.C., 1914, #52

Henry Ivan Neilson (1865-1931)
The Old Wood Bridge n.d.
etching on paper/gravure sur papier
14.3 x 21.4 cm (Imp.)
Collection of the Musée du Québec/
Collection du Musée du Québec
At/à C.A.C., 1914, #57

A. Phimister Proctor (1860-1950)
Prowling Panther 1891-92
bronze
24 x 85 cm
Collection of The Agnes Etherington
Art Centre, Queen's University, Kingston,
Ontario, Chancellor Richardson
Memorial and Wintario Matching
Funds, Purchase 1979
At/à C.A.C., 1909, #51

A. Phimister Proctor (1860-1950)
Young Fawn 1893
bronze
17 x 6.6 x 20 cm
Collection of D.R. Wilkie, Toronto
At/à C.A.C., 1909, #56

A. Phimister Proctor (1860-1950)
Mountain Lion 1897
bronze
30 x 42 x 2.5 cm
Collection of The Glenbow Museum,
Calgary, Alberta
At/à C.A.C., 1909, #58, as/comme
Standing Puma

A. Phimister Proctor (1860-1950)
Charging Buffalo 1897
bronze
30 x 19.6 x 41.2 cm
Collection of The Glenbow Museum,
Calgary, Alberta
At/à C.A.C., 1912, #64

A. Phimister Proctor (1860-1950)
Moose n.d.

bronze
46 x 37.1 x 12.7 cm
Collection of The Brooklyn Museum,
Brooklyn, N.Y.
At/à C.A.C., 1910, #55

John W. Russell (1879-1959)
Boy with Bird 1906
oil on canvas/huile sur toile
48 x 61 cm
Collection of Mrs. Joan E. Fry, Quebec
Similar subject/même genre de tableau
at/à C.A.C., 1909, #65, as/comme
Boy With Pheasant

Marc-Aurèle de Foy Suzor-Coté
(1869-1937)
Village de Cernay, France 1899
oil on canvas/huile sur toile
58.4 x 72.6 cm
Collection of Nipissing University College
At/à C.A.C., 1913, #36

Horatio Walker (1858-1938)
Les Scieurs de Bois 1900
oil on canvas/huile sur toile
71.3 x 96.8 cm
Collection of the Musée du Québec/
Collection du Musée du Québec
Similar subject/même genre de tableau
at/à C.A.C., 1908, #40, as/comme *The
Wood Cutters*

Horatio Walker (1858-1938)
Evening, Ile de'Orleans 1909
oil on canvas/huile sur toile
71.8 x 91.4 cm
Collection of the Art Gallery of Ontario,
gift of the family of Sir Edmund Walker,
1926
At/à C.A.C., 1910, #59

Homer Watson (1855-1936)
The Lone Cattle Shed 1894
oil on canvas/huile sur toile
61 x 45.8 cm
Collection of The London Regional Art
Gallery, presented by Mr. & Mrs. H.R.
Jackman, in memory of the Honourable
Newton W. and Mrs. Nellie Langford
Rowell, 1977
At/à C.A.C., 1910, #70

Homer Watson (1855-1936)
*The Smugglers' Cove, Cape Breton Island,
N.S.* 1909
oil on canvas (laid down on masonite)/
huile sur toile (couchée sur masonite)
86.4 x 121.9 cm
Collection of The Beaverbrook Art
Gallery, Fredericton, N.B., gift of Lord
Beaverbrook, 1959
Similar subject/même genre de tableau
at/à C.A.C., 1910, #66, as/comme *Grey
Headland, Cape Breton*

Homer Watson (1855-1936)
Evening after Rain 1913
oil on canvas/huile sur toile
80.3 x 102.9 cm
Collection of the Art Gallery of Ontario,
gift of the Canadian National Exhibition
Association, 1965
Similar subject/même genre de tableau
at/à C.A.C., 1913, #85

Homer Watson (1855-1936)
The River Drivers 1914 & 1925
oil on canvas/huile sur toile
87 x 121.9 cm
Collection of The Mackenzie Gallery
At/à C.A.C., 1914, #70

Homer Watson (1855-1936)
Camp at Sunrise c. 1915
oil on canvas/huile sur toile
152 x 181 cm
Collection of The Canadian War Museum,
Canadian Museum of Civilization,
National Museums of Canada/Collection
du Musée canadien de la guerre, Musée
canadien des civilisations, Musées
nationaux du Canada
At/à C.A.C., 1915, #98, as/comme
The Ranges, Valcartier

A. Curtis Williamson (1867-1944)
Misty Morning, Newfoundland c. 1906
oil on canvas/huile sur toile
97.8 x 128.3 cm
Collection of the Art Gallery of Ontario,
gift of the Reuben and Kate Leonard
Canadian Fund, 1926
One of three works/une des trois
oeuvres at/à C.A.C., 1908, #48-50,
as/comme *Impressions of Newfoundland*

A. Curtis Williamson (1867-1944)
Portrait of William Cruikshank c. 1911-12
oil on canvas/huile sur toile
154 x 97.1 cm
Collection of Mr. Karl Allward, Calgary
At/à C.A.C., 1912, #73